THE GREAT STATUARY OF CHINA

THE GREAT STATUARY OF CHINA

By

VICTOR SEGALEN

Translated by

ELEANOR LEVIEUX

Edited by MADAME A. JOLY-SEGALEN

Afterword by VADIME ELISSEEFF

The University of Chicago Press
Chicago and London

*I wish to express my warmest thanks to Mrs. A.
Joly-Segalen and Mr. Yvon Segalen, daughter and son
of Victor Segalen, for their unstinting cooperation
and assistance at every stage of this translation.*
 Eleanor Levieux

The University of Chicago Press, Chicago 60637
The University of Chicago Press, Ltd., London

Published originally in French in 1972 as
Chine: La grande statuaire by Flammarion et Cie
© Flammarion, 1972

Library of Congress Cataloging in Publication Data

Segalen, Victor, 1878–1919.
 The great statuary of China.

 Translation of Chine; la grande statuaire.
 1. Sculpture, Chinese. 2. Statues—China.
I. Joly-Segalen, Annie. II. Title.
NB1043.S4213 732'.7 74-27928
ISBN 0-226-74448-5

Contents

Illustrations

1. Photographs

2. Drawings by Victor Segalen

A. *Tomb of Ho Ch'ü-ping. Horse bestriding a Hsiung-nu barbarian. Profile.*
B. *Tomb of Ho Ch'ü-ping. Horse bestriding a Hsiung-nu barbarian. Rear view, three-quarters profile.*
C. *Tomb of Ho Ch'ü-ping. Horse bestriding a Hsiung-nu barbarian. Barbarian's head.*
D. *Tomb of Ho Ch'ü-ping. Horse bestriding a Hsiung-nu barbarian. Face.*
E. *Plan taken from the local chronicles of the city of Hsing-ping.*
F. *Burial place of Kao I. Winged tiger, standing. Three-quarters, rear.*
G. *Ch'ü-hsien. Winged tiger, seated. Profile.*
H. *Right-hand pillar at P'ing-yang. Corner motif. Hydras entwined.*
I. *Left-hand pillar at P'ing-yang. Corner motif. Winged horse and runner.*
J. *Left-hand Shen pillar. Front. "Dash to the Unknown."*
K. *Left-hand Shen pillar. Inner side. Barbarian archer.*
L. *Tomb of Hsiao Ching. Cross-section of the fluted column.*
M. *Chia-ting-fu. Ma-wang-tung. Statue of Bodhisattva.*
N. *Six schemata of wing variants, from the Later Han to the T'ang.*
O. *Burial place of T'ang Kao-tsung. Ostrich.*
P. *Burial place of T'ang Jui-tsung. Ostrich.*
Q. *Burial place of T'ang Jui-tsung. Column.*
R. *Burial place of T'ang Kao-tsung. Official with "chignon."*
S. *Burial place of the mother of the empress Wu. Official.*
T. *Shen-chou. Guard of the Bell Tower.*
U. *Shen-chou. Guard of the Bell Tower.*
V. *Shen-chou. Guard of the Bell Tower.*

"The great poet who wrote Stèles *here reveals to us, as no one had ever done before and as no one since has done, the spirit of the art he studied. In its field, this book is* irreplaceable.*"*

—André Malraux

Preface

The subject of this book is Chinese stonework in its sculptural form. It is the original expression of China in terms of what is solid and voluminous. Through an anomaly of which there are few examples in the history of the arts, it happens that this subject—the most heavy, cumbersome, visible matter there is—has been the least looked at until now, and has been given the least space in the already copious inventories of either the imponderable or the plastic arts of the great country I have made my province.

Two thousand years ago, the Romans sought the beautiful textiles of Serica, or country of silk; and five hundred years ago, the Persians, masters of the art of making pottery, acknowledged the mastery of the Chinese in making porcelain. More recently, through the missionaries, we had glimpses of the Chinese poets, and began to suspect the exquisite art of calligraphy. Nowadays, finally, we are aware of their lacquer ware, their bronzes, their inimitable, decorative, expressive style of painting. For each of these arts, in which so many things remain inexplicable, we suspected periods of progress and decline, origins, archaism, zenith, decay—in short, the overall arabesque.

But, by contrast, most of the mighty carved stone monuments of pure ancient China continued to be overlooked by the European scholars—unknown to them or, worse still, unvalued by their own compatriots. As a result, this book, which deals exclusively with those monuments for the first time, may seem to be quite a latecomer in the full series.

The reasons are many. China is huge. Even when limited to its "eighteen provinces," even when stripped of its wild tributary peoples—Manchus, Mongols, Tibetans—China is huge. Its classical territory is four times as large as modern France. And from the standpoint of archaeological appraisal as such, China is unexplored. Now, most of the monuments involved are not very movable: monoliths from three to ten or twelve feet high, attached to a pedestal that roots them to the ground. The people who carved them and placed them there are dead. Nor do we ourselves live in the days when the chimeras, unicorns, or lions weighing ten thousand weight, towed along on stone wheels, miraculously began, when they neared their destination—generally a princely tomb—to sniff the wind, to shake themselves, and leap onto the site reserved for them, as happened, say the texts, in the reign of Wu-ti of the Liangs, in Nanking, nearly fifteen hundred years ago. . . .

13

Those that remain are still far away. They live in noncoastal provinces that the railways have not insulted yet, in areas mapped out only in the Chinese manner, where the rivers and the roads of the old days lead. And, yet, many of these monuments would have warranted real pilgrimages if an unfortunate geographical accident hadn't placed *near* the coast—like traps set for foreigners—the most deplorable products of that art, the stereotypes of the least exalted periods: that livestock of bovines, humans, felines, elephants, and camels which were all too familiar, even famous in travelers' tales as the "Statues of the Tombs of the Ming" in Peking or Nanking.

Since these statues were within excursion reach, these were the only ones that people saw. And since they were ugly, no one was eager to go looking for any others. Since they were heavy, and since people had to describe them somehow, they were dubbed imposing. Since they were guaranteed to be five hundred years old, all the ancient virtues were heaped upon them. Which is why, for lack of anything better, the products of a long period of decadence were held to be examples of the loftiest achievement; and without looking to see whether other statues, in other places, did not testify to quite another type of genius, people concluded that this was "the style" of carved stone throughout Chinese time and Chinese space.

So the mistake has now been pointed out, at the very outset of this study.

Neither in theory nor in fact do the Chinese scholars appear to have been concerned with the potent and authentic art, taken as a whole, of the three-dimensional carving of a stone block. Whereas there are countless adequate documents on the other arts, the catalogues that deal with stonework, which is rarely treated by itself and generally placed under the heading "Stones and Metals,"—are chiefly concerned with epigraphy. They are "corpora" of inscriptions. If they do happen to reproduce the sculpture in the work that accompanies the inscription, it would seem to be out of a scruple for documentary accuracy; certainly not out of any concern with sculptural art. As depicted by the brush, volume is reduced to a clever two-dimensional line, powerless or careless to express a third dimension. Moreover, only to a rather slight extent do these catalogues point out monuments that still exist. Many of the ones they indicate have disappeared. And though there are a hundred texts to tell us the names of millions of scholars, painters, and calligraphers, when it comes to sculpture in the round, in what was genuinely ancient China, we are told the name of *only one* authentic sculptor worthy of the name—and his work has been lost.

Here then is the gap, the void. Here is the mistake: the false Chinese starting point. After that mistake came the European error—more serious, more deplorable, and still being perpetrated today. I am talking about the Buddhistic heresy. When there was a glimmer of suspicion that the Ming of Peking and elsewhere but dimly represented the unknown splendor of ancient times, retaining little of the old beauty, then amateurs of "China at all costs" prostrated themselves before the equivocal statues that had just been discovered, I will discuss them in the seventh chapter of this book, in order to reject them. Immediately, the profiteers began to take advantage of the situation. These statues were lucky enough to date from a more remote antiquity and reflect more lofty ages. But foreign

though they were, having come from very far away—and by such devious paths!—they were assumed to be Chinese. To these outgrowths of apostolic Hinduism an indigenous value was assigned. Since for the first time they showed human beings in stone, people looked for the natural appanage of man: his face. People were grateful to these statues for introducing the human face into "Chinese art." But since these inexpressive Buddha faces—inexpressive by nature and by dogma—could not be called handsome, they were said to have "spiritual beauty," "spirituality." They were greeted with ecstasy. And the art dealers took care of the rest.

As a result, until the beginning of this century, the field of study was wide open. In no European language, and still less in Chinese, was there any overall work presenting the authentic sequence of China's true statues.

The first major historian of stone sculpture in China was the master of French Sinology, Edouard Chavannes. I haven't room here to summarize the expanse covered by his work or the development of his thought. Starting with philosophy in general, he arrived at Chinese philosophy, and then at Chinese history, and, from one detail to the next, he arrived at what was to confirm that history in the most resounding way: research into monumentary archaeology. It is that research which must be summarized here. That is the real gateway to this book. His research constituted the lesson, the teaching, the trail blazed.

Edouard Chavannes was the first to guess, without any genuine Chinese treatise to guide him, that beneath the plenitude of obscure or erroneous allusions to the ancient statues, most of which decorated tombs—scanty allusions scattered throughout the vast collections of "Provincial chronicles"—there was a hope of truth, a hope of making some find; and he had the great merit of *going there to find out*. In so doing, he broke with the sedentary tradition of his predecessors, who scarcely left that factitious strip known as "the coast." It is true that his first mission, in 1893, was limited to points that were already known, already localized in the provinces of Honan and Shantung, where the famous "small funeral chambers" were situated. But he published so complete a study of them that thereafter the analysis and use of stone evidence, not only inscriptions but figures as well, were reinvigorated, full of promise.

That promise was amply kept when he made his second trip. In 1907, he started out from Peking, accompanied by a Russian Sinologist, J. X. Alexeiev, who was drawn especially by the texts, by the Chinese language as such, by the poetry. Together they revisited the "small chambers" of Shantung, the pillars of Shantung and Honan provinces; and this time Chavannes gave a detailed description of them which is definitive. Then they saw Yün-Kang and Lung-men, the two great Buddhistic sanctuaries; and there again, nothing more will need to be done for a long time as far as translating texts is concerned. Finally, they set out for Shansi and Shensi, the fundamental provinces of ancient China. This is where the discoveries were made. For the first time, statues were observed and described that were incomparably older than the statues of the Ming tombs along the coast: the statues of the Sung in Honan Province, going back to the tenth century, those of the T'ang in Shensi (eighth century) located near the ancient capital,

Ch'ang-an. Suddenly, the whole history of sculpture in the round in ancient China opened up. No longer was the field of study confined to that Ming menagerie dating from the fourteenth and fifteenth centuries, in Nanking or Peking; now it reached back, and with so much greater breadth, to the ninth, eighth, even seventh century B.C. As was to be expected, a single rule prevailed, one that will recur throughout this book with increasing firmness, in every style, every school discussed: the oldest examples of any given style were always the most beautiful and obeyed the "law of ascending beauty."

It was after Edouard Chavannes had made his trips that, in 1909 and again in 1914, we ourselves set out, under his aegis and faithful to the methods he had transmitted to us. "We" means Gilbert de Voisins, Jean Lartigue, and myself, together or separately. This book is the product of our tripartite research; while some of the discoveries remain personal, most of them are inextricably mingled.

The method that our master had so masterfully inaugurated consisted of methodically going through the voluminous collections of "chronicles" that each province, each prefecture and subprefecture drew up for several hundred years. Verbose, fact-filled, highly enjoyable or equally boring, they contain a vast historical and geographical description of the whole empire. The smallest such collection contains scores of volumes, but they can be leafed through quickly and the dead wood is easily cut out. Once you have set aside all of the chapters on ancient ramparts, the sites of vanished cities, lists of officials, famous men, springs and ponds, mountains and rivers, women of astonishing virtue, prodigies . . . you are left with three chapters of the utmost archaeological interest, generally entitled "Ancient Vestiges," "Stones and Metals," "Tombs and Monuments." And here, lost in the vastness of the book as if isolated in the geographical expanses, is where you find the description of statues that may still exist, regardless of whether they are considered (which is rare) as "ancient vestiges" in themselves or whether, because of their proximity to a contemporary inscription, they share in the glory reserved for the stele, the engraved "stone" that makes them memorable in the eyes of Chinese archaeologists, calligraphy enthusiasts above all. Or again, as most frequently happens, they decorate a burial place, and the dead man's name and an indication of his era have been historically preserved. Then the hunt is on, with all the hazards which that involves.

The texts describe these statues in a way that is minutely detailed, sincere, disappointing, or puerile, all at the same time; often unexpected. A tiger, for instance, is always called a "lion," although there were actually examples of both; and all of the other quadrupeds—cows, rams, or palfreys—are indiscriminately considered "horses." Among the tortoises, on the other hand, we find legendary distinctions that could have scarcely existed between the real species, and, among the dragons, authentic families. Furthermore, the quasi-legendary incidents connected with each one of these statues were always meticulously noted; but often the author fails to indicate exactly where they were located or—piously copying from an accumulation of precedents—to tell us whether the statue, which still existed at the time of the census taken by the chronicles of the fifteenth, seventeenth, or eighteenth century, under the Ming, the K'ang-hsi or the Ch'ien-lung, was still visible during the reign in which he was writing.

Lastly, topography is faulty, despite seemingly accurate erudition and the constant use of cardinal points. Not that the terms that are used are false in themselves, but they are stretched, elastic, full of variants. The unit of length is the *li*, a convenient, pleasant, and very human distance, for a *li* is equivalent to about one-third of a mile. A man, a mule, a horse, or bearer who walks for an hour over an average road covers practically ten *li*. This was our usual gait. But there were variants; and the starting point was sometimes one of those "cities that were"—one of those very *hsien* that were mentioned under the heading "Walls and Ditches" in the chronicles; then its outline had to be mapped out, located, resuscitated. Then we had the impression that we ourselves were moving in a past that was not only historical but geographical, in a "space of time past" whose ghost had to emerge in its entirety before any work could be undertaken.

These, then, are the major elements in the research whose results are offered here for the first time.

As we have noted, Edouard Chavannes revealed the true sculpture of the Sung and the T'ang, as well as the decorated pillars and "chambers" of the second Han dynasty, which were actually closer to architecture and drawing. The excavations carried out during our own expeditions, particularly the second, which was a continuation of the first and moved ahead on the map from Shensi to Szechwan, completed the finds dating from the T'ang that our master had made and, in both Shensi and Szechwan, revealed what sculpture in the round had been like under the Han. At the same time, the oldest stone statue between Persia and Japan, the most ancient stone monument of the entire Far East, was discovered: the Horse of Ho Ch'ü-ping, dating from 117 B.C.

But between the Han (from the second century B.C. to the second century A.D.) and the T'ang (seventh to tenth centuries), there remained a gap—of six centuries. The chance discoveries and leisure time of my third trip, made in 1917 to the country around Nanking, allowed me to fill that gap by studying the burial places of the "southern dynasties" which covered precisely that period.

From then on, the succession of links was continuous. With only explicable, historical, logical interruptions, such as the void corresponding to the Yüan-Mongols in the thirteenth century, it descended from the first date given, 117 B.C., to our own day.

This book is not a work of compilation but rather the result of personal research. The criticism and the descriptions I attempt to make here cannot but be vivid and biased. Most of the statues I describe or sketch we saw again and again, at will. A goodly share of them we discovered. Now, the fact of finding a statue, the act of unearthing it, partake of such novel excitement that it is difficult to hide it or refrain from conveying it in the words which describe that moment.

When a European eye beholds, for the *very first* time, a stone shape that bears witness to two thousand years in the Chinese past, when each blow of the pickax makes a little more of the earthen mantle fall from it, an impression of personal possession, personal achievement, swells such that the mere description, long afterwards, vibrates

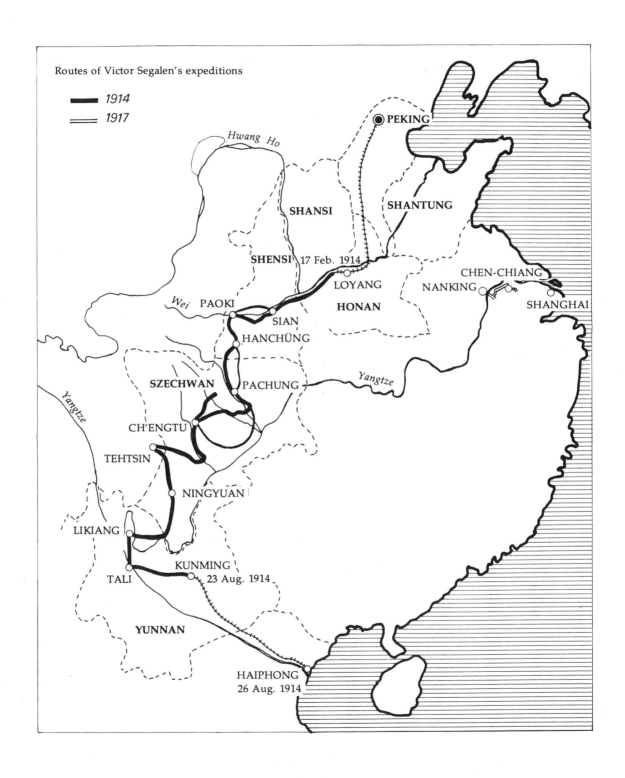

Routes of Victor Segalen's expeditions

━━━ 1914
═══ 1917

Hwang Ho

SHANSI

SHANTUNG

⊙ PEKING

SHENSI 17 Feb. 1914

Wei PAOKI

LOYANG

CHEN-CHIANG

NANKING

SHANGHAI

SIAN

HANCHÜNG

HONAN

Yangtze

SZECHWAN PACHUNG

Yangtze

CH'ENGTU

TEHTSIN

NINGYUAN

LIKIANG

TALI KUNMING 23 Aug. 1914

YUNNAN

HAIPHONG
26 Aug. 1914

LIU-HO-HSIEN

SHIH-ERH-WEI

0 5 10 15 20
km

P'U-K'OU

2 3 4 5 ×6
Yao-hua-men

Hsien-hung-men

M. •1
TS·S 7 •8
Chi-lin-men

Kao-chi-men Tofuszu
•9 × •12
Ch'un-hua

10 • •
11

CHÜ-YUNG-HSIEN

HU-SHU

Nanking-within-the-walls

Earthen levee

Gate, or road crossing

Town (subprefecture)

Village

Railroad in 1917

Monuments in the Nanking region
that Victor Segalen studied in March and April, 1917

1. Tomb of Hung-wu (Ming)
2. Tomb of Hsiao Ching (Liang)
3. Tomb of Hsiao T'an (Liang)
4. Tomb of Hsiao Hui (Liang)

5. Tomb of Hsiao Hsiu (Liang)
6. Tablet of Yu Wang
7. Tomb of Wen Ti (Sung)
8. Tomb of Hsiao Hung

9. Tomb of Wen Ti (Ch'en)
10. Tomb of Hsiao Cheng Ti (Liang)
11. Tomb of Hsiao Ying (Liang)
12. Tomb of Hsiao Chi (Liang)

M = Ming imperial tombs (1368−1644)
S = Sung imperial tombs (420−477)
TS = Chin imperial tombs (317−490)

with the thrill of personal adventure. And it is, above all, that sort of statue, that sort of adventure, that I will be talking about here. They scarcely seem "disinterred," "un-earthed," "laid bare"—they are alive. They are still lying where we found them. They have not yet appeared in any museum. They have not died a second death. But if something is not done about them, they are going to disappear once and for all: sinking to the depths of plowed furrows or being cut up and used as millstones or building stones.

That explains why this book, which is both tardy and hasty, although ten years of travel have ripened it, is not preceded by a Sinological report on the evidence. It is intended above all for artists; that is, for the people who are capable of accepting and understanding down to the least little planes or surfaces the artistry included in these antique shapes and of comparing them, for the first time, to the other forms of statuary.

THE GREAT STATUARY OF CHINA

Characteristics and Eras

The great statuary of China, or at least the statues of that category that we possess, taken as a whole, always has these four features: it is monumental, it is funerary (but profane), it is imperial, and it is historical.

Monumental. It is linked to the existence of an ordered whole, which it adorns and which, in turn, gives it its *raison d'être,* its function. Of all the statues of purely Chinese origin, not one can be said to have been carved for its own sake, quite independently of any architectural scheme. Usually the original ensembles, made of perishable matter —earth, brick, and wood—have disappeared, but traces of them can be found at the site; descriptions, sometimes full and detailed, can be found in the texts, and their image can be reconstructed without too much uncertainty. It was specifically for these composite wholes—ancestral halls, fields of tombs, sepulchres, long avenues leading to celebrated sites—that the statue was carved. The relationships of elegance and harmony must be considered, therefore, not only in the individuality of the sculpted block of stone, but also in its juxtaposition either with another statue or with the entire decor, or even sometimes with the natural framework of the particular work of art: the surrounding mountains. An isolated statue, with neither explanation nor relationship, can be a fine "piece" of sculpture in itself. But it remains surprising, not really Chinese, as long as its role, its function in the monumental ceremony, have not been at least mentally restored to it.

Funerary. The vast majority of the statues discussed here were found near former burial places; arranged in lines, these statues had led up to them or, laid out with cardinal symmetry, they had set them off as with a frame. In describing them, it is impossible to separate them from that original function. The texts in which they are identified speak of them or deign to mention them only in connection with the tomb whose approaches they guarded or honored. But the term "funerary" here must not be taken to mean or to emphasize what is conveyed in the West by our emaciated, recumbent effigies and all the appurtenances of hell. The great winged beasts, the handsome war horses, the lions, leopards, or white tigers that are the familiar keepers of the tombs in ancient China do not give off any scent of death. Although it was around the cadaver, the cessation of life, that the Chinese evolved their religious philosophy, in the case that concerns us, the deceased does not call for "another life" but merely for the extension of the life he has experienced, in all its variety, its adventurous brilliance. Accordingly, the dead man in his tomb is surrounded by day-to-day scenes from his existence. Although in China, as in so many

other countries, there was a natural tendency to turn the dead man into a genius, or *shen*, and the genius into a saint, it seems that the man who had been alive had difficulty resigning himself to being no longer alive. Even the most insignificant detail, the most scrupulously executed little figurative scene of the tomb, seems intended not to remind the dead man that he is dead but to restore to him, in brick or stone, what is escaping his grasp along with life itself. All of the statues at which we will be looking are not concerned with any god—whether posthumous, legendary, or resurrected—but offer instead an image of the most vivid life. Hence the term "profane," which will often designate them in the course of this book, and which is chosen only to accentuate the contrast with the essentially religious statues that Buddhism, an importation, brought with it.

Furthermore, they must be called *imperial*, and they are doubly so. The finest, the largest, and the greatest number of those that remain belong in fact to the funeral procession of an emperor and were carved on his orders, during his lifetime, for him. While most of them were not assigned the mission of illustrating concrete scenes from his reign, nonetheless, their style, their forcefulness or their awkwardness, their elegance or their coarseness, do reflect the characteristics of that reign.

Many other statues, which were very close to the reigning dynasty even though they did not have genuinely sovereign status, are found on the tombs of princes; either they respectfully imitated the earlier statues or were ordered by the emperor himself for his relatives. And the dignitaries, the high officials, and military officers imitated the prince and the emperor; in compliance with strict measures laid down by every dynasty, they arranged their tombs as scale models of his.

So we see that the administration of a well-surveyed, well-governed empire was evident even in the way private arrangements were ordered. The residence of the Celestial Son was simply the residence of any family, but enlarged. Similarly, the burial place of a modest civil servant shared in the imperial majesty by respectfully copying the imperial arrangements. As for the common people, while they were fully entitled to their place under the sod, there could be no question of honorary statues where they were concerned: never did any sculptures stem from any popular art within the genuine art. Hence that challenging air, that air of power and truly "imperial" grandeur.

Hence, too, the last, undeniable feature: this sculpture is *historical*. These statues do not mark the burial places of unknown men, legendary heroes credited with fabulous deeds, or eponymous geniuses. Often the tombs are those of civil servants, mandarins of unusual integrity or discretion, good administrators, and their names are found in the lists of civil servants, with a date and their rank. Sometimes the tomb is that of a hero who is especially renowned, but locally, in his village or province, and most of the acts attributed to him are plausible, related to the chronicles of the country; or it is the tomb of some woman famous for her daring in time of war, her faithfulness to her husband, or even her pernicious influence over a given reign. Most often the tombs are those of well-known princes. Finally, when the burial place is that of a prince who was a Celestial Son having carried out the mandate, it is an integral part of Chinese history, which is above all the history of the Celestial Mandate.

Now, that Chinese history is the most continuous, the most homogeneous, the most complete, possibly the most authentic monument erected by human memory throughout four thousand years, counted almost day by day, although not all of the dates in it are of equal value and importance.

Thus, every one of the statues I will talk about is linked to one of the great periods of Chinese history by its imperial function. It bears the seal of that period, so to speak. Accordingly, it is on the basis of Chinese history that this book will be divided, naturally, into eras.

Considered in relation to our Christian civilization, Chinese chronology, which we can more and more confidently look upon as authentic, is evenly balanced over a period of four thousand years: twenty-two hundred years B.C., and nearly two thousand years A.D. Unlike our Judaic Western tradition, Chinese history is not marked by any Messiah. It does not await anything. It looks back with some regret to the wise reigns of the past, but it exists above all in its extended present. From the too accurate date, 2357 B.C., when the astronomical chronology begins, to the year 1911 A.D., when imperial history is terminated by the question mark of a republic without any name, such as designated dynasties or reigns, it unfolds in a classic, imperturbable manner.

The principal dynasties were:

Hsia	Twenty-third to seventeenth centuries B.C.
Shang-Yin	Eighteenth to twelfth centuries B.C.
Chou	Eleventh to third centuries B.C.
Warring States	Third century B.C.
Ch'in	Third century B.C.
Early Han	Second and first centuries B.C.
Later Han	First and second centuries A.D.
Three Kingdoms	Third century A.D.
Chin	Third and fourth centuries A.D.
Sung	
Ch'i	Fifth and sixth centuries A.D.
Liang	
Ch'en	
Sui	Sixth and seventh centuries A.D.
T'ang	Seventh to tenth centuries A.D.
Sung	Tenth to thirteenth centuries A.D.
Yüan (Mongol)	Thirteenth and fourteenth centuries A.D.
Ming	Fourteenth to seventeenth centuries A.D.
Ch'ing (Manchu)	Seventeenth to twentieth centuries A.D.

The Hsia did not bequeath us anything that may be considered authentic. From the Shang-Yin era, we have undeniably authentic bronzes, revealing art of such sureness that we may pay tribute to the tradition that ascends to their immediate precursors, the Hsia: pottery and fragments of bone or tortoise shell, with characters engraved on them,

ushering in a remote but decipherable body of inscriptions. Under the Chou, the art of bronze work developed with an abundance, a generosity and a mastery worthy of a classical era, taking on the endlessly varied forms of the fine ritual vases.

The Ch'in dynasty, although strong, was too brief to develop its art. But the great sovereign who founded the dynasty and was virtually its only prince, Shih Huang Ti, devoted all his efforts to bringing together the scattered members of the enormous body, to making of them the unified empire that has borne his name ever since! China, country of Ch'in.

Under the Han, the statues that are the topic of this book—preserved, palpable, with their original modeling sometimes intact—appeared for the first time. They are rare (only about ten statues fully in the round are known, along with a greater number of high-relief monuments), but they seem to be endowed with such energy, to have been conceived and made with such vigor, that at first glance they convey the self-assurance of a style and of a school or, better still, of a family of highly distinctive forms. Han is the first great sculptural "age," in the great Chinese tradition, that is preserved today. It is perpetuated chiefly in the regions of the Yellow River and in Szechwan.

A second and equally beautiful era, quite independent of the first, left traces especially in the country around Nanking, in the lower valley of the Yang-tz'u, around the names of the four "southern dynasties," Sung, Ch'i, Liang, and Ch'en. The predominance of sculpture and the abundance of monuments from the third of those four dynasties enable me to give a name to this group. The second era therefore will be that of the Liang.

The last era, the remains of which are found in the north around the former capital of the Han, Ch'ang-an, in the Wei Valley, is characteristic of the great and beautiful T'ang dynasty.

These three periods, these three names—Han, Liang, and T'ang—represent and outline the summits, the great eras, in the entire development of the art of profane sculpture that has emerged thus far from Chinese soil. As far as is known, there are virtually no links between them. Between the Han and the Liang and between the Liang and the T'ang there is no continuous evolution, but rather a separation. It would seem that each one of those schools was obliged, through a violent personal effort assisted or not by influences from abroad, to create itself, shape itself, wrest neolithic forms from the rocky soil, cultivate them like a fruit, a local product. We shall see the successive stages in this effort, and, especially where the first two dynasties are concerned, we can look at their three phases: archaism, zenith, decline.

After each of these eras comes a vacuum; perhaps it will be filled by discoveries yet to come. The continuity would appear to be interrupted. Then the next school is born.

The T'ang dynasty is definitely the pinnacle of the crest line. After them, and stretching over nearly a thousand years, comes a decline that, despite certain attempts at colossal results rather than grandeur, is to become more and more pronounced. The works of the Sung dynasty disfigured those of the T'ang. The Ming ran out of inventiveness. And, finally, the Ch'ing consummated the decadence.

The Great Han

Early, or Western, Han
(Second and First Centuries B.C.)

Chinese history balances on either side of the year 1 of our Christian era, and the double dynasty of the Great Han occupies that honorable position, the middle. Four thousand years of chronology centers around them, in four centuries separated by the brief usurpation of Wang Mang, who cut the dynasty "like a man, down the middle of his trunk." The early Han are called "western," and the second "eastern." The texts refer to them this way because of the sites of their respective capitals: the early Hans had set up their capital at Ch'ang-an in the Wei Valley; but after that city was laid waste, the other Han had to fall back on Lo-yang in Honan province in the Lo Valley, ten days' march eastward.

The Hans were purely Chinese masters, sprung from the good yellow people or *li-min,* as they said, "the black-haired people." Liu Pang, founder of the house of Han, was a sly, robust man of peasant origin, who was seventy times beaten but never crushed. His rival for rule of the empire was a very different hero of courageous deeds, Hsiang-yü. But the empire was promised to the first man who could cross the mountain passes that make the Wei Valley the citadel of northern China. "He who is the first to enter through the middle of the passes shall be king," had decreed King Huai of Ch'u, in solemn agreement with his generals. Thanks to a benign fate more than to his own genius, Liu Pang was that man. Devoid of personal grandeur, he arrogated the grandeur of the kingdom to come. Bereft of military talent or courage, he saw his best enemy engineer his own defeat through excessive strategy and daring exploits. Later, as an emperor with little education, Liu Pang found it expedient to scorn scholarship, and history tells us seriously that he demonstrated his distain by "urinating in the scholars' bonnets." Yet his family grew with him. More important still, the name of his dynasty came to designate the subjects of all subsequent reigns, so that the word *han-jen,* "men of Han," "sons of Han," is even today a name of which any man of pure Chinese blood remains proud.

He established the seat of his empire in Ch'ang-an, that city of "Long Repose," the outline of whose ramparts—earth banks still accumulated over a distance of several thousand paces—lies a little westward of the present city of Hsi-an-fu, halfway between the western walls and the southern bank of the Wei River. At that exact place, we recognized and measured a large rectangular mound, distinctly higher than all the

artificially rolling country in the vicinity. Some 330 feet wide, it extends to a length of nearly one thousand, and its height reaches a maximum of eighty feet at the small northern base of the rectangle, whence it descends in a series of terraces. It is plausible to take this mound as the substructure of one of the Han palaces which the chronicles situate precisely at that place and which was given the name of Ling-t'ai, "Supernatural Terrace." It was built by the fifth successor of Liu Pang, the celebrated Han Wu-ti.

This mound of earth is venerable for the power that had its seat there. Around it spread the capital city; around the city, the richest, most densely populated, best protected provinces of classical China; and around that domain—Kuang-chung, the middle of the passes—stretched an empire so vast that for a man living in those days, it obviously included all of the "Earth-Below-the-Sky."

Power considerably overflowed the two large valleys, that of the Yellow River, the Huang-Ho, and that of the Great River, the Ta Chiang or Yang-tzu-chiang: in the south, there were the newly conquered commanderies, which even crossed the Hsi-chiang and reached as far as Hanoï and Thanh-hoa; in the west, total penetration (for which, as this book shows, there is iconographical proof) of Szechwan all the way to the Tibetan marches; in the northeast, the seizure of Korea; in the north, the barbarian hordes were forced back. As for the northwest, rushes into the endless Kansu Corridor opened the road through Turkestan.

The sovereign responsible for this immense expansion (140–87 B.C.) was Han Wu-ti. His reign had the brilliancy of the greatest eras, and, in the four-millennia life span of the empire, it must represent what a "masterpiece" means in the life of an artist. It was the masterpiece of the Chinese spirit, as is abundantly shown by history, even more than by legend. Letters flourished anew. Scholars were restored to a place of honor. The seasons were put in order. Mathematical measurements and musical measures were revised. The calendar was reformed. Rules were laid down for the choice of those denominations of good omen in government that came to be known as the *nien hao*, or year marks. The feng and shan ceremonies were restored, or perhaps inaugurated; in these obscure rites, vestiges of the old days, the gods from above and the gods from below recognized the legitimacy of the earthly sovereign. And, finally, in the year 122 B.C., a strange animal was captured that the people took to be the *lin*, the Chinese chimera. In short, the country was administered so perfectly that Ssu-ma Ch'ien, foremost historian of his day and of his country, was able to make an official inspection tour in regions that are barely explored today: from Li-chiang-fu in Yunnan to the Ordos in the midst of Mongolia. It is only fair to add, though the truth is harsh, that in reward for his services, and because of a petition presented in favor of a nonguilty friend, Han Wu-ti, the same emperor who employed him, inflicted total castration upon him.

In order to conquer so vast a kingdom and, especially, in order to keep it, Han Wu-ti constantly required powerful armies. "Wu" means "warrior," and it was not just as a flattering allusion that he was given the title posthumously. Of the fifty-four years during which he reigned, approximately thirty were spent in war—either wars of aggression, adding to his conquests, or defensive wars. Both types were waged chiefly against literate China's toughest enemies: the Huns to the north.

These Huns (whom the Chinese texts call Hsiung-nu) occupied the ill-defined, nonsurveyed territories that are called Mongolia today. They came from as far away as southern Siberia. They were tough and harassing adversaries, mobile and courageous; their hundreds of thousands hung like a swarm over the head of the empire. The sons of Han labeled them "slaves" but feared them. Good generals, including Li Ling (the one whose cause Ssu-ma Ch'ien had defended, at the cost of his own virility), had had to retreat before them, all their supplies eaten and all their arrows spent while, as the texts tell us, "their soldiers faced north and shook their fists." Two thousand years before the Han, these slaves who showed so little deference to the real masters of the world had made their entry into history; they were then simply known as the various hordes, as old as the histories. The first three dynasties—Hsia, Shang, Chou—were much weaker militarily than the Great Han, and almost every year the impact of the barbarian invasions rocked them on their foundations. It was against the Hsiung-nu that Ch'in Shih Huang, founder of the fourth dynasty, organized the Great Wall, whose defensive structure of earth, brick, stone, and mountain was united in one driving determination over a distance

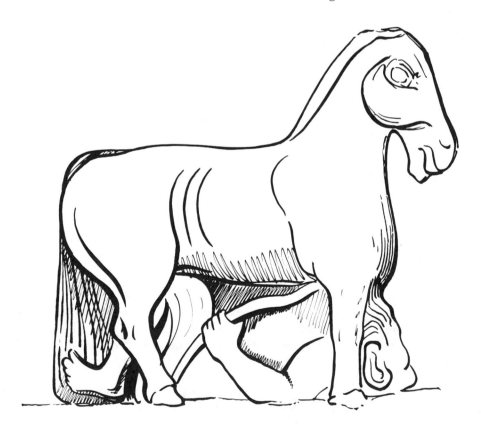

A *Tomb of Ho Ch'ü-ping. Horse bestriding a Hsiung-nu barbarian. Profile.*

of nearly six thousand *li*. The Han, who succeeded him by dethroning his incompetent son, had to fight the Hsiung-nu constantly. For the sake, then, of maintaining the Great Reign's equilibrium, there had to be as many good generals, constantly at the front, as there were poets, historians, calligraphers, astrologists, and music masters at the court. And in addition to these Chinese military virtues, these generals had to acquire the knack of beating the enemy on his own ground, far beyond the classical frontiers, and with his own weapons. The battlefield proved limitless: "two thousand *li* and more, beyond the Celestial Mountains." It was the terrain that decreed what weapons and tactics would be used. The fighting took the form of advances without halting places, hasty retreats, returns. The attack went on at a gallop over score after score of leagues. First bows and arrows were used, Turkish fashion, to shoot both forward and backward; then came pikes and swords. Finally came encirclement, the slaughter, and the mass beheadings. Seventy thousand heads fell in a single campaign. Here is where the light cavalry was triumphant, led by tall, dashing young officers. Then the heads were carefully counted, and that count, if not the heads themselves, was brought back to the sovereign. The victor, welcomed to the outskirts of Ch'ang-an by the emperor himself, who went out on an official expedition to greet him and shake his hand, could recall thereafter the finest moment of his victory, when his faithful mount, trampling on the defeated barbarian, imprisoned him with his four hooves.

This decisive gesture of the combat, reduced to the simplest but essential sculptural elements, is commemorated in the only statue that has survived, to our present knowledge, from the art of the early Han; until further discoveries are made, its date—117 B.C.—is the oldest in the repertory of Chinese sculpture in the round. It is the "unadorned horse trampling on a Hsiung-nu barbarian," from the tomb of Ho Ch'ü-ping (A), that I had the joy of discovering on March 6, 1914.

I had been guided by promising indications noted in the general chronicles of the province of Shensi (in the chapter on tombs and burial places). "In the subprefecture of Hsing-ping is the burial place of the marquis of Kuan-chün, Ho Ch'ü-ping. Located [nineteen *li*] northeast of the city walls, not far from Mou-ling, tomb of Han Wu-ti. Height of the mound: twenty feet. On the mound, raised stones [are visible]. In front of the mound, *stone horses and men*."

Hsing-ping is a small, third-class city, founded two thousand years ago some five *li* from the north bank of the Wei, in the plain of Hsi-an-fu. This plain is the ancient seat of China and its principal necropolis. Aside from the Han's capital city—I have pointed out where its walls were located and a palace was situated—the plain was the site of no fewer than four large imperial cities previous to that one. It is an undulating ill-defined expanse of cultivated land where one continues one's way on horseback whole days at a time, not much inhabited by the living, but made bumpy by hundreds of pyramids built of the same earth as the ground; these are tumuli. No other punctuation but the faults in the loess. No sign of any pathway but the great carriage road. One has to travel by compass, as if sailing. On the always jagged horizon, the imperial tumuli act as "remarkable peaks" and stand out from very far away as volcanic islets.

The Mou-ling is the most famous and most visible of them. So it was toward that

tomb that I headed, after taking a number of bearings so that I could situate it on the map, and not far from it I found the small mound "twenty feet high."

No doubt as to its identity: this mound did indeed lie to the northeast, two *li* from the previous one, which in turn lay to the northeast, seventeen carefully counted *li* from the ramparts of Hsing-ping. From a distance, I could see the "raised stones" on the mound. From closer up, the whole statue could at last be seen in its entirety—thick, ancient, insolent as compared to the others that were already known, surprising in itself, with no resemblance to anything seen before. There was hardly any need to consult the inscription on the tumulus stele a few paces away in order to be certain that this was, as the chronicles indicated, the tomb of Ho Ch'ü-ping, general of the Valiant Horsemen, grand equerry and marquis of Kuan-Chün (Plate 1).

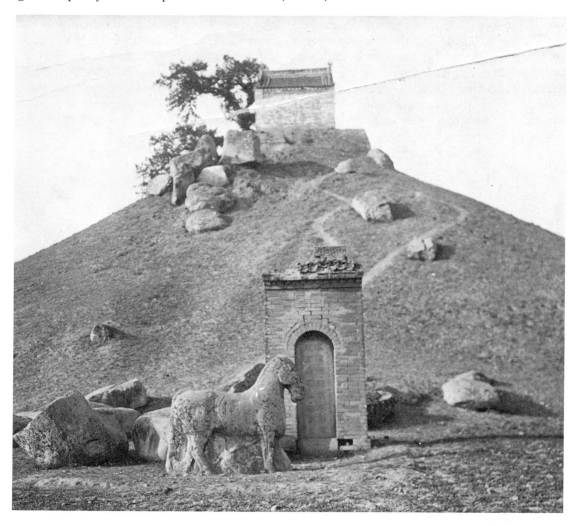

Plate 1. *Tomb of Ho Ch'ü-ping. Tumulus.*

Two lines of text had led me there.

From the strictly sculptural point of view, this is a very instructive work. It is not so much the statue of a horse and a man as it is a composite volume organized to give an impression of power, power that the dimensions do not account for, for they are small compared to the human frame (four feet, eight inches from head to pedestal; yet this horse, which barely reached up to my shoulder, filled the entire plain); power that is undiminished despite the erosion of the gray granite in which the statue is carved; power due entirely to the style, which transforms a four-footed animal into a solid rock flaring out at the base, to the decision not to scoop out the mass of rock, a decision that makes one solid whole out of a group of two sharply dissimilar and struggling figures.

The right profile is the best preserved, most accentuated, most meaningful. The tail, an integral part of this profile, is attached high up on the spine and falls straight down to the pedestal like a square-sided pillar, on which vertical striae reproduce the braiding of the hair (B). The hindquarters are round, very fleshy. The tendons are sharply delineated. The clear crease of the groin, the inguinal plane by which the haunch is attached to the belly, is noteworthy. It is the characteristic sign of the sculptors under the Great Han, both early and later, their favorite "touch" in handling the belly of a four-footed animal, be it a horse, a dog, a lion, or a leopard. We will see it even more distinctly, more insistently, in the chapters to come.

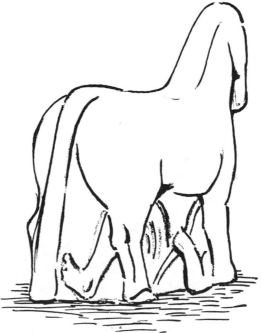

B. *Tomb of Ho Ch'ü-ping. Horse bestriding a Hsiung-nu barbarian. Rear view, three-quarters profile.*

Above that crease, in this case, rise three curved grooves, which must not be confused with the outline of a saddle: the horse is quite bare. These groves represent the ribs, the visible ribs of a somewhat lean animal, a long-distance runner. The shoulder joint is similarly emphasized by another simple anatomical line, which it is wise not to take for the attachment of a wing (as we will see, that attribute occurred frequently under the second Han). The mane, which is straight and cut short, is separated from the neck by a groove. The head, which two thousand years of rain and weather have ground down, worn away, deprived of its ears, forms a disagreeable, flat-nosed hood. The head is too large for the overall mass, and heavy, with its bumpy nose and the round mouth with the too-thick lips. But the equine likeness is remarkable, a stunning specimen of the sturdy Mongolian pony of north China. Despite his petrified coarseness, this horse of the Han of long ago was indeed brother to the flesh-and-blood horse I had come riding on to discover him, and which was grazing a few paces away from him. Only the chest of the statue took some liberties with the living model, proudly arched, imperious, decorative. The rigorously symmetrical, well-muscled legs on well-drawn hooves stand squarely on both sides of the mass and form one with the pedestal. It is inaccurate to say, as I too hastily said, that this animal is in the process of "trampling." Neither with the sole of his hooves nor with his weight does this horse touch what we see overthrown beneath him: a man. But he surrounds, stands over, encloses, and holds him. He *dominates*.

What he is dominating then is a man, grasping his weapons, no part of whom, from his toes to his forehead, is motionless. In the Han iconography, this large toe, standing out separately like a thumb, is the attribute of the barbarian or any naked fighting man; it will be found later, in other works, hundreds of leagues from here. Both foot and leg seem glued flatly onto the tail. Similarly, under the horse's belly, the outline of knee and thigh can barely be made out. But the very muscular left arm protrudes, and that large fist which holds the bow is carved with a determined chisel. All of this is embedded like a violent altarpiece between the legs, the belly, and the pedestal. Then, a mass stands out to the front, carved fully in the round; the first recognizable detail is an ear, an enormous human ear, well-shaped, stuck to the pasterns upside down; then a disk is visible, a round, flat eye. The nose has disappeared. From the mouth, the cheeks, and the chin rises a beard that flows out over the chest.

The horse's left side, more worn than the other, shows the barbarian's second arm, armed with a lance that it grips short, and which is thrust in upwards and obliquely. The other leg and foot can be seen, symmetrical, on the other side. Here is the whole man, on his back under the horse standing straight above him, but a man who is struggling furiously and industriously. The bow brandished by the left fist and which is so strongly emphasized is useless, but the pike in the right fist is savagely "drilling away" at the horse's ribs; the animal does not flinch. And from the toenails to the mask face, a struggle is going on, belly to belly and knee to knee, an effort to resist being crushed. Even the beard is vomited like a stream of petrified oaths and foams furiously over the chest of the crushing beast.

But something that is foreign to the material substance, something that protrudes from that substance although it belongs to it, willy-nilly, takes shape: a human face, which

must at first be looked at upside down (C): we recognize, from bottom to top, the low forehead, blending into the pedestal and the grass; the rictus slashing a mouth as thick-lipped as that of the horse; and the simian collar of bristling hair that clings to the cheeks and chin and will fill the space between the legs below the chest. Suspended above this head is the horse's head, monstrously long, its eyes placed far to the side, as on all four-footed animals. There is a surprising contrast between the blunted lines of the earless animal and the derisive human mask. This is what you see when you stand in the grass that will be wheat and you confront, from very close up, the group that has been pursuing its balanced struggle for 2,035 years.

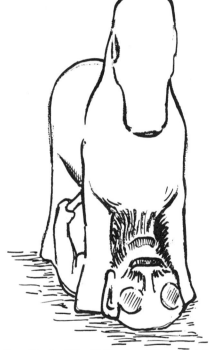

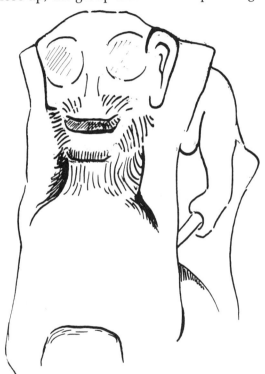

C. *Tomb of Ho Ch'ü-ping. Horse bestriding a Hsiung-nu barbarian. Barbarian's head.*

D. *Tomb of Ho Ch'ü-ping. Horse bestriding a Hsiung-nu barbarian. Face.*

Finally, you have to examine that face face to face, standing in an inconvenient and dizzying posture to do so; you have to turn it right side up, so to speak, the chin at the bottom and the forehead at the top (D), as is the customary way to look at a man. Then you recognize that face. It is horribly gay. It is the cynical portrait of a non-Chinese, a "slave," a Hsiung-nu. Feature for feature, it embodies the literary descriptions that pure Chinese wrote of the Hsiung-nu: on a squat body, a very large head, broad face, pronounced nose with flaring nostrils, heavy moustache, tuft of stiff hair on the chin, long ears. The way the characters in the books are drawn corresponds to the physiognomy rendered in stone: it is indeed the portrait of a Hsiung-nu.

Now we can see how the theme—"unsaddled horse bestriding a barbarian"—was conceived and how it was handled. This enveloping power, at once static and animated, and this overall impression of animal nobility and human contortion are achieved through rough but skillful work, clever ruggedness, especially through use of the chisel at every variable point and techniques ranging from full sculpting in the round to flat, hardly incised detail. While the two heads, the shoulders, the croup, and the tail stand out clearly in three dimensions, free and bathed by air, and claim our attention, the four legs, on the contrary, are imprisoned in the stone. Here we put our finger on the way the shaper of images proceeded under the Early Han. From the block of dressed stone, the sculptor first of all revealed and released the noble elements of the animal, and in the same way, and to the same extent, brought out the man's head, upside down. This took care of the theme that was decided upon, the victory of the Chinese horse over man. But this is no passive triumph: there are struggle and resistance; hence the energetic or convulsive positions of the head itself and the four human limbs. Here is where the suitable proportions appear: both full front and in vigorous profile, the head, treated as a piece of major statuary, strives by means of all its protuberances—ears, eyes, mouth, and beard—to free itself of the matter in which it is tightly held, between the two fore pasterns, to flee the gross, bestial lips that hang threateningly over it. But despite energetic accents, the two shoulders and the two arms partake only of the art of bas-relief. The clothing, thighs, and legs are merely ribbons, more drawn than carved, suggesting movement without carrying its effort over into volume. The big toe punctuates the whole.

As for the separation between the two chests, the two bellies, the old sculptor did not even begin to indicate it—either out of principle or because he was unable or did not care to. There is no "air hole." Matter is continuous. This is how the ancestral mastery, which created its craft and its physical types, differs from our petty modern reproductions. We can just imagine what a good pupil of our own day and from our own Western school would have done with the same theme: the horse rearing as if in a circus, dancing over a bearded figure going through an epileptic seizure. Sheer instinct, aided by the resistance of the granite itself, an ancient sense of form in those remote days when what did not exist had to be invented—in a word, the youthfulness of those times which we call archaic—led the unknown artist to leave the massiveness of this solid block intact.

The statue is placed twenty paces away from the southern side of the tumulus, which we can see in its entirety in Plate 1. Like all the antique tumuli of northern China, regardless of whether they were erected by emperors, princes, or civil servants, it is a mound of beaten earth shaped like a four-sided pyramid. It used to be sturdy and regular; now, though its edges have been blunted, they remain measurable. The four sides face the cardinal points. Judging from its volume alone, this must be a tomb of only mediocre importance compared with its giant neighbors in the same necropolis, for it is only thirty feet high, and each side measures only eighty-five paces. But what makes it abnormal, what sets it aside from all the others, is the presence of those "raised stones" that the chronicles cite as a landmark. The small edifice visible between the mound and the horse is modern and shelters a stele of the Ch'ien-lung period (eighteenth century). The small

structure at the summit that, in Plate 1, is notable for its inappropriate picturesque aspect is nothing other than a minute pagoda without any relationship to either the burial place, the statue, or the dead man.

But those blocks of granite are still a riddle, not only because of their very existence in this place but also because of the way they are scattered over the four sides of the mound. They are of the same stone as the horse and are eaten away by the same yellow lichen. They are not of any definite shape. There is no discernible link; they would not seem to have any architectural or ritual purpose. They lie here and there halfway up the mound as if they had tumbled down from the top of it. They look like a herd of stone animals, dead. There is really no knowing what to think of them. There is no question of their being fragments of what used to be a uniform covering, like the mantle of the Eygptian pyramids, for the foremost function of a tumulus is to "resemble a wooded slope" whose trees—species chosen for their longevity—are carefully tended. Nor can we imagine from what type of monument crowning—or crushing—the summit, from what enormous pinnacle, these stones could be the debris. The horse was a possible though unexpected find. But neither the horse nor the texts mentioned above give any classical explanation for these erratic heaps of stone blocks. We must have recourse to other texts, not to the local chronicles this time but to the histories, in order to find out what sort of man was this "grand equerry, Ho Ch'ü-ping, marquis of Kuan-chün."

A young and valiant chief of "valiants," expert horseman, dead, after superb campaigns, in the twenty-fourth year of the reign of Han Wu-ti (117 B.C.) and also the twenty-fourth year of his existence. In the space of his brief life, this young man accounted for an important segment of his times. The "Book of the Han" gives us a brilliant account of it, which I have adapted in the following few words:

He came from a modest family, hardly a notch above the stables of his uncle, Wei Ching, groom of the emperor Han Wu-ti. But under this dynasty geared to the military use of the equestrian art, horsemanship was the key that opened all doors. The regent of the empire, toward the end of his reign, was to be the Hun Mi-ti, a sturdy *ma-fu* whom the emperor had remarked one day for the conduct and grooming of his horses. Ho Ch'ü-ping's uncle, Wei Ching, therefore quickly became an officer, then grand marshal and minister. It is only fair to add that Wei-tsu-fu, a beautiful concubine and uterine sister of Wei Ching, whom she had introduced into the palace, added her own talents to her brother's equestrian ones, and these nominations in her family were not unrelated to the fact that she was the ornament of the imperial knights.

Under such auspices, then, Ho Ch'ü-ping, at age eighteen, was an outstanding horseman and archer. For six years, at a rhythm that hardly left his men time to relieve each other, he harried the Hsiung-nu, his sturdy foes. Already, in the year 123 B.C., leading a squadron of eight hundred light horse, reconnoitering ahead of the rest of the army, he "captured and killed many Huns." In 121, at the age of twenty, he was appointed "general of the Valiant Cavalrymen." With ten thousand good horsemen, he rode out through the passes of the upper valley of the Wei (known today as Kan-chou of Kansu), reached the Yen-che Mountains on the northwest borders of the empire, pushed a

thousand *li* beyond them, took some prisoners and cut off over ten thousand heads as, for the first time, he galloped headlong on the road that led to the unknown reaches of the continent. He came back in the winter, sallied forth again the following spring (in the year 120 B.C.), reached the foothills of the Altai Mountains, and cut off thirty thousand heads.

As the best cavalry fighter, hence the boldest guardian of the empire, he had his personal tactics. Always at the head of his squadrons, always the leader of a troop of elite fighters, he was favored by heaven—say the texts in the "Book of the Han." Never was he driven back, nor cut off from his troops, nor forced to retreat, as had happened to certain professors of strategy.

In 119, a cavalry force of a hundred thousand was brought together to cross the Gobi Desert and head not to the northwest this time but straight north. The commander-in-chief was Wei Ching, that uncle who had become "legitimate imperial relative," like his sister, "empress and mother." They did cross the desert. They came upon the khan's army, entrenched behind their chariots. A furious wind rose and the battle began. Sand, pebbles, a powdery air fought like the antagonists themselves. Both armies were lost in the opaqueness. The Huns fled, with fifty thousand horses in blind pursuit. The groping victory was so overwhelming that one good general of the old days, Li Kuang, who arrived too late to take part, slit his throat in mortification. The pursuit lasted several weeks, scattered over more than two thousand *li*. And the imposing total count of seventy thousand heads was submitted to the emperor. The Huns resolutely withdrew beyond the land of sand. The central Tarim River basin was open to the sons of Han and, through it, all of the Altaic border regions, the route to western Asia.

Two years later, in the one hundred seventeenth year before the Christian era and the twenty-fourth year of his age, Ho Ch'ü-ping died. History does not give us any explanation, but we do know about the arrangements for his funeral. They were worthy of his greatest expeditions: from the capital, Ch'ang-an, to the tomb, more than a day's march away, his men, the Valiant Cavalrymen, formed an uninterrupted honor guard.

We can see to what extent the story of his life affords a commentary on the sculptured episode that symbolizes for us all of his deeds accumulated in one: the crushing of his mobile enemy. It is not so much the dignified statue of a horseman as the image that is the most agreeable, most pleasing to a horseman's eyes: the perpetual triumph of his loyal mount over the defeated fugitive.

But there is more: the raised blocks of stone are fully justified at last by those same texts. Ssu-ma Ch'ien recalls in his memoirs that the emperor Han Wu-ti, who had already chosen the place where this tomb was to be situated, close to his own, wished to arrange the burial place itself, and he ordered that the mound of earth be covered with large stones so that, says the text, the tomb would "resemble Mount Chi-lien." Now, Mount Chi-lien, in central Asia, is an allusion here to the region where the hero had carried out his great deeds. Nothing could be more appropriate than that symbol, nor could any project be better fulfilled. This accounts for the anomaly, the profanation almost, of an earth mound covered with undressed stones rather than planted with trees. This is what makes it surprising: it is a mountain in barbarian territory.

Plate 1 clearly shows that the statue, which guards the southern side of the tumulus and is turned to the east, is not located on the north-south axis of the burial place but instead stands to the left, to the west of that axis. On the basis of the traditional symmetry of Chinese monuments, an observation borne out in the ancient dynasties, we may assume that this horse used to be opposite another which was similar if not identical, and which was placed to the right, to the east, facing west. There is no trace of the second horse today. Moreover, it would be vain to look for exact references by which to reconstitute the original arrangement. Although the "Books of the Han" abound in quotations referring to the care given the dead, these written references are unusable in the field. What pretend to be accurate measurements and painstaking descriptions are actually a literary guessing game, where a mountain is confused with a mound, a statue with a sketch barely incrusted in the stone. There is no telling whether the "funerary avenues," those grand cardinal roads that are often mentioned, are underground or on the surface, whether the living can ride over them or whether they are reserved for the soul of the deceased. Even if the text is illustrated, the drawing, which is relatively modern because the major editions of the chronicles date from the Ch'ing dynasty (seventeenth and eighteenth centuries), merely makes matters worse. A good example of this erroneous situation is to be found in the chronicles of the region, concerning the horse of Ho Ch'ü-ping itself.

E. *Plan taken from the local chronicles of the city of Hsing-ping.*

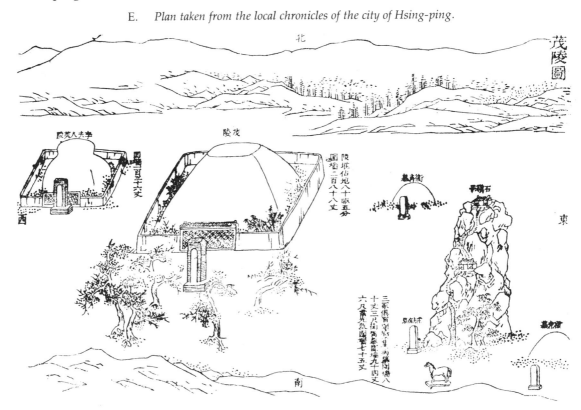

While, as we have seen, the general texts of Shensi were content to indicate the site and attributes of the tomb with satisfactory accuracy, the local chronicles of the city of Hsing-ping offered a highly picturesque plan, which I reproduce here (E). It will be useful not so much in showing exactly how the burial place was arranged as in demonstrating how, in any bit of Chinese appraisal, a certain truthfulness blends with the most charming fantasy, and well-intended error with scruples that are sometimes excessive.

In this bird's-eye-view drawing, the orientation is observed with utmost care, as always in China. But the northern mountains should be pushed upwards and outside of the drawing because they are really situated five or six hours on foot away and so are not visible to us. We will also delete the little hills in the south, which are sketched in here merely for the sake of elegance. In the lower right-hand corner we notice, with some surprise, an odd little hillock made of stones stuck together, highlighted by tiny little houses and frail twisted trees; in short, a rock-garden "landscape," very much *à la chinoise*, such as one sees in rich people's homes. This is nothing other than the thoroughly modern way of depicting the tomb of Ho Ch'ü-ping. Four ideograms close to the stele we see at the foot of this hillock specifically label it as such. Right next to that a small horse standing on a little board indicates, like a child's toy imitating a man's work, that a "stone horse" still exists there. The "rock garden" is supposed to represent the wild Mount Chi-lien. The toy horse, simplified, stripped, castrated of the man on whom its weight pressed down, represents the other horse "bestriding the barbarian." In fact, it represents it backwards. For while the real horse faces eastward, this one looks to the west, or to any other place, haphazardly. The monument itself is two thousand years old; this reproduction dates back barely two hundred years. So here we have the contemporary Chinese treatment, caught in the act. Perhaps the person who made this drawing had not seen the objects he drew. In his function as calligrapher, he simply embroidered on the words of the text.

It is in this negligent way that modern China considers the other China, the ancient China. That is why I wished to publish this picture despite its error-ridden ugliness.

Another error, topographical this time: the chronicles situated the tumulus of Ho Ch'ü-ping—and I checked this—two *li* northeast of the Mou-ling of Han Wu-ti. The picture in figure E situates it to the southeast—for that imposing pyramid roughly in the center is indeed the Mou-ling. It has lost the enclosure we see here, which was superadded and which, like the explanatory stelai, must have dated from the same Ch'ien-lung period (eighteenth century). It is bare, gullied, dried up, a mountain on the moon, with no life and even no dead man, as we shall see later.

The tomb of the concubine Li is accurately shown to the northwest and recognizable by its constricted beehive shape. The two blunted little mounds to the right bring us back to the family of Ho Ch'ü-ping. The one nearest the Mou-ling is that of the uncle, Wei Ching, the groom-made-marshal. The last one to the southwest is the tomb of Huo Kuang, half-brother of Ho Ch'ü-ping, more famous for his nonmilitary virtues; he survived the sovereign and became regent of the empire. So the emperor was surrounded, even in death, by his ladylove and his good horseman, not far from the marshal of court and army, close by the honest regent. But the inevitable happened: in the year A.D. 26, some rebels

who came that way opened the main tomb, scattered the bones, as was the custom, and shared the treasure among themselves so as to melt it down into ingots. But the unsaddled horse remains.

It seems to have been the only one to remain. At the time I write these lines, we do not know of any other statue carved in the round genuinely dating from the dynasty of the Early Han. And yet, a hint that Edouard Chavannes noticed in the book of the same dynasty made us hope momentarily. "One Wen Weng," it said, "dispensed learning in Szechwan, from the very beginning of Han Wu-ti's reign, and did so with such venerable zeal that when he died, a 'hall of offerings' was built in his honor at Ch'eng-tu, the capital of the province." Chavannes added, "According to a tradition which I cannot trace back any further than a certain testimony of the Mongol era, there used to be, in the stone chamber of Wen Weng, a seated statue of Confucius. The soles of its feet faced backwards, its knees were bent forwards; to both right and left of it were depicted the princes and subjects who had become famous in History, as well as the Master's seventy-two disciples."

As soon as we arrived in Ch'eng-tu, we hastened to look for Wen Weng's hall of offerings, hardly daring to hope that there we would discover the image, in genuine Han stone, of the sage, patron saint, as it were, of schoolteachers, who lived three or four hundred years before the Han, at the other end of literate China.

The "stone house" of Wen Weng, said the Szechwan chronicles, could be seen south of Hua-yang, in the prefectorial school of Ch'eng-tu. Long in ruins, it had been repaired in the thirtieth K'ang-hsi year (1691). There followed four or five pages reproducing the main body of an inscription dating from the same year, 1691: lists of donor-repairers. "To be translated from the first name to the last, if what we find is worthwhile," our travel notes added.

We did not find any trace of the monument. "Hua-yang" is nothing more than an historical phrase. The big city of Ch'eng-tu is so brimming with life that it has devoured antiquity. But the prefecture school does exist, with the most modern impudence, and stands precisely *on* the leveled site of the ancient chamber of Wen Weng! Of the chamber itself, not even a bit of debris. But—and this was the final irony—on the second door after the entrance was an inscription put up day before yesterday: "Stone chamber of Wen Weng." It is painted in stark black and white on a wretched panel of new wood.

In all events, the real sculptural loss, if we look carefully at the original texts, is not much. I will not go along with Edouard Chavannes' remarks, in this matter. Where the authenticity of the presumed statue is concerned, he himself cannot trace it back any further than the Mongol era. Now, more than fourteen centuries separate the Mongols from the Early Han. Given such a lapse of time, can it really be asserted that this statue was carved in the round rather than in a very pronounced bas-relief? The expressions "hall of offerings," and "stone chamber" make me doubt it. Both of these terms designate a small ritual structure where one was to worship the dead man; we have well-preserved, later examples of this in the little funeral chambers of Hiao-t'ang-shan, in Shantung. These are smoothed-out slabs on whose surface we have outline drawings of countless scenes; they

are not carved but engraved, by a calligraphic process. In this imagery, Confucius occupies an important position, and his seventy-two disciples are near him. So I am inclined to conclude that what adorned the walls of the chamber of Wen Weng was not a genuine statue but a barely cut-away drawing; and even if it were still to exist, it could not, because of the technique by which it was made, be included in this history of statuary.

It follows that the horse of Ho Ch'ü-ping is indeed the only legacy that has yet come to us from the western Han. It was spared by accident, a lucky one. Among the imaginary statues that can be dedicated to the grandeur of Han Wu-ti, this symbol of the best general's heroic deeds is an expression of the age. It places a weighty seal upon the victories of that year, 119 B.C., which marked the acme of the prestige of the sons of Han over the Huns. There are other, harder monuments, though of impalpable material —the histories, and also the poems—which are not so altered, to transmit the elegance, the courtesy, the spiritual joys of that age. Among the good poets it is only fair to include the emperor himself. "Here are the blossom and the scent; scent more lasting than the blossom; blossom more solid than the walls of the garden that gave birth to it." Today the Great Wall is sinking into the ground and disappearing. The verses of Han Wu-ti blossom anew every spring in the hearts of scholars. But in order for them to germinate, an ardent, living wall was needed, farther than the Great Wall, between the poet and the barbarian; its towers and redans were the sturdy infantry and outposts of Ho Ch'ü-ping's squadrons. This statue remains the symbol of it, petrified down to our own day.

It happens that while this symbol protects a lofty civilization, at the same time it also expresses a savage fierceness. No sooner do we glampse this lustiness in combat, these bulging muscles, these brutish fists, the bow and the pike, the toes tensely curled—all of these instruments of the struggle that free themselves one by one from the calm and static stone, this art of combat and vengeance—than we are involuntarily reminded of other plastic examples of fierceness and struggle. If we had to find a western equivalent, we would look in Mesopotamia. Already, instinctively, we have said "Assyrian."

There can be no question here of trying to determine what influences guided the chisel of the Han sculptor. That will be reserved for more extensive, more digressive studies. Historically speaking, at the beginning of Han Wu-ti's reign, China was still supremely isolated. That was when the great expeditions took place. The imperial envoy Chang K'ien, whose tomb we found in the very middle of the first Han fief (Han-chung-fu), managed by means of fourteen years of adventures and absences to unite the capital of the Chinese world with the westernmost point then known: the northwest regions of India. His ardor led him to the limits of the setting sun and his luck, greater still, brought him back. At the end of his travels, he found tangible proof (objects made of bamboo and silk) of the trade that existed between southern China, India, and Persia. Though he was not the first Chinese to travel so far, he was the first to have the feeling that he had gone far—"twelve thousand *li* from Ch'ang-an, to the southwest"—and to report to the emperor about it. Already, under the harsh Ch'in dynasty, which came before the Han, something about China—its very existence, to begin with—was known in the West, since our

41

languages included the name "China," derived from "Ch'in." But what was involved then was expansion, gifts from China to the foreign world, gifts that do not presuppose any exchange, except between traders, and still less any contribution in the other direction (from the outside world to China) or any teaching or the slightest statuary influence. If we are to talk seriously about that influence, we will have to obtain proof of the same sort—sculptural proof. Among the statues that we know to have been carved in the Tigris and Euphrates region by those rough Chaldean-Assyrian fighters, many of them, to tell the truth, give an equally cruel impression, show the same placid approach to murder; the king, taller than all the others, impassively executes the terror-struck captive. But there is not one of them whose sculptural mass, whose planes and round surfaces—in a word, whose style—is related to our pure Chinese horse. The antiquated peridivagations on linguistics of a man like Terrien de Lacouperie must not be brought out again and warmed over, in the name of a supposedly comparative iconography. When, at two opposite ends of the old world, that venerable and whimsical man came upon two notions that he thought should be connected, he looked for two words, two "vocables" of dubious homophony and vague meaning; then, juxtaposing them, he concluded they were identical. This method, with its wealth of approximations, turned an historical text into a verbal adventure story. Words were not the only things to be forced. The same violence was done to shapes. Lacouperie sprinkled Persia all over China; Dudley A. Mills imported Egypt into China, so near-sightedly and eagerly that one fine day he did not hesitate to make an obelisk out of a stylized tree drawn by Han artists.

In fact, the unsaddled horse of Ho Ch'ü-ping has nothing in common with any other statue except certain qualities of archaism—its robustness and stark simplicity —which belong to all material arts at the stage when they are searching for their identity, are coming into being and revealed the difficult triumph of tools over the raw block. These qualities lead to expression of the most accurate sort—not a single unnecessary gesture, nothing theatrical, nothing literary, nothing that is extraneous to the art in question. The horse and his master fought their battles. The emperor decreed what the reward was to be. Alone, the sculptor did the rest. This statue is therefore the result of an art that is doubly Chinese, that emerged from Chinese soil like the granite of which it is made, extracted from the nearby mountains.

This is a work of art that meets the test of the four characteristics that define the great statuary of China: it is part of a whole greater than itself; it adorns a burial field; it was carved upon imperial order to honor the memory of a hero who was not only figurative but personalized; and it is concrete, for historical bones should be found not far from it, a few feet under the earth.

The Second Han

Later, or Eastern, Han
(First and Second Centuries A.D.)

When the great usurpation came to an end, and the bold and mysterious Wang Mang, of the imperial family, had disappeared, the dynasty righted itself again and began to live once more, but it was never to recover the vitality of its ancestors. These were still Han dynasties, but they were no longer the great "early" Han. In accordance with chronology, they are called the "later" Han, Hou-Han; and because their capital, Lo-yang in Honan Province, was situated far to the east of Ch'ang-an, they were called the "eastern" Han.

This shift was merely a last resource, a slow retreat. After an interval of a thousand years, the Chou makeshift was repeating itself: a tottering dynasty fled from west to east. Not that that refuge was inaccessible; simply, the dynasty could not do anything else.

Despite this backward move, however, the second Han had the benefit of the strength and splendor of the earlier reign. Stone witnesses are there even today to show us how much life filled a people that was still master of greater Asia.

The territory covered by the empire has changed little, except in the north and northwest; and it is over an enormous expanse of land that the many monuments are scattered that bring those people back to life, making them fight, dance, struggle, run, live, live to the hilt. . . .

Tombs and more tombs. The major "deposits" of preserved burial places stretch over most of the classic provinces: Shantung, Honan, and Shansi, and they also, in surprising abundance, cover a good deal of western China, the splendid Szechwan region.

Truth to tell, although Szechwan, the Chu country, had the untamed, powerful, savage look of the Tibetan border areas—mere geographical extension—it had been colonized, penetrated, and civilized for six hundred years. Its twelve native, and perhaps real, kings had given way to the Ch'in colonists even before Ch'in became Shih Huang-ti. The early Han had their finest commanderies here. The imperial officials from the prefectures of Honan or the capital willingly came to administer this province and willingly died here, assured as they were of having handsome, decent, well-decorated burial places.

43

For some inexplicable reason, there are a great many more such places that have been preserved down to our day in this province than in any other.

The country such officials found there was an attractive one. Szechwan is a place unique in the world. Ringed by a barrier of formidable mountains, crossed by four mighty streams or rivers (the word "Szechwan" means "Four Waterways"), it embraces a country comparable to France, under a humid, fertilizing sky, with gently undulating hills and a "red" (or, rather, purple) "basin" of sand tinted with manganese violet, and the rusty tones of iron oxide, and sandstone colored by sulfurous penetrations. The sandstone is uneven, astonishing, for depending on the vein or the way the rock happens to present itself, it yields—in terms of statuary—a substance that splits and disintegrates in a matter of two hundred years or even in ten years, so that you see triumphal arches, raised in

Plate 2. *Burial place of Kao I. Winged tiger, standing. Left profile.*

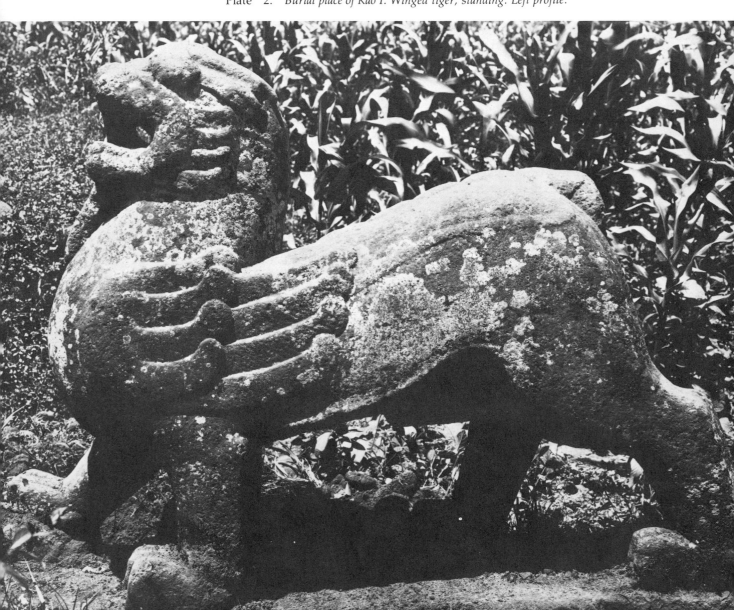

honor of some scarcely wilted virginity, which are worn away, blunted, sucked by time as if they were concocted of sugar or sand; whereas relics of past ages, whose sandstone was extracted from better-chosen quarries, preserve, with stupefying accuracy, the Han worker's chisel blows and even his preliminary marks on the stone block.

The Szechwan region therefore plays a leading role in this study of the later Han, because it is this region that holds in safekeeping for us the greatest number of statues known to be from that era, and because it offers us the best preserved, most complete, scarcely blunted statue in the round: the winged tiger of the tomb of Kao I (Plate 2).

It is a large feline, long of body, strapping and supple. Here again, as with the horse of Ho Ch'ü-ping, the actual size is small and the effect produced is out of proportion. The beast's head is held well back, supported by the unforgettable arching of the back. The head is too worn away to give us an indication of the real movement of the jaws or the expression of the eyes. The animal is chewing a sort of ball, held by the four canines; I do not know what its symbolic value is, but I find its sculptural effect deplorable. Eye and ear have been lost, as the rain has dissolved them in the sandstone, but the rectangular rictus is still visible, carried on by three pinnae that stand out from the cheek, toward the neck.

The chest thrown forward and the neck distinctly drawn back, despite the vertical nape, show this preference for a haughtily curving posture that is going to characterize all of our animal relics, our feline relics of the Han period.

The animal is winged, bipinnate; four pinnae and four quill feathers start from the chest and are going to spread out over the flanks.

The position of the limbs is surprising, unclassified even in our heraldic science so familiar with fine animals in movement. This is not a walking—i.e., in heraldry, "passant"—tiger, even though the forelegs do give the impression of a powerful gait, because the left limb is placed straight as a sturdy pillar, and especially because the right paw rests on a sort of ball attached to the pedestal, and one does not walk on a ball. So I propose, in heraldic terms: "winged tiger, hindquarters passant, forequarters resting."

The main part of the statue is the hindquarters, which are long, developed, enormously powerful. In the horizontal profile, they come up to the level of the mandibles! The beginning of a tail (F) is visible but broken; we cannot tell how it was shaped. The thigh is prodigiously developed in order to support the arch of the back. As the right leg is placed forward, the left leg, almost outsize, is thrust far backward. The line of the belly, which is more oblique toward the top than the line of the back, joins the thigh in a pronounced curve, with a marked inguinal plane—the sharp-edged plane that we will find in that position on all the feline statues under the Han. Lastly, an astonishingly powerful penis is seen in horizontal profile between the thighs, below the belly; it is visible on every Han drawing.

The paws are big, slightly blunted; they do not all show the toes and claws, which are nervously clenched like a fist with right-angle knuckles.

The movement of this profile shows contradictory power. While the head and neck are drawn back, swelling out the chest and resting their weight on the ball to the front, all of the hindquarters, tense and huge, lean on the left thigh, which is thrown far

F. *Burial place of Kao I. Winged tiger, standing. Three-quarters, rear.*

back, and thrust, rise, arch, stretch forward. The dominant impression created by these two conflicting postures is that of some force ready to gush forth.

This animal has a double—another statue symmetrically placed opposite, face to face, twenty paces away. Symmetrical and similar as to size, bearing, movement, but in an advanced state of wear; it does not teach us anything more. Both beasts are neighbors to two stone monuments, renowned since the investigations carried out by Edouard Chavannes: the "funerary pillars," the mysterious Ch'üeh of certain Han burial places, and Han only. I intend to come back to this monumental whole and discuss it more thoroughly later.

The discovery and the definite identification of the winged tiger and pillars of Kao I we owe to a study of the provincial chronicles. Having consulted the *Szechwan t'ung shê,* Edouard Chavannes was able to tell Commander d'Ollone, before he left in 1907, where the burial place of Kao I was situated: "Near Ya-ch'ou-fu in Szechwan," Chavannes reports, "are pillars dated 209 A.D. In front of the pillars, two winged lions, passant."

As we can see, the texts—and likewise Edouard Chavannes, in his scrupulous translation—call "lion" what we have termed "tiger," and not just haphazardly. Discussion of this should be postponed until we have looked at the other statues to come in this book, as they will bring us elements of comparison.

One date is certain: A.D. 209. There is thus a gap of over three centuries between the two statues compared thus far from the two Han dynasties. But very luckily other witnesses remain; they are more truncated certainly, less complete, but they fan out according to logical dates. At the same time, the diversity of animal types will become

more marked: the winged tiger, ambling and half-passant—like the one we have just seen—appears to occur the most frequently; winged tiger seated; lion passant.

While we were staying in Ya-ch'ou to study the complex burial place of Kao I, Jean Lartigue was going north to Lu-shan-hsien, a subprefecture that was not so much fallen from glory as so remote and inaccessible that neither the Chinese maps nor our own included it.

There was another important funerary monument there, that of Fan Min. And it was by the edge of the road, in the midst of a tall-growing rice paddy, that Lartigue discovered the second specimen of a winged tiger, half-ambling and half-passant, dating from the Later Han. While its relationship with the burial place of Fan Min cannot be affirmed with certainty, its identity of style with the tiger of Kao I can. Therefore, it cannot be called "tiger of Fan Min" but "Han tiger at Lu-shan-hsien" (Plate 3).

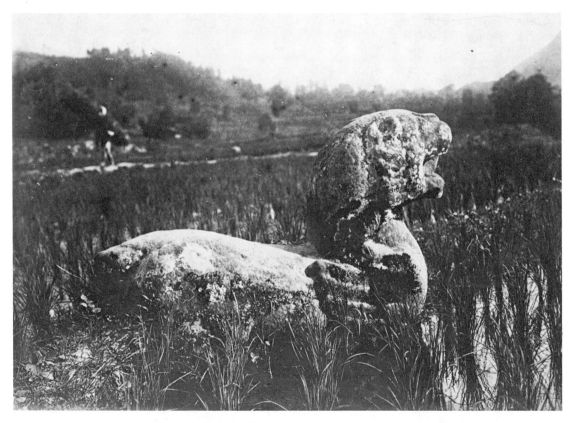

Plate 3. *Han tiger at Lu-shan-hsien.*

Its four limbs are broken, and it rests, motionless, among the tall rice plants which, even if cleared away, would not have revealed anything more. But we can be

satisfied with the superb attitude that remains: the double-arched Han attitude. The head, of a type similar to that of the Kao I beast, is more vigorous, more delicate, less blunted, with its jugal feathers and its virile, curved neck. The wings stand out clearly, and each has an equal number of large pinnae; the croup reproduces the lumbar arch of the previous type, but with more delicate vigor. Compared to the first statue, it is more than a replica: another statue on the same fundamental idea, born of the same inspiration, and likewise made of red sandstone. And it matters little that the grasses grow taller, that slimy mud surrounds it. In the middle of the fields, there remains a living, wounded animal that opens its mouth and that for two thousand years has been miaowing a stony cry choked by the ball, in a posture of rage whose contours the rain has not been able to rub out. The human achievement is there, despite desertion, despite crops that are more all-invading, more stifling, than the bush, the jungle, or the forest. Abandoned, the beast cries out.

Like the previous one, it is a "tiger."

The same expedition, the same neighborhood, revealed another statue to Jean Lartigue. It is the only one of its kind, a new kind, and must be called "winged lion at Lu-shan-hsien" (Plate 4).

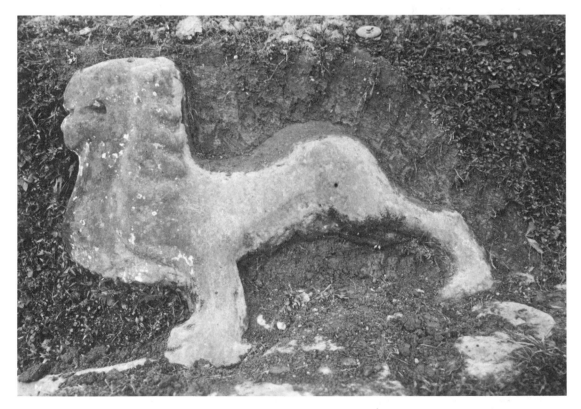

Plate 4. *Winged lion at Lu-shan-hsien.*

It has not sunk into the ground; its phantom legs are held fast by the rice field, and it is half buried alive but standing up quite straight in an embankment. Here again, we would like to see it freed, unearthed, bathed with light. Impossible: nothing of the other side remains. What we see from one side is total. This is a statue that used to be carved fully in the round but is now reduced to the haut-relief of its left side.

The profile and the round surfaces are striking—and different. The overall attitude is indeed symmetrical: curve of the chest, enormous arch of the back, the left foreleg placed like a vertical pillar, the left thigh stretched far backward, the inguinal plane very clear, the male sex organ large. But first of all we can see that there is no trace of any wings; of this we can be sure, despite the statue's state of wear. The mighty neck, on the other hand, bears four, possibly five, deliberately ornamental scrolls altogether different from the straight, jugal pinnae of the Kao I and Fan Min tigers. There can be no doubt that this represents a mane, stylized but well-placed. If we add that the proportions of both chest and neck are heavier, more developed, then in all likelihood we can continue to call the earlier felines, winged but furless, tigers; while this one, wingless but furred, and with an even more robust and majestic bearing, deserves the title of lion. Faced with this stone evidence, it is immaterial whether or not the Chinese under the Han were familiar with tigers but not with lions: what we have here before our eyes, created by their chisel, cannot be given any other name but lion.

Thanks to this distinction-making find, we can now knowledgeably point out the few feline-type statues, carved in the round, of the same era, and the countless feline-type bas-reliefs that must be dealt with afterward.

In the order of their present state of preservation, the fourth statue dating from the Later Han that is known today is the winged seated tiger (Plate 5), which I temporarily ascribe to the tomb of Feng Huan, at Ch'ü-hsien. This allows me to date it from the year A.D. 121.

Having suffered worse treatment than the tigers of Kao I and Fan Min, the beast has lost its head and both forelegs. What remains are: the chest intact, the back, all of the hindquarters, sitting as a cat would, on a well-preserved pedestal. It was found by Gilbert de Voisins; while the pillar of Feng Huan was being studied, he explored the area around the burial place. He noticed a rounded-off block of sandstone drowned in a rice paddy by the side of the road; one edge of it, a bit of hardly visible relief, seemed to him of good sculptural quality. He had the mud cleared off, had it lifted out, brushed, and dried. This revealed the very fine piece of the best Han type that we see in plate 5 and G and which, for the first time, showed a new bearing of a Han feline figure: the sitting position.

The mystical or monstrous ornamental elements seem to be of the same type as those of the earlier tigers: a nonbipinnate wing, a scaly backbone. The wing, which is more ornamental than feathered, starts from less far away on the chest and ends, upward and oblique, in a fine single scroll. From that scroll a long two-pronged wing feather curls off, stretches over the back and becomes three-pronged at the base of the rump.

The neck is thin. Not the slightest trace of any thick mane, but a few plain locks of hair, somewhat horselike and unrelated to the ornamentation of the felines we have

already seen. There can be doubt as to the absence of a mane, allowing us to decide: this is a tiger.

The sculptural effect is static and majestic. Despite the missing head (it is hard to picture how it can have been attached to so slender a neck), despite the two missing forelegs, there is an unexpected equilibrium deriving from the curving belly, the solid position of the doubled-up thighs, especially from the hind paws, clinging to the debris of the pedestal by means of four voluminous toes, clenched like an enormous fist.

This incomplete animal gives a false impression of stability. And I must admit that any attempt at reconstitution is futile. Suppose we wanted to draw in forequarters despite the beginning of a chest, deludingly intact—where would we take them? From what angle would we draw them? You *cannot invent* a Han gesture in our day. The head must have been elegantly small to fit onto so small a neck, or else monstrous, paradoxical. You cannot do a mask again, not even an animal mask, from the days of the Han!

As such, the find was a handsome one. We left it where it had been in the rice field, but standing up now, not far from the pillar of Feng Huan, which no doubt gave it its *raison d'être* and its extremely probable date of A.D. 121. So it appears as intermediary, at the beginning of the second century, between the horse of the western Han and the "tigers

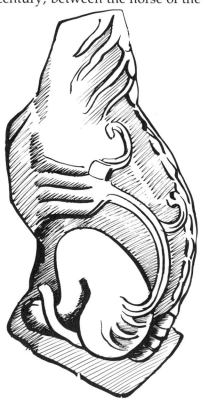

G. *Ch'ü-hsien. Winged tiger, seated. Profile.*

passant'' of the early third century. Cunning, powerful, the chisel marks well-preserved, broken—no doubt but what it has already sunk back into the mud and that soon it will be impossible ever to find it again.

Finally, there still remain—or in 1909 there still remained—some fragments of an animal dating from twenty-six years after the seated tiger of Feng Huan and some eighty years before the tigers of Kao I and Fan Min, a statue from the same period of sculpture but located at the opposite end of China, in Honan Province. The texts called this animal a ''lion,'' as did Chavannes and Sekino, who unearthed it in the burial field of Wu-liang-tz'u. The pieces found were the head, which is indeed that of a large feline; part of the flanks; and stumps of the forepaws, connected to debris of the pedestal. This cannot be called a sixth Han statue, and the reproductions that its discoverer published of it do not offer a basis for any criticism; the date (A.D. 147) and the location (burial field enriched by other monuments of great interest) should be remembered. We will come back to them.

Thus, in Szechwan Province, five statues fully carved in the round: two of them intact (the winged tigers of Kao I), three diminished, and the debris of a sixth—this is what has come down to us, or what I believe is known that undeniably dates from the time of the later Han. These specimens are the only ones, in my opinion, that can be called authentic. They are authenticated by the texts in which they are mentioned, by the places in which they are found, and by the inscriptions that designate and date them. This is not true of the many miserable shards of stone that the gravediggers for antique dealers have been inventing or pressing into service for some years and which should be treated with the strongest mistrust.

So we see that today the statuary of the eastern Han and the statuary of their predecessors alike are represented only by certain animal types. I searched the texts at great length for some mention of the statue of a man—a human visage, a face done in the Han style. The *shih-jen*, ''stone men,'' of the Han era abound in the chronicles revised under the Ming or even under Ch'ien-lung, which proves their persistent existence until that time. Despite my desire, my haste, my eagerness to contemplate, face to face, a human countenance fashioned out of stone in that era, I did not meet a single one. Sekino did report the existence, not far from the Wu-liang-tz'u beast, of a ''stone man.'' But the fact that no reproduction of it is given makes us doubt its ''human'' appearance or identity. And, yet, at Ch'ü-hsien in Szechwan Province, in the same region as the tombs mentioned above, a few *li* away from the seated tiger, the geographical texts told me that a statue survived in a village called ''Village of the Stone Man.''

I found it, with some difficulty, for it lay among wheat stalks already grown tall. It was a large, rock-gray body stretched out full length (nearly six feet) on the ground, worn out like an old block on which a hundred generations have placed their feet; a sort of long tunic with the waist barely marked, no feet, and the head buried face down in the ground. The grandeur of those straight folds, the statue's majestic character, most of all the place itself, a small village today but what had been under the Han the ''ancient opulent city of Ch'ung,'' justified relating it to that era. For a few oppressive instants—caused by our haste, the excitement of making this find—I cherished the hope that I was about to contemplate a Han man face to face! With the help of a large number of peasants, the

enormous individual had to be raised, turned over, and finally placed upright. The peasants, when called, began to laugh: you do not raise up an enormous figure that has been stretched out since "antiquity." But the first strokes of the pickax stopped: the figure had been beheaded! So any chance of finding a human face lying there was withheld from me.

As a result, I have never seen any human face dating from the Han, carved in stone and having sculptural proportions. Of course, there are a multitude of terra-cotta statuettes (the Han were expert potters) that give us replicas, but these are only toys worked by fingers in a soft material. It is disappointing to find that until such time as new discoveries will have unearthed the unexpected human face, it would seem that the only life-size face carved in the round in the so-Chinese stone of the Han is that of a non-Chinese, the Hsiung-nu barbarian, seen upside down and defeated between the pasterns of the old horse! The horrid grimace rather than what could have been a noble, classical countenance. . . .

Now we must turn to the Han monuments near the statues we have already mentioned, in the same burial fields. Because of their seemingly architectural forms, I was inclined at first to exclude them from this history of the grand statuary as such. These are the Han honorary pillars. Paradoxical, surprising monuments, without any apparent interrelationship, but they are to be numerous from now on, and we can arrange them in series, under the most dissimilar species, with unexpected results.

The Chinese call them *ch'üeh,* a word of many meanings: palace door, guard tower, imperial city, and, lastly, the stone pillars that, in Tai shan Province, stood around the altar for the Feng ceremony. This is the name we should use were it not so dissonant in a French sentence. Translating it in monumental terms is difficult: "pillar," to us, conveys something altogether different, and "column" is too thin. "Pillar" is definitely the better term, and usually it is made more precise: "funerary pillar." "Pillar of the eastern Han" seems to me the happy medium, for it is never found outside the Han period, and although these monuments do generally decorate and indicate a burial ground, there is at least one of them that does not stand guard over any dead man but merely marks the edge of a celebrated place.

The discovery, study, and exegesis of the first known pillars must be attributed solely to Edouard Chavannes. These are the Shantung and Honan pillars. Yet it is not one of those that he discovered and described which can be cited here as the initial type of pillar. As we will see, among the various types, the pillars he studied elude any study on statuary. On the contrary, I would like to describe, as the first impression of these very clever monuments, the one that I found the simplest, purest, and most sculptural among the thirty now known, the pillar of Feng Huan at Ch'ü-hsien in Szechwan Province (Plate 6).

We can guess its total structure, elegantly balanced. Superimposed from bottom to top were: a pedestal in the form of slabs, hidden by the grass (the hexagonal sandstone rim is modern), a slightly trapezoidal shaft, then a tiered arrangement of small beams, an engraved flange, above that a level of rafters, and, finally, a roof. The whole is made of six blocks of sandstone, superimposed without any visible cement, perfectly fitted and carved.

Plate 5. *Ch'ü-hsien. Winged tiger, seated.*

Plate 6. *Pillar of Feng Huan. Front.*

"Carved" in this case does not mean decorated, treated ornamentally, but dressed on every side to form a harmonious volume. Seen and described in their own artistic entirety, these monuments add a new element to the art of sculptural volumes. We can see why they cannot be confused with an architectural creation: although they are made of six superimposed blocks, there is no masonry or architect's work involved. The pedestal is common and similar to that of the preceding statues, and is simply separated. The shaft is monolithic. As often happens, it is a statue made of several "pieces" of stone, all of whose joints are horizontal in this case. These pillars are not monuments. The one we have here before our eyes is a real statue, a three-dimensional stone reduction and formalization of an object, a concrete "model," and we must now find out what kind of model it was.

For a statue, especially one in antiquity, and even in our own day, supposedly "imitates" a model, living or concrete. The tigers, the lions, the horse, and the man we have already seen were modeled on human beings or felines made of skin stuffed with flesh and bones. Here, in the case of this pillar, the form is borrowed not from the animal kingdom but from the realm of architecture: hence, the first, false impression of architecture given by our "statue" as such. Hence the imperative of looking for a model.

This is not a column, I have already stated; the longitudinal complexity of the shaft is visible. A column "supports" something or someone, whereas this statue is surmounted by a real roof, a sheltering, covering object, functional in itself. To tell the truth, the word "pillar" is no more satisfactory, but if we analyze the decoration of each portion, we can go much further.

The roof, which is actually flat, or whose edges are barely concave—even though, seen from below, the curve of the ribs seems to have the familiar upturned pagoda shape—is nothing other than the roof of a Chinese house dating from any period. Other specimens tell us that the Han hardly indicated the curve, and that their descendants exaggerated the point curving in the air, almost making a caricature of it. Here the overlapping of the tiles is normal. It is the roof of a dwelling place, of a Chinese building, palace or shanty, or temple, and nothing more.

Below the roof, quite naturally, are its supports: rafters of a particular U-shape, analogous to those of our own day; all made of wood. Just as the stone imitated tiles on the superstructure, here it is given the customary appearance of wood. It is no secret what an unfortunate, even deplorable influence wood and brick, those decaying and perishable materials, have had—especially wood—on the Chinese art of building, whereas the stone edifices appear prodigious and deserve to be singled out for attention. So, beneath the tile roof and all the way down to the pedestal (a slab "imitating a slab of stone"), everything is a wood framework "treated in stone." The level called "beam abutments" is the most characteristic: it is handled by overhanging squared ends, a very common technique in heavy carpentry. The model for this was perfect (through their tradition of monumental building, the Chinese were carpenters on a large scale).

Under the overhanging level, a clearly visible horizontal stretch from which three strips descend; they stand out three millimeters in relief on a recessed field; beyond the shadow of a doubt this represents the main framework, the façade of the whole building, with the necessary horizontal piece and the supports that hold up the whole.

This means that the object was not intended to support a cornice in the air (as the false appearance of the very decorative rafter section might lead us to believe) but rather a roof. Now, there is no reason for a roof to exist unless it covers something. The object of this whole exercise was quite simply to represent a Chinese house, or, rather, such a house reduced to two intercolumniations.

Instead of taking the single column, whether slender or powerful, as our starting point, we must take the large building with its rooms, its ridge-tile framework, and its roof; and by an undeniable effort of synthesis, a twofold sidewards thrust, we must compress it, crush it, reduce it to three uprights, so as to make of it the object of symbolic use, the concrete model that this pillar faithfully translates into stone. In short, it is the statuette of a Chinese house; to be exact, a *t'ing*.*

That is why it does not belong in the future history of this country's architecture but right here, among the statues carved "in the round," despite the anomaly of the word contradicted by its square shape. But neither art nor its essence nor art criticism should vary according to the model. And here we must not speak of construction, but of the sculptural shaping of the stone, any more than we should refer to zoology or the art of cavalry when discussing the lion of Fan Min or the horse of Ho Ch'ü-ping. This Han pillar is indeed a statue, the statue of the invariable *t'ing*, the eternal Chinese palace.

To tell the truth, despite the svelte, exquisite, well-balanced shape of it, its air of being definitive and complete, the pillar of Feng Huan has not come down to us in its own integrity, neither single nor double. To begin with: it was certainly flanked by a sort of buttress, a miniature of itself, standing shoulder-high to it (the left shoulder) with a half roof and half rafters. Of this we are absolutely sure upon examining the base, which protrudes considerably to the left, and especially the left side of the shaft; it is not polished, only roughly squared away, and with its mortises, it is ready to receive the tenons and the accolade of the prop.** The sight of the other, more intact pillars that come afterward will confirm this.

Next, this pillar, even when completed in that way, was not alone. It was simply one of the boundary stones along the access-way to the burial field. It marked off, between it and its mate, its twin, the roadway of the dead man's soul. Later we shall see how each of these terms is accounted for; and although at this point we are entitled to play on words this way, we shall also see how, at a distance of two thousand years, these funerary words take on life.

There is no doubt that the ultimate function of the pillar of Feng Huan (like the function of all the pillars in Szechwan, Shantung, and Honan provinces) was to offer the passer-by this single inscription, the dead man's name and titles: "Roadway of the soul of the deceased commissioner Feng, who had the titles of Shang-shu-shih-lang, mayor of the capital of Honan, prefect of the district of Yu and of the district of Yü."

T'ing means "tall house," "tower." Under the Han, some *t'ing* have two roofs, as we can see on the bas-reliefs. (Note by V. S.)

**On *all* of the pillars which no longer had their buttress, we found that side prepared for it, with or without mortises, and the protruding base. (Note V. S.)

By its rare elegance, this pillar occupies a halfway position among the varieties of Han funerary pillars. Geographically speaking, although it is not centrally situated, it is curiously midway among the types showing extreme variants. They are considerable from one province to another. I shall first trace the eastern variants (Shantung and Honan) among the pillars, poor in the architectural type of statuary but richly epigraphical, which Edouard Chavannes discovered during his second mission (1907–1908).

The provinces of Shantung and Honan are almost as fundamental as Shensi Province to the old Chinese tradition. In Honan are located not only a swarm of famous places but also the second capital of the Chou and the Han: Lo-yang, not far from the present-day city of Honan-fu. Shantung, former kingdom of Lu, is the homeland of Confucius, whose majestic tomb ennobles it. It also boasts the most sacred mountain in all the empire, the mountain where, in the rite of Feng and the rite of Shan, the sovereign was invested with his office: the T'ai shan.

Edouard Chavannes' study of the monuments existing there, on the surface of the ground, is definitive, masterly. The comments he made on his discoveries and the way in which he endorsed the chance adventures of a few precursors continue to be our veritable introduction to active Sinology and future discoveries.

In Honan and Shantung provinces, Chavannes found six pairs of pillars similar to each other but quite different from the Feng Huan monument. Their general shape is altogether different. My photograph shows the pillar of T'ai-she (Plate 7). The first thing that strikes one is its graceless outline; the subtle elegance of the Feng Huan pillar has disappeared. What we have here is not a polylithic statue but a piece of genuine square-edged masonry; the stones overlap on every level, and even stick out from the pillar as such to the buttress that stretches toward a miserable little wall. The roof is heavy; and while certain details still imitate the Chinese house from which they are taken, we can see that they have none of that unity of volume, that pleasing contour, which characterize the elegant "statue" of Feng Huan, the decorated kiosk that we have taken as the pivot of any comparison. This pillar of T'ai-she looks like a fragment of a wall which at the doorway—a veritable main entrance—is terminated by a pilaster that does not so much decorate as it indicates or protects. The materials used to produce art have changed. The few flat motifs (dragon-bird, cartouche, rosette of Feng Huan) have disappeared. Sculpture is now out of the question; there is barely a touch of architecture; at most, this is primitive masonry.

So we see how the nature of art has changed, though the starting point and the model are the same.

The Honan and Shantung pillars, on the other hand, though poor and ugly as to decorative forms, are rich in inscriptions, covered with magnificent epigraphical matter, which allows them, though they have nothing to do with sculptural art, to belong to that superbly Chinese art, half calligraphic and half literary, the great art of the brush.

We can now see why, despite their historical importance, their importance as testimony, they could not be singled out as examples in this study of the art of shapes having volume in stone and achieving expression, not through ideas but through curve and contour.

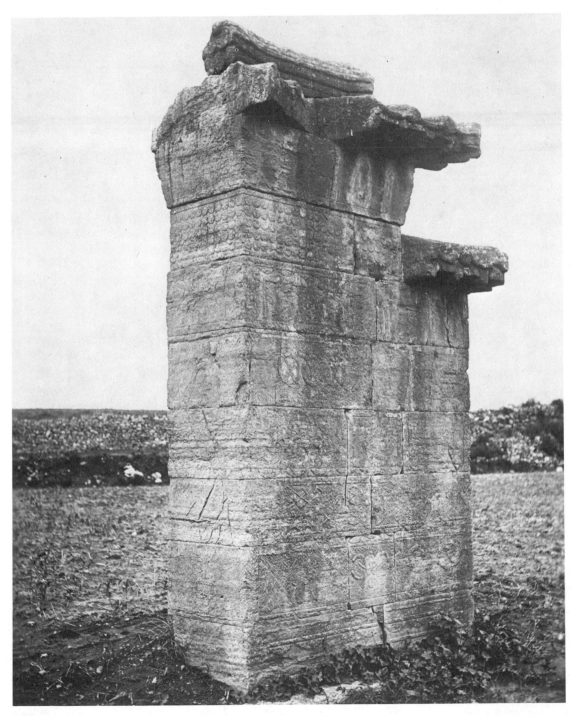

Plate 7. *Pillar of T'ai-she.*

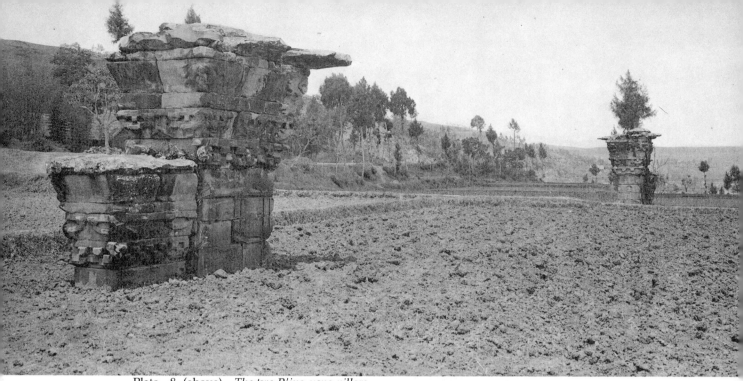

Plate 8. (above) *The two P'ing-yang pillars.*

Plate 9. (below) *Right-hand P'ing-yang pillar. Rear.*

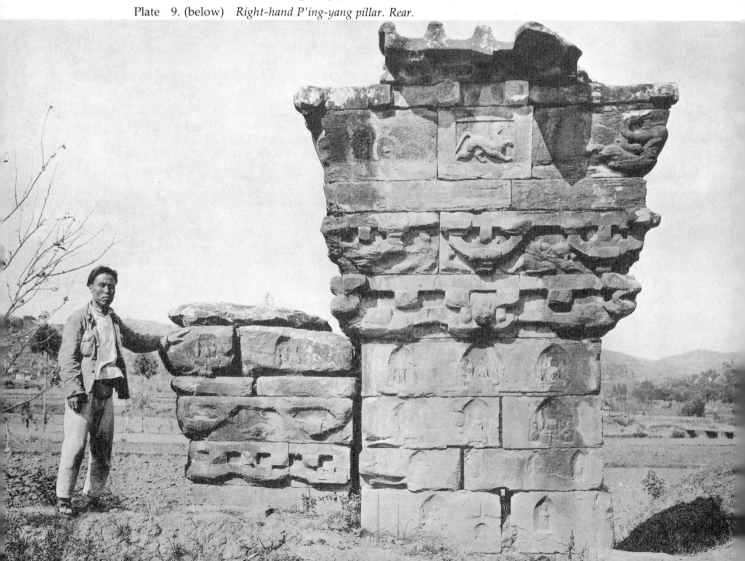

Far at the other end of western China, in the westernmost part of Szechwan, are to be found many-leveled pillars with their well-developed pinnacle, of an utterly different type, rich, complex, abundantly decorated, profusely carved almost in the round. As examples, I propose the pair of pillars at P'ing-yang (Plate 8), in the vicinity of Mien-chou (northwest of Ch'eng-tu).

There are two reasons for my choice: very abundant and successful sculpture in three dimensions; unique state of preservation of the pair of pillars, complete, with the pair of buttresses, the roofs, and the pedestals in their original state.

The story of how they were found is also a good example, almost a hard lesson in the hazards involved in such a hunt (the quest for the unicorn, the search for masterpieces conducted throughout this book).

The best archaeological inventory in Szechwan Province, the Chin-shih-yüan ("Garden of Stones and Metals"), did not so much as hint at their existence. The provincial chronicles placed them some "eight *li* east of Mien-chou." After the customary official visit to the prefecture, as soon as we had arrived in Mien-chou—a rapid but necessary exchange of compliments—we hastened to ask, "Where are the pillars of P'ing-yang located?" Astonishment. Some consternation in the *yamen*. They do not know. They express polite surprise that foreigners should be concerned about such things. . . . They do not know. They go and fetch an old scholar. Very solemnly he rereads the text of the chronicles but has nothing to say. There follows a succession of secretaries, satellites, parasites. No one, so short a distance away, hardly one league away (the French *lieue*, or league, being equivalent to eight Chinese *li*), no one knows about them. . . .

And this, plus the fact that the Chin-shih-yüan, that priceless guide, does not mention them, makes us believe a little hastily, a little lazily, that they are not there, they have disappeared. No point in looking for them, working eastward *li* by *li* in a radius of eight *li*; if they do exist, they are now only shapeless, worn-down remains, and stumbling upon them is the only way to find them. They have sunk into the rich purple earth that yields the abundant harvests in the Szechwan rice paddies, that gobbles up burial fields and even roads, the better to feed its seventy million living creatures. . . . And the Voisins, Lartigue, and Segalen mission gave the matter up for lost, a bit too fast. . . .

So that on our way back from an expedition to quite a different goal, precisely eight *li* east of Mien-chou, we were startled to hear one of our servants—Chou the groom—shout, "The pillars! The pillars!" He had looked for them as we had; and now that they were there, two hundred paces off to the side of the road, and we, our heads drooping from the fatigue of a 120-*li* stage in our journey, were about to miss them as we went by for the last time, he pointed them out to us just in time.

Because of this, Chou-ma-fu had earned the right to have his picture taken alongside the pillars of P'ing-yang. Although modern Chinese individuals are deliberately missing from most of our drawings about ancient China, here he is "giving an idea of the size," his left hand resting familiarly on the P'ing-yang buttress pillar on the right (Plate 9).

These pillars have seven superimposed layers, thus: base, shaft, two levels of overhang, a frieze, coping, and the roof. Although the sandy violet and gray stone of

Szechwan is in a fairly advanced stage of wear, we can still see how rich and abundant the upper levels are.

There is no denying that the whole no longer has its original purity of line. The monument is buried approximately three feet deep, and this makes it appear squat, less slender, spreads out its width, and emphasizes the heaviness of the summit. The pillar seems to be a creature with a big head. We see the original structure, complicated by all the original features, but here the purity has been destroyed. It is certainly another statue of a *t'ing*, and yet this statue is no longer a masterpiece of statuary.

The buttress pillar that we see preserved here, although all of its parts have suffered some wear, cannot be accounted for from the standpoint of decor-in-space. In reality, it is a demi-auxiliary. I am not aware, in Chinese architecture, of any use of a demi-*t'ing*. We must admit that although, to a European eye, its use is scarcely necessary, here it is used as adroitly as possible. And when you have recognized and sketched a constantly increasing number of such pillars, in the end you can appraise them expertly, as a pair and in their quadruple hypostasis, according to the laws of a hybrid art that becomes their own.

On the other hand, the pillars of the Mien-chou group, complex* and composite pillars, suddenly offer us a wealth of volumes and shapes, an abundance of "sculptural" features that the discreetness of the Feng Huan pillar did not imply and the ugly, clumsy uncouthness of the masonry pillars of Honan and Shantung provinces even made it difficult to hope for.

Between the three extreme types chosen—(1) epigraphical, masonry pillar, poor and simple, of T'ai-she; (2) pure pillar (statue) of Feng Huan; and (3) decorated pillar of P'ing-yang—there are a certain number of analogous or intermediary monuments.

The pillars of Kao I, which are close to the handsome winged tiger I have already cited as typical of the feline in Han statuary, belong to the composite P'ing-yang type. One of them is now only a fragment; the other, better preserved (Plate 10), shows a more meager, sometimes clumsily tumultuous decoration. In the same region, there are pillars of splitting stone, and it is hard to say whether their ugliness is due to wear or to their initial proportions. And, finally, really intermediary between Feng Huan and P'ing-yang, are the two pillars of Shen, whose art is both ornate and delicate.

They are more thickset and stocky than the Feng Huan pillar, and their summits, though not carried to the same point as the "big head" at Feng Huan, are developed and very decorative; and on them are the finest little statues, carved almost in the round. We will talk about them in a little while.

Now these diverse pillars—there are roughly thirty of them—which were totally unknown to us white people at the start of the century, and which represent for us both statuary and architecture under the Great Han, these first witnesses of the greatest dynasty are truly very strange, very surprising and mysterious Chinese monuments.

* They must be called complex because of their arrangement, in which the blocks are piled on top of or dovetail with one another, their larger dimensions making the monolithic shaft out of the question; also because of an enlargement of the upper stories or levels. (Note V. S.)

Plate 10. *Kao I pillar. Three-quarter front, inner side.*

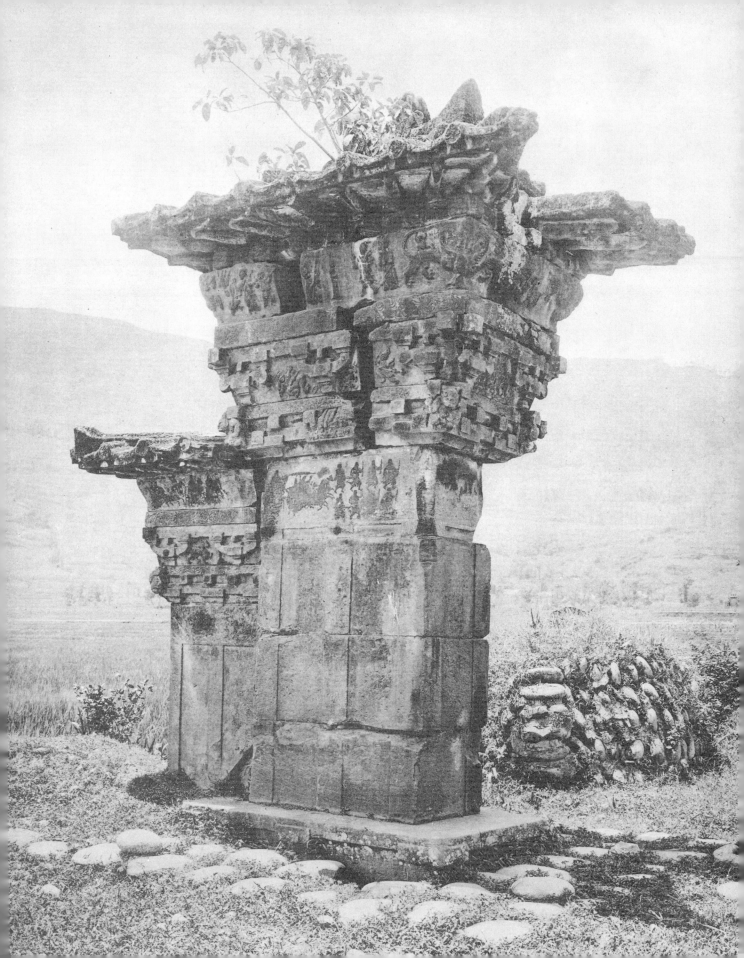

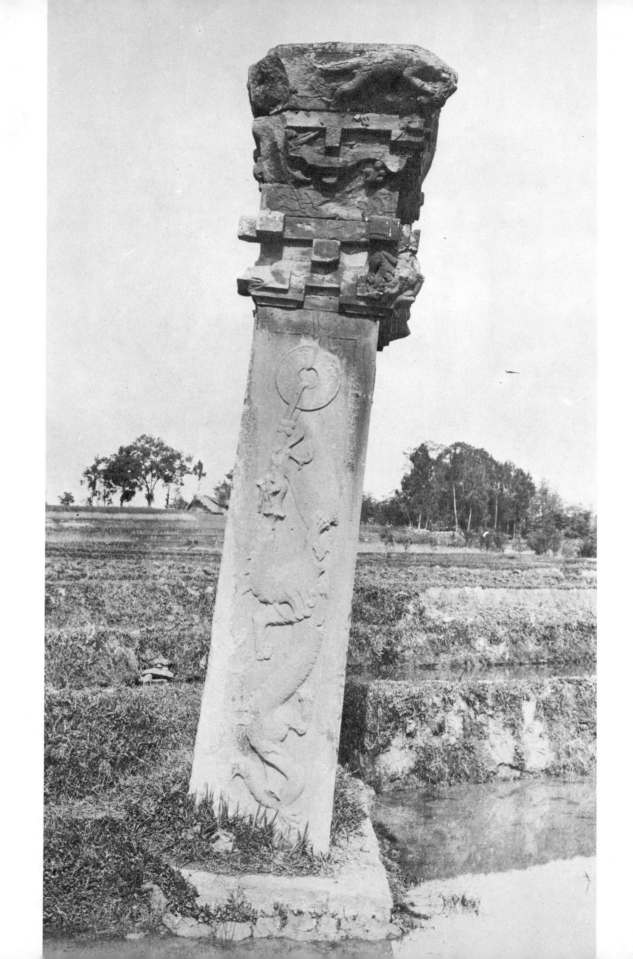

They seem to appear abruptly in the first years of our Christian era. Neither the oldest texts nor the most recent discoveries have succeeded in dating them farther back than the year zero. So these are sudden episodes in the reign of the Hou Han, the Later Han, reigning at Lo-yang. Moreover, they disappear, not at the same time as the Han in A.D. 221, but along with that dynastic extension of the Han, the Shu Han, Han of the country of Shu, in the celebrated days of the Three Kingdoms, who for a few years more possessed the vast province of Szechwan. After this, we no longer hear of those pillars.

Under the Later Han, they must have been abundant, copious, sought-after, in demand for any rich burial place. The fact is that they are found well-preserved in unexpected proportions. Statistics, though always false and easily distorted, can be brought in here. It is probable that every "mandarin" burial place created in the days of the Han, who reigned for four hundred years over an enormous country, was decorated with animal and possibly human statues. Now, as we have seen, we possess but six of them in all, plus the debris of a seventh; whereas we have some thirty or so pillars that are worthy of study. This means that if both the statues and the pillars had the same causes of destruction, the number of pillars must have been far greater than the number of statues. But that is open to debate.

In China, a stone statue, even a sacred one, is a very perishable thing. Not that the Chinese do not respect antiquity; instead, they respect it to such a point that Europeans ignorant of everything about China have made of that particular virtue a uniquely Chinese virtue. Only we must take into account that, by and large, the Chinese living in China today reproduce and multiply. And that a living being has no other means of subsistence than by eating the products of the earth. Everything in China, when it comes to that, is a matter of earth, soil. A sacred soil that no one dares touch or dig up and disturb, a soil that is carefully cultivated and which devours the dead. In this way seeds are sown in most of the burial fields, the tumuli are razed, sites are destroyed. This is especially true in the blessed land of Szechwan, where the beautiful dark purple soil gives three crops a year, where mankind is so numerous that men prefer to carry loads themselves in order to eat, so as to expel the competing beast of burden.

If, in the process of this invasion, the pillars were spared more than the statues were, that is because the pillars did not have the same characteristic, in the eyes of the ancient Chinese, as the statues did, that of being—as I have decided to put it, from a broader standpoint even than that of ancient China—a statue but rather, that of carrying, in *characters*, the names and titles of the deceased. A pillar, in the Chinese view, in the eye of the Chinese beholder, is a *stele*. This explains why the pillars have been relatively well-preserved, why their pedestals have been surrounded with respect; a respect that is also relative, for one of the most handsome pillars—though an anonymous one, it is true—of the Ch'ü-hsien region is leaning to the point of almost falling into the rice paddy, its familiar foster father, where it will soon topple and disappear (Plate 11).

Stelai and pillars, mingled in the chapter which follows, and which will close the era of the Han, will enable us to find further examples of the great statuary, the sole object

Plate 11. *Leaning pillar. Inner side.*

of this book, and to further our acquaintance with it through volumes in stone, small as to size but grand as to manner.

In so doing, we will learn something more about the great art of life under the Han.

The Great Art of Life Under the Han

We find animation, a throng, a sparkling, a rush of people, of animals, monstrous or banal, improbable or ordinary, with mettlesome gestures, a ceaseless dynamism of the muscles, an effort to wrench away from stone and at the same time a desire to reach culmination in stone, to transform the block of stone into the formalized whole that is a statue carved in the round . . . and all this, scattered through Szechwan Province, clings, turns, slips, flings itself around the pillars of tombs, and some, slower and graver, around the impassive feet of stelai.

Above all, we have the pillars of Szechwan, and among them the pillars of the Ch'ü-hsien and Mien-chou groups, which provide us with the finest examples of this small but powerful statuary, sometimes minute in size but always producing immense effect. The vast majority of them develop their revels around all four sides of the summit of the pillar, between the roof and the level of beam abutments, in a space three or four feet high; but it is naturally at the corners that they achieve their fullest statuary development.

First of all, here is the scene we may entitle the "combat of the felines" (Plate 12). It forms the magnificent decoration on a corner of the right-hand pillar of P'ing-yang. What we see above all is a mightily wound up, terrifying embrace, supple and sinewy, the rounded effort of a great snake, but which is here a four-legged, tiger-tailed monster. These are no longer tigers but long felines; the stronger and larger of the two, overcoming the other and bending his back under the cornice, dominates and subdues the weaker, which is crushed beneath him. He holds him by the neck, but the other one grips him by the right paw. The clawing hind legs struggle. A man is pulling the tail of the larger beast. The grappling felines form a single, terrible volute, decorating and capping the angle that juts out beneath the roof, turning that angle into a vigorous projection, a violent group which is virtually wrenched from the cornice but at the same time neatly fits the overall decoration of the monument.

We do not know what this scene symbolizes. Yet is must have a specific meaning, for there is hardly a pillar on which we do not find it, either in the same place of honor (and sometimes it is just as powerful as here, but nowhere else has it this development as of a muscular arch) or on the front, in a reduced semi bas-relief. But the meaning has not

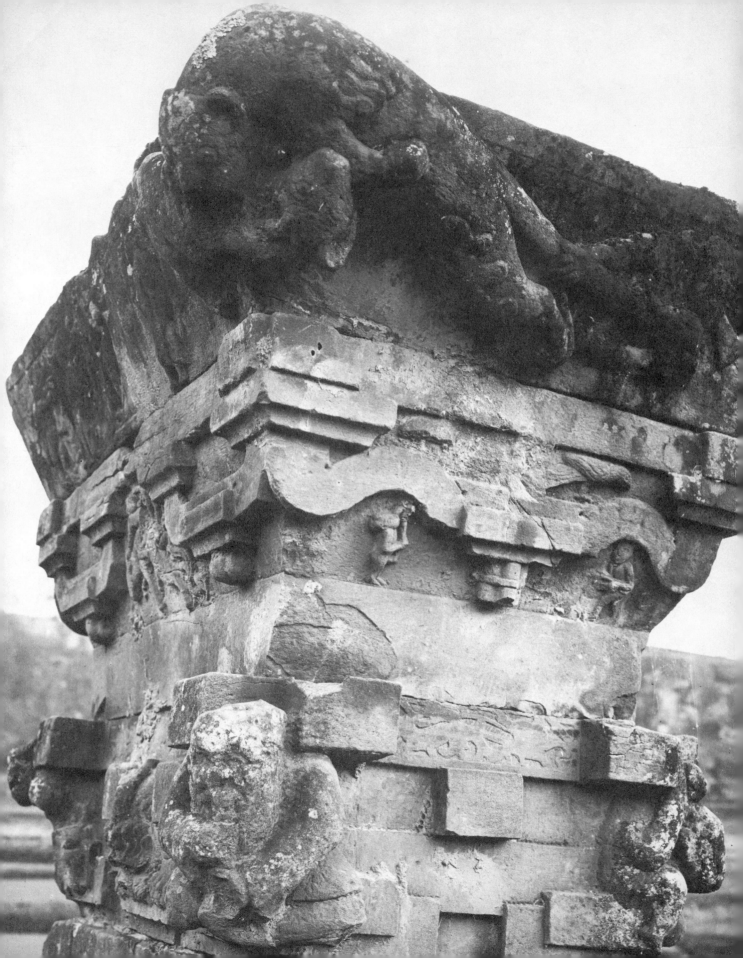

been revealed to us by any text. Why does a man take sides for the defeated animal? What are these virile beasts with their eel or serpent bodies, their heavy paws and tiger tails, and the small ears of a bear? And who is that man? And what relationship, after all, with the nearby burial place? None, perhaps.

On the other hand, as we can see, this is a large and beautiful piece of sculpture, carved—and I stress this—in the round. It would take very little for all the voluminous sides of this scene to be freed from the sandstone and plunged entirely in the light. The sculptor who carved this group was of a high enough caliber to go all the way around it. What we have here is no longer bas-relief (as seen on so many examples of Han work and even the pillars) but the support material used in all its three fine dimensions. The chisel, not the brush, was at work here. That is why this group, and all the analogous themes, are fully entitled to be mentioned in this book. Moreover, although the dimensions of the scene are modest, it breathes an undeniable grandeur.

The same sort of frantic intertwining is to be found on the same P'ing-yang pillars, in the harmonious combat, or the grasp, or balanced embrace, of two supple horned hydras—scaly dragons as it were—from the Han era (H). Here we find more decor as such, more equilibrium, a swinging gesture in the struggle; the twofold animal "motif" is also double in the way it is thrown outwards, in its double curve, its backward effort, the knot it forms. The chests and paws are entwined, entangled, yet remain distinct; the heads describe a fine double arabesque. There is a capricious, self-assured elegance; a volute achieved by living forms, poised like the beam of a balance on the knife edge of a gable end!

For here we come upon the other problem—an unexpected, curious problem, a matter of simple but solid geometry. The single gesture of the stonecutter, working entirely freely, is imperiously subject in this case to two directives: the right angle of the corner of the pillar or, rather, this precisely definable dihedral: the angle of the trunk of a pyramid with its point upside down. That was what had to be covered with sculpture in the round. We have just seen these two examples. In the first—the combat of the felines—the sculptor devoured everything in his passion of lines and thicknesses and huge muscled curves, and the resulting whole is decorative, satisfactory. In the second example—the entwined hydras—he divides the scene down the line formed by the corner, and on either side of this partition the two arabesques, swollen but even, form their right angle; if we turned them around, we could make it coincide in this symmetrical space.

The third example is more delicate and carries more prestige. It is the one I have sketched here (I). Around the corner of the summit of the left-hand pillar at P'ing-yang, a winged horse trots rapidly, led by a thin and peculiar personage with pointed hanging sleeves who holds his reins, going before him and turning around to him, urging him on, pulling him. That is the unexpected theme. The way it is carried out is more surprising still.

The horse, which appears to be "drawn" rather than carved, for the degree of relief here is very little, trots (without cantering) on his four hooves alternately. The hindquarters are rounded, the well-nourished chest is thrown back, along with the head, as if he is indignantly refusing—he, a winged monster, with his six limbs—to be led on a

Plate 12. *Right-hand P'ing-yang pillar. Corner motif. Combat of the felines.*

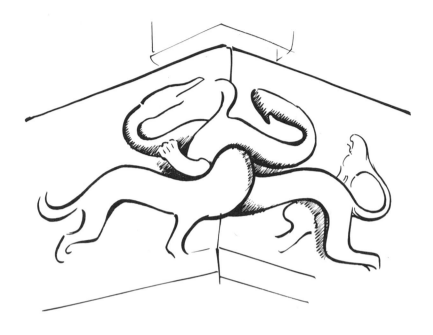

H. *Right-hand pillar at P'ing-yang. Corner motif. Hydras entwined.*

leash by a mere two-legged man, even a misshapen one. The man, who turns his mute, noseless, mouthless, eyeless face toward the animal, has already stepped beyond the right angle, whereas the horse himself is in the very process of crossing it. And this difficulty he overcomes by a tour de force in space, frolicking as he does so without losing anything of his fine air. While we cannot say that he is bent into two surfaces, we find that despite the slight degree of relief with which he is carved, he manages to envelop and get around his "difficult angle" and satisfies our eyes from every visible standpoint.

Now we come to a statuary that perforates space, solid space; stone pierced through and through, no longer bathing in light but in matter itself. This produces a strange effect, as of an effort successfully attempted, stark determination. I am talking about the horned head, a glutton's protuberant mask, doubtless *t'ao-t'ieh*, which emerges from the front of almost every Szechwan pillar without exception, at the beam abutment level, and breaks through between two of those beams. On the pillar of Kao I, it is bland and flat; on the P'ing-yang pillars it improves; and on the two Shen pillars at Ch'ü-hsien it is done in powerful, handsome relief. Here (Plate 13) is the one on the left-hand pillar; though analogies are dangerous, there can be no mistake: it recalls a sharp and vigorous Han bronze.

The relief is globular, the details extremely distinct. A single horn appears to be braided at the base (the homologous beast on the right-hand pillar has two horns). The features are thick but stylized by sharp curves. A broad, flat nose, eyebrows like hard little

wings, pointed ears, and, in the upper angles, two powerful little curved pinions. Under the jaws, the upper teeth—teeth more human than feline, to tell the truth, "omnivorous" teeth—sink into the stone. Below the cheeks, the short forepaws appear, with four short clawlike digits.

With the effort of a mole digging away and finishing his hole, the beast emerges superbly from the stone, fitting his horned, winged, and clawlike protuberances, his large skull, his bloated mask, his greedy cheeks and teeth into architectural space with a gesture that is full of rage and appropriateness (J). Now we can see why the nose is flattened out: he has pushed back the stone. We can see the necessity for the armed eyebrow, the hard, fortified armor-plated eyebrow: he has penetrated the stone. Likewise the *raison d'être* of those gravedigger's paws, the short, broad, paws of a mole; lastly, the vigor of those pinions swimming in solid matter. Beyond the shadow of a doubt, the beast has just pushed its way *through* the pillar's shaft. It is still bathing in the stone; though carved, it is still caught in the matrix of the stone. And so that no doubt can remain as to this "penetrating" explanation, if we go around to the other side of the pillar, we see on the back of it, at a symmetrical point on the same level, the tail and the hind legs, just as squat and stubby. We can hardly see them; they are going to sink in and disappear; the animal's body is literally carved *through and through its pillar*.

I. *Left-hand pillar at P'ing-yang. Corner motif. Winged horse and runner.*

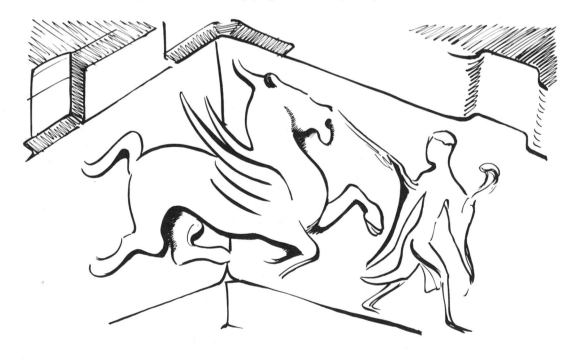

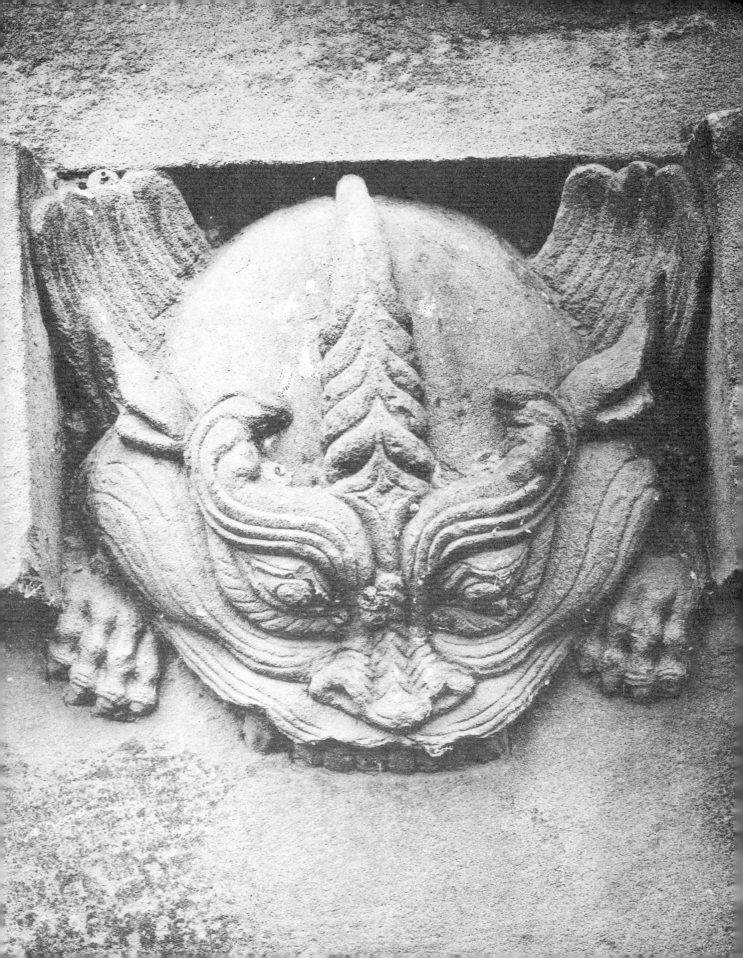

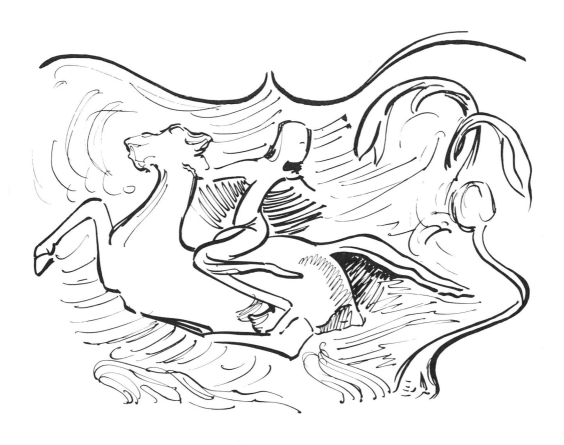

J. Left-hand Shen pillar. Front. "Dash to the Unknown."

On these same Shen pillars—whose date is not certain but doubtless falls somewhere in the second century—we find strange scenes on a small scale.

The figure with the misshapen sleeves, the thin floating, dancing figure, a sort of exhibitor or tamer of wild beasts who walks before the winged horse, is not the only one of its kind. In the same style, with the same disturbing gesture, a horde of whimsical phantoms come and go, fight one another, pulling and knocking each other about, fall from the sky and walk on their hands: solar-lunar animals, nine-tailed foxes, three-legged crows, jugglers and acrobats, monkeys with or without tails. . . .

The most violent of all these scenes is the one that, for lack of any explanation in the texts, I propose to call "Dash to the Unknown" (drawing J). It covers a small surface—hardly one square foot. It is very worn away, very damaged; what remains is this: another of those thin, whimsical Han figures riding an animal that is a cross between a

Plate 13. *Left-hand Shen pillar. Front. T'ao-t'ieh.*

horse and a stag, three of whose legs are split or worn away, lost, so that the fourth gallops all by itself. An impressive runaway. The rider seems to turn his face, his worn-away face, to the rear, and so crumbled is this purple and pink and bluish sandstone that we do not know whether it is a noseless, eyeless mask. Both his arms are unfurling something; we cannot tell whether it is wings or a garment, but the animal's body, the thighs, the legs and the feet, the way the rider grips his steed, all this is recognizable, vigorous, bold. The broad foot, without the suggestion of a stirrup, reaches backward to spur the beast on. The whole goes hurtling ahead in a mystery of lines now disappeared, lost forever, and making it more singular still, an enormous arabesque of flowers, bigger than man or unicorn, pursues the pair with its spiraling stems, curving and hovering over them.

Once again the relief of a human figure in stone has been lost.

Just as among the thinly populated ranks of the very large statues, the same question arises amid this throng of little anthropomorphic beings: where is man? Where is the well-preserved homunculus of the Han?

We do find it, and sometimes in good condition, in the form of caryatids or atlantes fitted into the four corners of the beam abutment level, in the composite pillars of Szechwan Province (Plate 14). Given six corners (four on each pillar and two on each buttress), this gives us quite a number of human specimens. These statuettes are almost entirely carved in the round, for their functions as caryatids make them protrude from the stone, as detached as a corner pillar; they are generously round and plump, and all that connects them to the block of stone is the back, the seat, and the fatty part of the calves. Many of them are worn away, smooth as pebbles on the beach; some of them, protected by the projecting beams and roof, have kept a semblance of face.

Here again, disappointment. This is not a human face—I mean, the face of a classic Han—but the face of a barbarian, a slave, a grotesque creature with big, round eyes, the caricature of a Hsiung-nu with his unruly beard, his ridiculous posture, his small eyes so enlarged by fright that they protrude from their sockets. These are monkey faces aping man, but this is not what we are looking for. And to make the gesture more disconcerting still, out of spite, some of these obese street porters carry their heads in their hands! As with the first Han, we are reduced to seeing only the face of a Hsiung-nu barbarian!

And yet on these very same pillars—specifically, on the inner side of the left-hand Shen pillar at Ch'ü-hsien—there does exist a perfect little statue of a man with a sweeping gesture and thorough equilibrium. Though of minute proportions, it stands out in such relief that we need not hesitate to describe it as carved in the round; and although it has suffered, the movement of its lines is worthy of many of the most celebrated attitudes in the most sculptural antiquity. It is the "archer" on the left-hand Shen pillar. Barely as big as one's hand. Barely visible from the ground. You have to erect a sort of scaffolding and climb more than nine feet up the pillar to see him. Even then you are still below the level on which he is supposed to be standing. But since the summit of the pillar slants, you can throw back your head to maintain a decent parallel relationship and look at him, see exactly what his attitude and volume are. Any attempt at mechanical photography is vain: there is no light under the overhanging roof. Seen from below, he is a mere point;

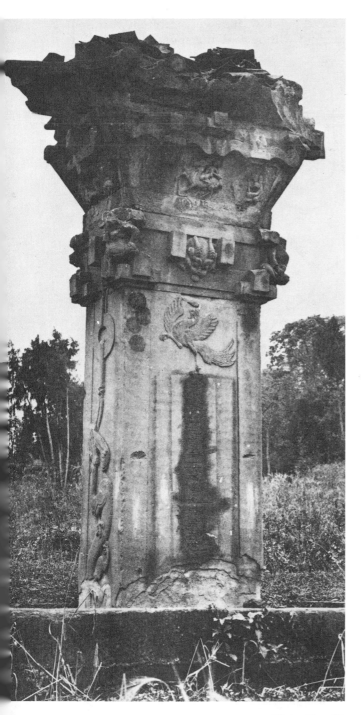
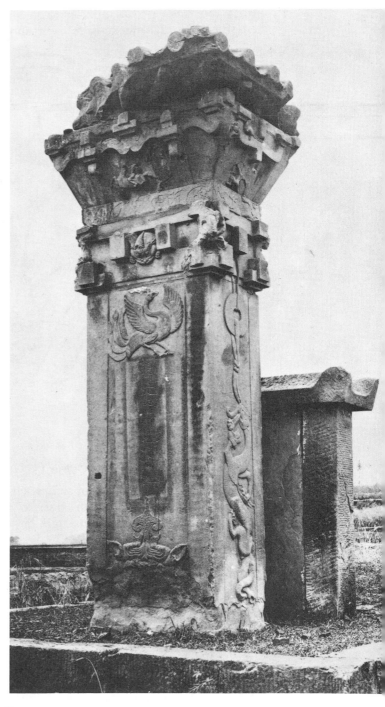

Plate 14. *Shen pillars.*

from too close up, a monster. You simply have to draw him very carefully, without emphasizing any one thing, without foreshortening, without any nonspontaneous stylization (K).

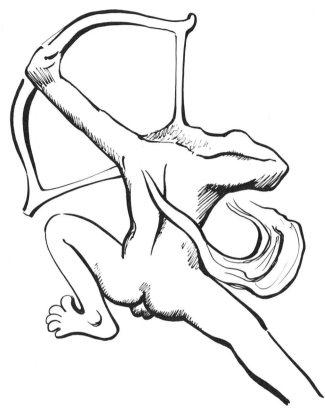

K. *Left-hand Shen pillar. Inner side. Barbarian archer.*

This little man is an archer. His target is high up, in the upper left-hand corner. In his left hand he grasps the heart of the classic Chinese bow: the same circumflex for three thousand years. With his right hand, or rather his right arm, or rather with his whole body, all the force of his back, he is stretching the bow, about to let fly. The gesture is assisted by a sort of sack or wallet that describes a countereffort on the same side, augmenting and offsetting on the right the curve of the bow. The missing right foot was placed vertically, sturdily; the toes of the left foot, which is disproportionately visible, are spread out and attack the very surface of the pillar. Everything about him is stretched taut. The arrow is about to fly. It doesn't matter what its target is. Perhaps the bird that is still decipherable under the small beams? It doesn't matter. Nor does it matter that another figure to his right makes so imploring a gesture that the hands, the great awkward hands, are all that remain of him. The taut little archer is quite alone amid erosion. And the relief of him which persists is a fine achievement in sandstone.

But the Shen archer does not—any more than the atlantes and grotesques do—give us any human expression, neither classic nor Chinese. There are several reasons for this. First of all, he no longer has a head. But you do not notice this until you think about it, so complete is his gesture as an archer, so well-balanced his way of taking aim and making that effort. Then, judging from his enormous foot with the widespread toes, we can suspect him of being a barbarian archer and—like the victim of Ho Ch'ü-ping and the porter of the pillars—still another Hsiung-nu. Lastly, because he is visible only from the back.

It is true that that back is perfectly and thoroughly executed from top to bottom. The shoulders, the muscular ridge all the way down the backbone, the hips forming two sturdy, supple masses, the well-marked waist, the sinewy buttocks and, finally, suspended immediately below them, the instruments of the most robust virility—all this gives us a decisive idea of the attributes that the sculptor in the time of the mighty Han so readily assigned to his animals, even when legendary, and to his human beings, even when barbarian. What would he have done if he had had to depict the genuine son of Han, the Chinese man in all his strength!

Plate 15. *Right-hand Shen pillar. Front. Red bird.*

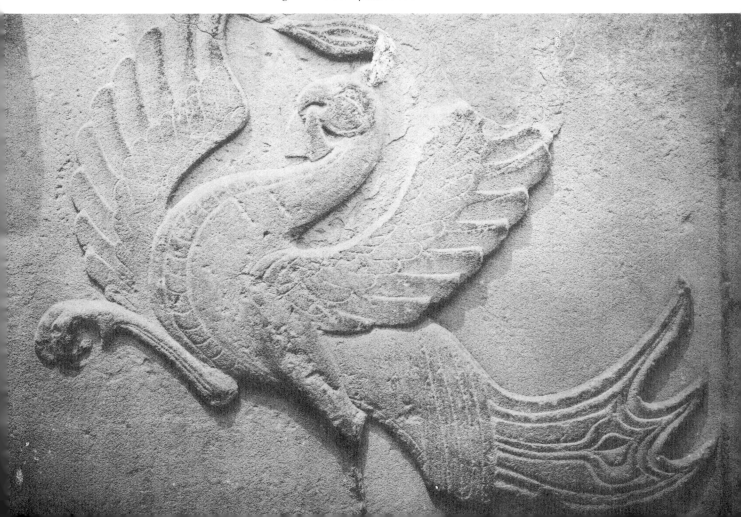

Very near this perfect image of a man—minus his head—on the same Shen pillars is a masterpiece of winged elegance, a fine example of harmonized distinction between beak, feathers, and vigorous limbs. I am talking about the phoenix or, better still, the red bird of the Shen pillar (Plate 15).

The whole beast is sturdily poised on one foot, the rough tendoned foot of a fantastic gallinaceous fowl, as on toeshoes. This is where the symbol starts.

The body is powerful and arched. Even a bird is endowed with the handsome feline arching of the Han beasts. The head is drawn back in deliberate anger, and this movement is matched by the rear portion of the body, by the four trailing feathers of the tail.

Forwards, first of all, there is that right foot which is flung out and up: a clenched, clawed, round fist, a bird's talon with its hard, glossy tendons, the claw of a fighting cock—half scaly like a serpent, half stringy—terminated by that shell-shaped node which our own stone-carvers handled so well in the thirteenth century. And the bird's fist, the hard, clawing gesture, is flung so far out that it overflows both line and relief.

The drawing of the two wings is very elegantly done. There is just barely what is required for flight, if necessary: a row of quill feathers and a fringe of secondary feathers, but the equilibrium of the curve in which they appear is such that flight itself would be superfluous here. The beak of the haughty head grasps a sort of crumpled emblem whose meaning I do not know, and the head itself is topped by a crest pointing forward. The ocellated tail, with its single great median eye and its three horn-shaped tips, offsets the chest and the right fist and right wing. The whole—body, feathers, tendons—is poised on that pointed equilibrium: the stump of one powerful leg, a pillar in the center of the pillar, which in turn is perched exactly above the line of characters, the calligraphic column that from top to bottom of the shaft is formed by the double series of the names and titles belonging to the deceased Shen. But that latter equilibrium belongs perhaps to a subtler, purer art, the art of the brush. My business here is merely to put in its place in space the carved sculpture that I am discussing.

Seen from any angle, from the standpoint of any art, the Shen bird is a fine example of fulfilled energy. Later we will have to look for its funerary, ritual, and intellectual symbolism. The texts call it the "red bird." It would be no insult for us to call it a "phoenix." It is better just to contemplate it in the pink sandstone whence it emerges and where it has been strutting for nearly two thousand years.

It then becomes disturbing. Should we really consider it a *great* statue? Its degree of relief is very slight, hardly a finger deep; and yet its lines suggest possession of space rather than linear art on a flat surface. As such, it brings us irresistibly to that other art, the art of the brush which, since we do not allow it to enter in here, must be put back in its proper place, all on one level: that of the *champ sur champ* bas-reliefs of the small funeral chambers and certain decorated surfaces on our pillars: the famous Han pictorial scenes.

The handsome "red bird" is on the borderline between the chisel and the brush. We would have no reason here to be concerned with the brush were it not that for over thirty years this art using flexible bristles was confused, for lack of anything better, with

that of chisel on stone. So it must be dismissed from a topic where it had occupied a position it did not deserve.

In 1881, the doctor attached to the English legation in China, S. W. Bushell, drew archaeologists' attention to the ancient Chinese stone bas-reliefs in the funeral chambers in Honan and Shantung, but no serious work was done with them until Edouard Chavannes came along. What he published about these monuments, although it was flawless as to detail and exegesis, had a misleading title: *Stone Sculpture in China at the Time of the Two Han Dynasties*. For, in fact, only one of the dynasties, that of the Later Han, was involved, as successive investigations by the same author proved. There was no going further back than the date of A.D. 147. Above all, and graver still from the standpoint of vision as such, of art criticism, there could be no question of sculpture.

Regardless of whether we are talking about the funeral chambers in Honan, or the motifs on the pillars in that same province, or certain episodes depicted on the flat surfaces of our Szechwan pillars, they all present the same process, emblematic figure, and justification: a linear art, an art of drawing. The lines are represented by a flat furrow one or two millimeters deep in a stone surface that is also flat. While the material used is the same, the origin and the outcome are totally different. Even assuming that the worker who held the chisel was the same in both cases, there is still this flagrant, fundamental difference: the first group (the free-standing statues, powerful bas-reliefs at the summits of pillars) proceed from the three dimensions that they need in order to exist and be; the others (bas-reliefs in Honan and sides of pillars) require only two dimensions: a flat ground. We have every reason to be certain that the line on the flat ground, which the mechanical chisel is going to follow, is nothing other than the line that fell from the bristles of the brushes held by the great master calligraphers.

To go from the one to the other or to confuse the one with the other seems just as grave a thing to me as to imagine that a serene and handsome statue, sovereign over our physical space in length, width, height, suddenly wishes to accede to the fourth dimension.

So it is eminently logical to postpone for a discussion of the great art of the brush what is geometrically reserved for it.

This, then, is what the Great Han bequeathed us, or at least what remains of the Great Han on the surface of their ground, without making any guesses as to their promising subterranean depths. It is an art unknown to earlier or subsequent ages, unknown to our Western civilization, whether classical or barbarian; an art which, until there is evidence to the contrary, we can and must consider purely Chinese, purely expressive of the genius of Chinese antiquity.

There are two sides to this art, corresponding to the epochs of its existence. The first Han, who are represented by only one statue, cannot claim to exemplify a law, a generalized style. But we must note that that statue is logical in its sculptural definitions: archaism and symbol expressed in a single static gesture. Only the opposite would have been startling.

Let us take the second Han. With their dynamic animation, their gracefully

vigorous types of posture, the choice of their favorite animal, the feline and, among the felines, the most feline of all, the winged tiger, the second Han, on the contrary, show their characteristics, their gift for the most intense life, life that surrounded the dead and, far from insulting, revived them. We have clearly seen that all of these sculptures called "funerary" because they were made for dead men, these sculptures that stand guard over tombs and were commissioned and paid for by dead men's heirs, speak not of death but of life—exuberant, exorbitant, wildly enthusiastic life, a life of fighting, hunting, and doing battle, solar life and earthly life, life of acrobatic games and entertainments, life of riotous movement—but also a chaste life, where the woman is not actress but spectator, the man is immensely virile, and male animals carry the escutcheon of their masculinity taut beneath their bellies. Life of creativity and combat, a life so animated in its stone that despite the gritty crumbling of the sandstone in which it was expressed, we still find it, so ardent and precise that even the least Han gesture—the arching loins of a feline or the way a man's shoulder is thrown back—is unforgettable and can be divined in even the most decomposed shapes. Frenzied life of the Hou Han, decadent but ardent. Powerful, sturdy life of the first Han, ancestors and founders.

Here then, just as they are to be found, just as we found and drew and sometimes recomposed them in their curves and gestures, are those stone creatures, the erratic witnesses of all the sculpture that was done throughout the four hundred years when the two Han dynasties ruled over a hundred thousand square leagues of surveyed land. What are they? I have just described them. Where do they come from, these most ancient of the statues known in China? Either from Chinese ancestors or from very distant congeners, forebears through western or since-lost alliances. . . . This question is not appropriate here in these chapters of vision, of direct observation. What we know about the statuary of the Great Han that is positive, new, and truthful must end here.

Posthumous Continuations of the Han
The Chin: A Vacuum
(Third and Fourth Centuries)

In the period between 220, when the last of the second Han succumbed, and 265, when a single empire was again founded by the Ssu-ma family in a reassembled China, men fought and devoured one another—but nobly. This was the famed period of the "Three Kingdoms"; every Chinese bookworm is familiar with its legendary adventures, the chivalrous romance of it, but the historic version of it is part of the most authentic historical sequence. China was divided at that time into three provinces, three empires; split among three kings, three emperors, all of whom took themselves seriously, were three kingdoms: Wei, Shu, and Wu.

As we have linked the Shu kingdom, called Shu Han, to the second Han, we have just seen how it stood: a vast area in Szechwan, weak regressive politics, strong, abundant statuary. It has the virtue of having preserved the name of Han. It is a son of Han kingdom.

As for the Wei kingdom, to the north and east, we will see later what new destiny it was to know, what an astonishing mishap it was to suffer. The kingdom of Wei doomed itself to a marginal existence in Chinese history. It was soon to betray all of China, go over to the foreign presence body and soul, heart and soul, heart and mind. It was to become the promised land, in full flower in the midst of what we must call and consider China's major heresy, her fault, her slavery: Buddhism.

There remains the kingdom of Wu—classic, filial, its immense tradition a force for continuity. For the first time, the seat of a kingdom was situated south of the Great River, as if classical China, a product of the north and of the Yellow River, was angered by the dangers that had come from the north and took shelter behind the gigantic gap formed by the river that we call the Blue River, but whose real name is Ta Chiang, the Great River, or, more decisively, the River, without any adjective.

The Ssu-ma of the Wei kingdom set to work so well—was it the *feng shui*, that mysterious, scientific, real geomantic power of the winds and the waters?—that in approximately four decades they absorbed and destroyed the other two kingdoms and could profitably, safely call themselves emperors. Genuinely Chinese emperors, with the dynastic name of Chin.

First of all, the Chin could not do otherwise than to settle in the same place as the second Han: in Lo-yang. These were the western Chin. From one dynasty to another, one stage in time to another, there was a repetition or recurrence or imitation of the same history, the same stories, often even the same anecdotes. Just as there had been eastern Han, so there were eastern Chin. And it was these who retreated, these who finally fell back on the haunt of all the Chinese dynasties that had been thoroughly vanquished: the region south of the Yellow River.

But this is immaterial to us. I do not know why I am lingering over the somewhat shameful acts of a family that slipped away and fled, and whose greatest claim to glory is perhaps the fact that it bore the name of an illustrious historian: Ssu-ma Ch'ien.

The Chin did not leave any trace in the orderly series of great works of statuary. We do not know—or, to put it more fairly, I do not know—of even a single stone statue, whether handsome or ugly, which could unchallengeably and justly be ascribed to the years between A.D. 265 and 420, that is, during the reign of the Chin. The only equivocal fragments that dare to refer to this period are merchants' lies, mistakes made by slightly naïve collectors, or decisions by those who label museum exhibits. In the procession of great Chinese statuary, the name of Chin is like the empty, dark hole that represents our solar nebula on a chart of the heavenly bodies.

Doubtless there are excuses, the poorest of them being a principle of acting economically. To justify the Ssu-ma family, we could bring in texts that would show that out of a sense of decency and upon imperial order, statues were not to be used so prodigally henceforth but were to be reserved solely for the emperor. Unfortunately, the emperor himself was in as straitened circumstances as the others; if we follow him —renascent phoenix of the mandate—from Lo-yang to Nanking, we find spare, bare tumuli. In this unhappy (worse still, unlucky) dynasty, we find the deplorable example of an emperor who answers his family, when they implore him for protection, "I who am emperor am as poor as you."

That apparently is the final word. But, on the other hand, there is an unexpected awakening: while during the period 265 to 420 (from the end of the Chu Han to the established throne of the first Sung) there is nothing to say about what the soil of China itself has to offer us, the tributaries of China, the neighboring countries that touch on its borders, reveal an extraordinary wealth. I am talking about the recent finds on the fringes: in Annam, to the south; in the mysterious country of Lob-Nor to the northwest; and to the northeast, in the hermaphrodite soil of the great kingdom of Kao-li, in Korea. Paradoxically enough—and this is only the first paradox—although China is laconic and mute as to details, at the same instant in time, though thousands of leagues away in space, decorative art begins to arouse our interest.

In Annam, tombs are excavated more freely than in China itself, and while they may not yield up violent sculptures, they do at least bear the undeniable stamp of a prolonged era, the era of the Han. We find the same human figures, the same animals, the same monsters or merely four-footed beasts; and in the brick of these tombs, we see what are obvious though rough reflections of that vigorous art of life that bears but one name throughout all of our ancient China, the name of the Han.

To the northwest are the adventurous colonies, the closed regions, drainage basins, witnesses of the mighty ancestors of Chan Ch'ien and Ho Ch'ü-ping. We catch sight of strong, athletic gestures in the clay, but these are only glimpses, only debris. In the loop of the Ordos, we find the vestiges of a whole erratic civilization.

And in Korea, finally, another projection, of the same type as a banderole streaming on the air far beyond, far above the heavy rocks. But this is to be said with words and cannot be expressed by stone: this is great art, the genuine article, the greatest art of the brush.

There is only one name we can put on these floating streamers, and that is the name of Han.

The Liang Wild Beasts
(Fifth and Sixth Centuries)

Once the Chin were quite dead, the great dividing-up took place. For the first time in 2,500 years the empire, that unique land, that celestial heritage, that undivided orb under the heavens, was split between the sons of Han and the barbarians. The latter, the T'o-pa Wei, held henceforth all the northern territory, the atavistic valleys of the Wei and the Yellow River, the lands the most steeped in the ancients, the tombs that were the most Chinese. They also—and this was the greatest tribute they could pay to their forefathers —took over or accepted the customs, spoke Chinese, and, decked out in masterly cast-off robes, acted out the great drama of the rites to perfection. But more unluckily, they brought certain beliefs with them, because their caravans had traversed the corridors of black Turkistan; and although those beliefs were not new to China, they were enhanced by an embodiment in stone which was totally unknown in China. It is through that imported art that we will be obliged—but not until the next chapter—to include those barbarians in this book on Chinese stonework. We shall include them the better to exclude them from it.

Very fortunately, other princes, newcomers to the empire but pure Chinese, maintained the great dynastic tradition. They had taken refuge to the south, behind the vast estuary of the Great River, which, for the second time, formed the rampart of classical China. History very rightly refuses to the northern peoples the role of passing on the Mandate of Heaven, which passed from the Chin to the Sung, the first of the "southern dynasties." Involuntarily but inevitably, the Sung transmitted it to the Ch'i, the Ch'i to the Liang, and the Liang to the Ch'en. But the four southern dynasties that, in the space of two hundred years, were to succeed one another on the southern throne—the only legitimate throne—formed a single epoch. Despite their savage dissensions, their arguments and murders and intestine usurpations, their emperors were linked by one and the same power. They fought with and devoured one another, but their fighting was a family affair, and they fought much better and just as ruthlessly against the foreign invaders. It is to them that we owe that Chinese continuity of history in this unhappy, divided period. In the south, they formed a classical, homogeneous whole and had but a single capital: the city we call Nanking today, the aptly named "southern capital;" during their reign, it was known as Chien-k'ang or Tan-yang. Uniting them still further was the fact that two of

these dynasties, the Ch'i and the Liang, had more than a political relationship: an actual family bond that gave them both the same patronymic name, Hsiao. And in the center stood out the personality of this Hsiao, the Liang prince, stronger than the predecessors he brought down, more convincing than the puppets who followed him. Acceding to the imperial throne in the year A.D. 502, he named his dynasty after his principality, Liang, and was the pivotal figure of this whole era.

This man was the foundation, as it were, of all that was to come. He was not the first but the strongest. Without him, the history of Chinese statuary in the sixth century would amount to nothing more than a few grotesques. I propose adding his name to this style and this era, that of the Liang, by adding, "of the ancient family of Hsiao." In this way, the traditional Chinese chain is intact.

Like the name of a landholder in the European heraldic nobility, Hsiao is a name derived from the soil. The name of Hsiao was born at a specific point on the soil of the empire and is continued down to our own day (in Chiangsu, the present province of Nanking, there is a subprefecture called Hsiao-hsien, subordinate to Sin-chou) but, to make them more noble still, the Hsiao claimed to trace their ancestry back to the Flood—i.e., in China, to the tribute of Yu. Moreover, the dates are there to bear very precise witness to this. Their ancestor, say the chronicles, was Ti-k'u, emperor from 2436 to 2366 B.C. Ti-k'u is somewhat legendary, but his Biblical contemporary, Abraham, did definitely exist, the Jewish annals affirm. And just as we go down the tree of Jesse, branch by branch, and the list goes on and on—Isaac begat Jacob, Jacob *autem genuit* . . .—so we can trace through the texts, not Hebraic this time but Chinese, not translated but in the original tongue, the lineage of Ti-k'u down to Chung-yen, 1100 years B.C., and then to one K'an, eighth generation descendant of Chung-yen. Military fame began with K'an's grandson, Ta Sin, who, as a reward for some success, was named feudatory prince of Hsiao and who passed on this name, which had become a patronymic; but it was not until the Han dynasty that historical glory and fortune appeared. We have already seen that, after the Ch'in had collapsed, there was a race for empire, and how the Han dynasty's founder, by manipulating the masses, the peasants, and the bourgeoisie, won that race. He had excellent friends, including Hsiao Ho. In exchange, he appointed him minister, and from then on, the family's fortunes never declined. From the Han to the Chin and then to the Liang, the Hsiao successively occupied good positions as ministers, notaries, imperial tutors, censors, "officers of grand merit," prefects, doctors of all kinds. In this way, the great tradition was not abandoned; and although this does not redound to the credit of Emperor Liang Wu-ti, a self-made man, it does show how he could lay claim to anything and everything in a country where the valet of a monk (Hung-wu) was to become emperor. This rapid ancestral survey has been intended solely to clarify Liang Wu-ti's real rights to uphold the descendants of archaic China solidly against the foreign north.

Toward A.D. 490, the Hsiao, both father and son, needed to display their hereditary talents. Their relatives were already reigning and were known as the southern Ch'i. Another Hsiao, the prince of Pa-tong, rebelled. The emperor, Ch'i Wu-ti, made Hsiao Shun-chih, the then prefect of the capital, responsible for making the rebellious kinsman listen to reason. Which he very successfully did.

This was not the first time that Hsiao Shun-chih had served the dynasty; he may even have helped it to win the throne. And as he came into greater and greater favor, his titles rose accordingly: he was successively minister, commander of the bodyguards, tutor to the crown prince, general-in-chief, prefect of the capital; and when he died, in about 492, he received the doubly appropriate title of "general and pacifier of the north."

Especially in China, the death of a father is the official occasion for a demonstration of filial piety. "Now, nature had endowed the future Liang Wu-ti," the texts tell us, "with very profound filial piety. When he lost his mother at the age of six, he renounced all elaborate or dainty food, as a sign of mourning. For three days, he did nothing but lament and weep and suffer excessive sorrow. When his father died, he was adviser to Prince Sui, whose court was located at King-chou, in Hupei Province. The sad news was not yet confirmed, but hardly had he learned it than he abandoned duty and ceremony and was off as swiftly as a shooting star. Neither sleeping nor eating, he traveled in stages double the usual length. Neither the fury of the wind nor the dangers of the storm deterred him; not for an instant did he stop. He had always been healthy and robust. But when he returned to the imperial capital, where his father had died, he became so thin it was frightening and was little more than a skeleton. No one could recognize him—neither intimates nor relatives, colleagues or friends. At the sight of the home wherein lay his father's mortal remains, he fainted away and remained unconscious for a long time. With each lamentation, he spat several *shen* of blood [a rice measure, containing a little more than a quart]. For the duration of his mourning, he would eat no rice, only two *I* [half of a *shen*] of barley flour a day. When he visited his father's tomb, he shed tears and vomited blood and wherever these fell, the plants and trees were so moved that their leaves changed color."

With his father dead, the future emperor perpetuated the family tradition, which was to battle for the dynasty with his cousin, whom he had placed on the throne, and to battle determinedly and gloriously. He forced the formidable Wei to respect him and stifled rebellion within the empire itself. But if it is true that a worthy son must outdo his father (which is quite legitimate because he honors him by doing so), Hsiao Yen* aspired to much more than a title of "pacifying general." He wanted, personally, to teach the emperor a lesson by placing the emperor's own fifteen-year-old brother, on the throne. This was in the purest Chinese tradition: one does not stand forward oneself, one has a representative. One never usurps the throne, one covets it. The faithful generals rejected him and put up resistance. They were defeated. The emperor was assassinated by a "traitor" and Hsiao Yen's protégé became emperor. So fully was this acknowledged as pure Chinese and therefore human tradition that the empress mother named the powerful minister duke of Chien-an, then duke of Liang, in recognition of his traditional merits. He politely refused, in return for which he was officially made prince of Liang. Again he refused, but for decency's sake had to accept. Now, twenty-four days later, the emperor abdicated. The new prince dutifully resisted at first, but, urged by all of the officers, pressed by an imperious and formal order from the withdrawing emperor himself, he obeyed and

* Name of Liang Wu-ti before he acceded to the throne.

accepted the dignity of his imperial position. The accession to the throne took place on the day of the fourth moon of the year 502 (April 30) and, as was only fitting, "amid universal joy."

No emperor was ever more hereditary, more imperiously sought than this one. Through his distant ancestors, he belonged to antiquity. The Han dynasty, which was the Chinese dynasty *par excellence,* had given his family historical glory; his father had offered the throne to the predecessors, the Ch'i, his relatives, whom he was succeeding. What could be more purely Chinese?

He carried on the tradition. To begin with, he raised his father to the rank of the nobility, and his ancestors with him. Thus his father, Hsiao Shun-chih, became emperor and dynastic head, under the name of T'ai-tsu. His mother became empress, as did his wife, who was already dead. His deceased elder brother, Hsiao I, was made a prince. Then, having dealt handsomely with the dead, as was only right, he took care of the living: all of his numerous brothers were made princes and when any of them died, he was treated as such, honored by a princely burial place. How very lucky that they were numerous! It is to them that we owe the fine statues which honor that era.

With all the powers that the throne conferred, Liang Wu-ti proved to be a just and powerful emperor. Having devoted the first day of his reign to honoring his father and mother, he dedicated the second to making himself secure. On that second day, he had the ex-emperor executed, he who had abdicated in his favor and hoped thereafter to lead a modest existence under the name of Prince Pa-ling. In so doing, Liang Wu-ti conformed to the most universal tradition. Then, and again as it behooved him to do, he carried out reforms worthy of a great prince. The scholars and the wise men who were living in concealment were sought out and covered with honors. Schools were built. Confucius was given temples. The emperor displayed all the aspects of the great Chinese prince: good minister, good warrior, good scholar who drafted his edicts himself and found in poetry a refuge from the crushing cares of power.

For nearly fifty years, this powerful, firm, and expansive reign continued over an empire as extensive as the difficulties of the times allowed. The territory was enormous, taking in first of all the luscious valley of the Yang-tz'u, all of southern China, and seven fine territories in Annam. To the west, few historical indications, but this pillar at P'ing-yang, right in Szechwan Province, which we discovered and which is overengraved with the mark of Liang Wu-ti, 529, clearly shows that his empire extended that far. This man did not reign over classical China, but he did at least reign classically over the richest China.

From one end of his life to the other, he was indeed a classically Chinese emperor. He took in everything: accession, reign, power. And every act accomplished during his lifetime was to be represented in various aspects of the figures that his epoch bequeathed. Point by point, it was all to be made glaringly obvious and explicable in palpable sculptured shapes. His words, his acts, his deeds—likely to rot in space as does a formerly living body, buried in the earth—are marked by great statues crystallized in the fine gray marble veined with red and white, black and deep in the rain, which time has polished but scarcely worn.

Of course, these are funerary statues once again. The tombs of the Liang, scattered over the countryside in that northerly-bulging loop formed by the great river between Nanking to the west and the old city of Tan-yang to the east, inhabit the imperial soil of the Hsiao and mingle with the living.

Their statues are now in the middle of fields, surrounded by the growing crops, half drowned, up to the chest in the rich loam, with stalks slipping into their armpits and their wings; or else in the villages, imbricated in farmyards, sheltered under haystacks, among implements in daily peasant use, covered with manure or rubble or fallen stones and earth, smothered in household rubbish—or else all alone in deserted fields, real classical ruins.

Where the Liang tombs are concerned, we do not find any sepulchres or bodies, or any more than in the Han tombs; the tumuli themselves have disappeared; but as with the tombs of the previous era, there are animals and stelai. The funerary pillar is replaced by an unfamiliar, unexpected monument: the fluted column.

The Liang "animals" fall into two categories, which are as different from each other as one could imagine and are never confused: chimeras and winged lions. The chimeras seem to be reserved for the tombs of persons having actually or nominally reigned, such as Emperor Ch'i Wu-ti or Liang Wu-ti himself. There is also a chimera on the ruins of the tomb of Hsiao Shun-chih, father of Liang Wu-ti, on whom the son bestowed the imperial title as soon as he had taken possession of the throne himself.

The chimeras are large (nine feet long) and monstrous-looking animals, with large, scaly, horny, even misshapen heads on thin necks; a goatee joining the jaw to the chest; a long body more like a dog's than a lion's; and short legs with five claws. On top of that, there are wings, little wings, pinions, arabesques, protuberances, and embellishments everywhere: on the jowls, the neck, the flanks, the squamous spine, and the hindquarters, which droop like a limp carapace, with folds and festoons. . . . The overall impression is graceless. And it is very displeasing to find, so early on in the history of this art, so little time after the Han, so far back in tradition, the ancestors of our contemporary bric-à-brac, pagoda, knickknack monsters. . . .

For despite all their efforts to frighten the beholder, with their jaws open, their ill-fitting carapaces, their heads swollen with self-importance, their little snub noses, their stupid ugliness and self-satisfied air, the chimeras of Ch'i and Liang actually rank as very poor sculptural achievements. The elongated saddled body does not express any muscular litheness but rather a lax softness. Both the forequarters and the hindquarters are thrown outward, with neither predominating. Both ends of the beast seem to show off breasts and rump with the preening assurance of a "well-turned-out" parvenu old lady, bedecked and protected with awkward ornaments, stiff corset, and hat. Even the wings themselves are frills and furbelows. We get a clear impression that the intention was to place armor over the limp, low loins. Instead of making the beast hold his head with dignity, the sculptor raised and enlarged the head, replacing an air of intelligence with a hydrocephalic attitude. The beard is carved in such a way as to leave a disagreeable aperture between it and the rest, a useless triangle in the sky. Everything about it seems to be a trick that can be taken apart—the head appears removable, the armor droops, the

pedestal needs only wheels to become a toy, and even the sex, though male, of course, seems an accessory out of place below the belly of this out-of-breath dowager.

In other words, nothing about it is plausible. We can hardly cast this as a reproach upon an animal that has never lived, since simulating life is one of the most serious blunders that statuary commits; but there is such a thing as a statuary existence that is superior to life itself, and these animals do not have it!

Of the half dozen animals that remain, four have been overturned and are scarcely describable. Those that I show in Plates 16 and 17 are dated from the death of Ch'i Wu-ti, A.D. 493, and from the construction of Liang Wu-ti's own tomb. The first one has lost its left foreleg, but I doubt if that limb, even if it were present, could compensate for the overall appearance. Seen from a certain angle, certain details are handled with *brio*, as if the tool was having fun. But I deplore the composite order of the whole.

Plate 16. *Tomb of Ch'i Wu-ti. Chimera on the left. Profile.*

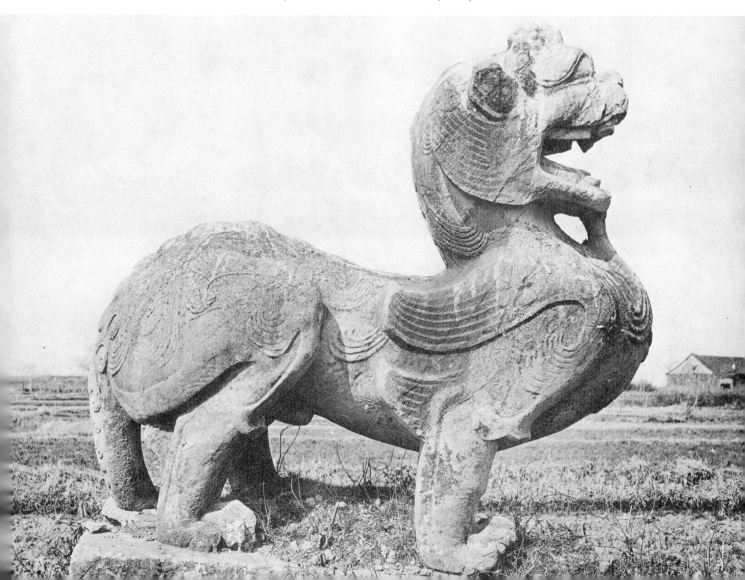

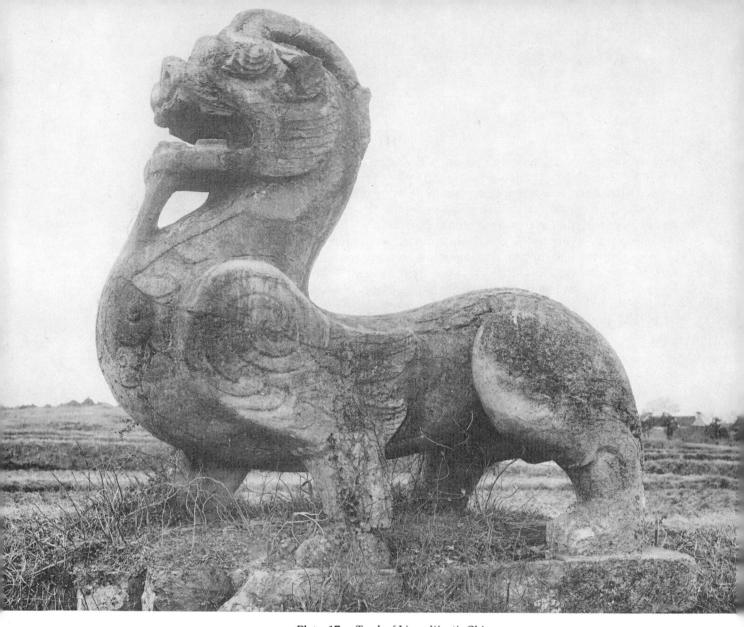

Plate 17. *Tomb of Liang Wu-ti. Chimera.*

And as for the chimera of Liang Wu-ti, a glance at figure 28 is enough to see how comical and ridiculous it is. I must add that nonetheless these beasts were viewed with a certain degree of admiration by the Chinese. Father Mathias Chang, who calls them "winged horses," finds that they "are rather grand-looking after all" and "seem to give off quite a rare impression of strength and life." Little more than a stone-carver's plaything, they are like something out of a vague treatise on "comparative art." These are the first extravagances of the Chinese chisel, the first subsisting samples of that polymorphic, whimsical, multishaped, and shapeless beast that the Chinese texts call chi-lin—a name which I have not translated but replaced by "chimère," "chimera."

The words *chi-lin*, which necessarily appear here for the first time, have been given countless interpretations. Translating *chi-lin* as "unicorn" does not explain anything; defining the *chi-lin* by means of commentary on the texts is a perpetual game of wordplay that leads nowhere. Some believe the *chi-lin* is a stag; others, a horse.

Doubtless it is somewhat demanding of us to look for plausibility in the anatomy of so implausible a monster, but these contradictions are found only in the texts, and here we are dealing with statues, with a rather silly but perfectly defined sculptural type. The word "chimera," an excellent term from our venerable French bestiary, and which does, after all, designate a monster with a goat's head on the body of a winged lion, seems to me to be the best term, not for translating haphazardly the term *chi-lin* but for giving a French name (*chimère*) to these beasts that present themselves to us, defined and all alike: the chimeras of the Ch'i and the Liang.

They would not have sufficed to make of this era a great period in Chinese statuary if the emperors of those days had been the only people to die and have decorated burial places. Here is where the copious Hsiao family reappears in a very timely way. All around Liang Wu-ti was a swarm of brothers, uncles, cousins, nephews, grand-nephews. . . . As his fortune grew apace, so did theirs. When he became prince, they rose several ranks higher in the hierarchy. When he became emperor, he made them princes; and because he was lucky enough to be endowed with longevity, he gave them all princely burials. It is to that family that we are indebted for the majesty, the power, the perfection of a statue which no ensuing dynasty was ever to equal or even be capable of repeating: the great winged lion of the Liang (Plate 18).

The lion is the appanage of princely tombs only. In terms of the aesthetics of that period, it was preferable not to have reigned, for the tomb of a prince was distinguished by a more sovereign form than the tomb of any of the dying sovereigns themselves. It forms the most powerful statue in space that exists today anywhere within the entire Chinese empire. There is no hesitation possible here: this beast is no longer a chimera, even though it never was a living animal, with bones, flesh, hide or hair. It exists and it is eternally leonine, more leonine than a real lion.

I counted thirteen of them, four of which were wholly preserved; the others were partly broken, tumbled from their pedestals or sunk up to the chest in the loose soil where they seem to be navigating furiously. Not one of them is like any of the others. Their state of preservation varies: some are whole, forbidding, standing; others are fragmentary, chipped, dismembered; and one of them lies upside down with its pedestal in the air at the bottom of a gully. But all of them are derived from a single module, a single type, the type that I have called the great winged lion of the Liang.

I will describe it briefly in these words: a large supple animal over nine feet high, its body describing a pronounced arch, its muzzle yawning as widely as it can. At the top, two blunt points, the ears, blending with the mane, which falls backwards in two powerful ovoid masses. To the front, the muzzle is framed in a conch, which is separated from the ovoid masses by a superb keen edge, a clear-cut curve that gives the whole beast, whether seen in profile or from three-quarters or from any other angle, and the carriage of the head their character, their elegance, their imposing presence, their statuary cleavage in space.

The two pectorals of the enormous rounded chest are separated by a deep groove that thus forms, frontward, two other ovoid masses that offset the two buttocks of the mane. The head is always slightly oblique, and its gaze, as we shall see later, is directed at the person approaching it. To suit the direction of that gaze, one leg is thrown very

obliquely forward, while the other is poised slightly to the rear. The animal is always ambling or, more precisely, half ambling. The hindquarters are supple, less bold than the chest, elongated, and the belly is round and quite firm. The backbone is indented rather than salient, thus extending the groove of the mane all the way to the rump. A mighty tail falls straight as a column and curves up when it touches the pedestal.

The overall attitude is twofold: the neck and head are strongly arched; and the weight of the entire animal is leaning, through the oblique gaze, toward the approaching visitor, and is carried on by the projected forepaw and the rearward projection of the rump. On top of all this, the ornaments. Some of them are purely decorative: elegant arabesques, festoons, large floral designs; two of them are symbolic: the wings, which are not really intended for flight in this case but are simply attributes, robust, solid, integral parts of the statuary block of stone.

This, then, is the great lion of the Liang; but the type, the very specific module of this lion, was not servilely, mechanically repeated. Every one of the thirteen beasts I saw has its own individuality or, better still, bears the mark of the man who carved it—the hesitation, the awkwardness, or the sheer successfulness with which the chisel bit into the stone block. As many variants of this type were carried out as were animals; no two wings are interchangeable, and I would recognize every one of these lions with my eyes closed, just by touching its haunch. Furthermore, because of the prodigious oblique movement, there is no boring symmetry between the left flank and the right; the wings themselves are asymmetrical. Every shape, every surface retains its figurative egotism. Each of these statues is an animal moment petrified by the personal human gesture that carved it.

The examples of errors in taste are no less piquant than the examples of success. Let us look at both in detail.

The right-hand lion of Hsiao Hsiu (Plates 18, 19, and 20) is a superb animal —graceful, robust, and supple. If we view it in profile, we notice how the incurving edge of the mane fades away at the winged shoulder, which forms an S-like extension of the grand overall movement. The wing, with its three large quills and one small axillary wing, is fairly long, and the articulation occurs at the level of the shoulder by means of three quill feathers in the same style—large double commas—as those that decorate the rump, in two rows facing in opposite directions. The animal is buried up to its hocks, but I doubt that the fact of uncovering the buried part would add to the oblique movement that thrusts the hindquarters back. The line of the back is perfect.

The tongue is too flat; it makes a sudden angle where it sticks out over the teeth. Seen from three-quarters in front (Plate 19), the jaw is a little too square—the nostrils are comically joined to form a single hole—but the posture, the carriage, the swelling of the forequarters are noble. And, finally, examined from the standpoint of symmetry from three-quarters rear (Plate 20), the animal describes a very harmonious movement. First of all, we distinctly see the twin egg-shaped masses of the mane; the strong gesture at the shoulder of the right wing and the way that wing is joined to the mane; the way the weight is thrown on one leg (this very supple and very harmonious oblique gesture is clearly visible here); the left hind leg pushing the bulk of the body and the asymmetrical hindquarters responding to the effort that we can sense.

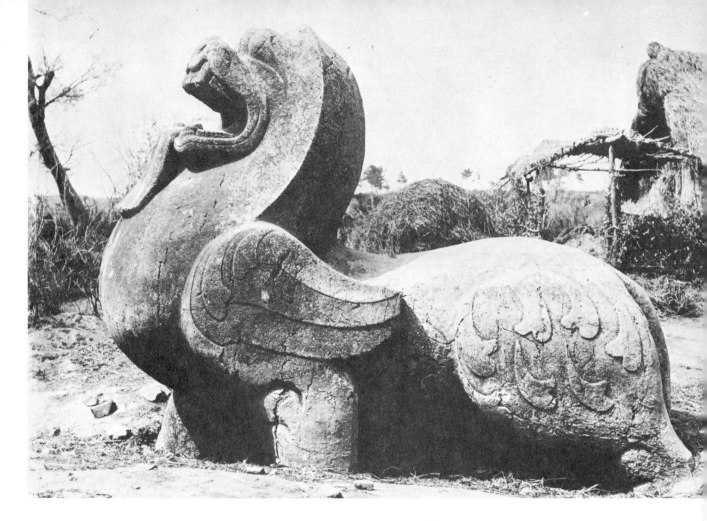

Plate 18. *Tomb of Hsiao Hsiu. Winged lion on the right. Profile.*

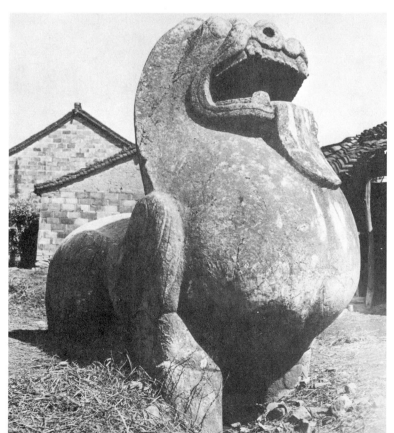

Plate 19. *Tomb of Hsiao Hsiu. Winged lion on the right. Three-quarters front.*

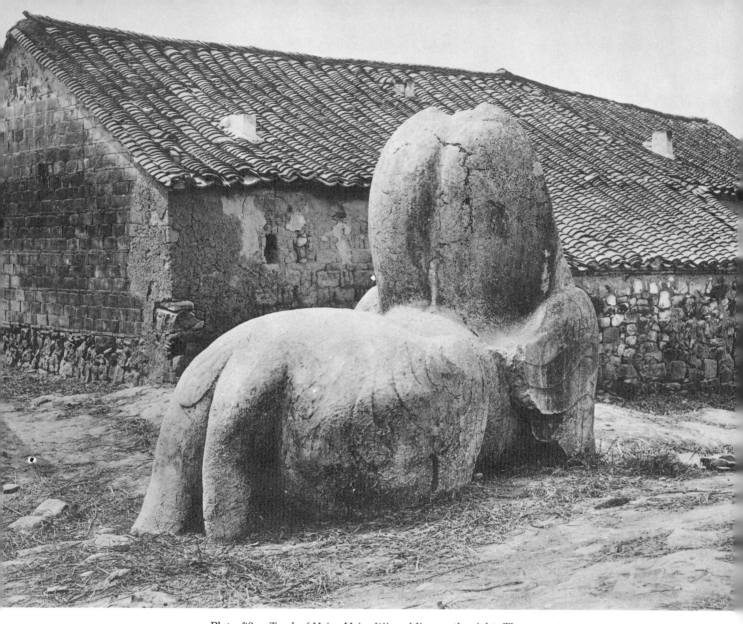

Plate 20. *Tomb of Hsiao Hsiu. Winged lion on the right. Three-quarters rear.*

The two beasts of Hsiao Hui (Plates 21 and 22) are not so well-preserved. The one on the left has a long, supple position that the lesser degree of arching elongates. The one on the right is somewhat heavy but powerful.

One of the animals at the tomb of Hsiao Ying has suffered worse treatment (one oblique section of the nape has fallen away, and the general lines are a little worn), but its posture, amidst the cultivated fields that drown it, is fine, and was worth saving. This one is arched and does not have the same oblique posture as the others; its head does not so much turn toward the approaching visitor as it leans to one side. The bulk of the body itself, though weary, remains handsome.

The two lions of the tomb of Hsiao Chi at Shih-shih-kan (Plate 23), though better preserved and standing freer of the soil, are also the heaviest and coarsest of all these animals. The one on the right is as clumsy as a peasant who doesn't know which foot to

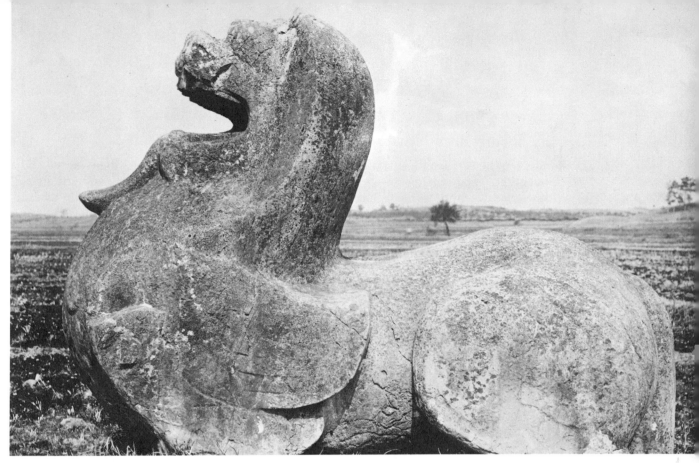

Plate 21. (above) *Tomb of Hsiao Hui. Winged lion on the right.*

Plate 22. (below) *Tomb of Hsiao Hui. Winged lion on the left.*

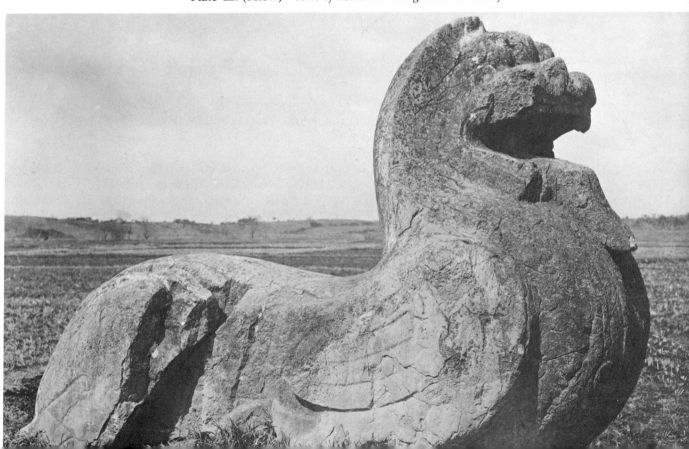

stand on. The left legs are straight and massive, badly squared rather than carved. No "movement," no "placing of the weight." The animal looks approximately straight ahead with a massive and self-satisfied air. Its companion to the left is heavier still, obese, asthmatic, though bathed in air down to the paws; it hasn't so much the lion's strength as the seal's unexpected gracefulness.

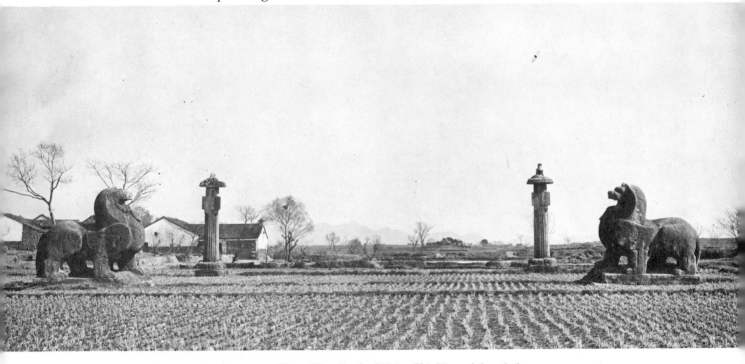

Plate 23. *Tomb of Hsiao Chi. View of the whole.*

But I show them here because of the fine ensemble that they form, with the two columns, intact, and also so that I will be sure not to leave out any aspect, even the least flattering, of this horde of varied wild beasts.

I also include the picture of the lion of Hsiao Hung, which I found, upside down (Plate 24) in a gully, fifty yards to the north of the stelai and columns marking the burial place of that prince. A stream that swelled a drainage canal undermined the earth beneath the pedestal and tipped it over, burying the head. It appears to have all the features of the other lions of its family—arched posture, wings, tongue. We might deplore the fact that it lies that way rather than standing in its original position, but, upon closer analysis, we note that the head is too massive, the neck too long, the wing fairly well-shaped but too heavy, the tongue curt, the legs absurdly short, the rump graceless. And we conclude that the lion of Hsiao Hung, the least handsome of all, shows good taste in lying upside down, and that it is better not to turn its picture right side up, even though, instinctively, the reader has already done so.

Plate 24. (above) *Tomb of Hsiao Hung. Lion upside down.*

Plate 25. (below) *Tomb of Hsiao Ching. Winged lion. Three-quarters front.*

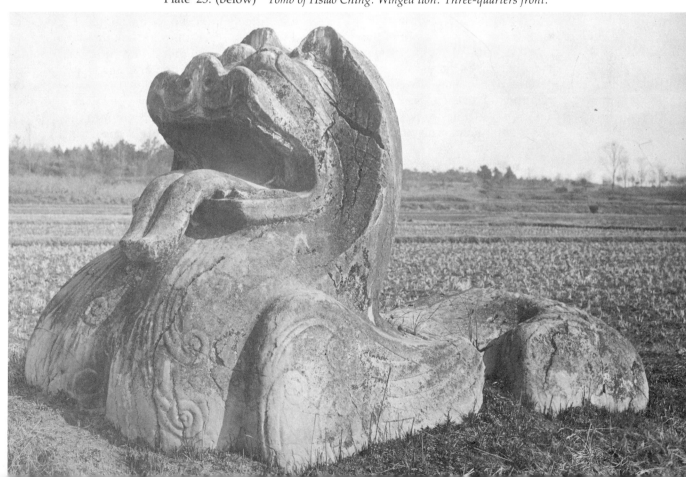

I shall end this appraisal with the lion of Hsiao Ching (Plate 25), which is also the first one I saw. I shall never forget the imperious, decisive, fearsome, total stance in which it appeared to me—one hour's walk in the evening rain from the great earth bank that rings Nanking for a distance of twenty leagues. The wet marble was black; the earth, ready for germination, was brown and russet. The lion had been navigating, rearing rebelliously, furiously, for fifteen hundred years, struggling against submersion, with that haughty "Liang movement" so clear that ever since then, and even at a distance, before I have made out a statue clearly or actually seen it, I can recognize it.

This posture sufficed unto itself, and I had no wish to have the statue dug up. A crack visible between hindquarters and wing and a place on the rear where the stone is chipped reveal that under the earth it is doubtless not intact. Spiral ornaments spill onto its chest, and the deep medial groove exaggerates the two powerful pectorals and projects them forward. It is here especially that balance is achieved between the upper concavity and the solid convexity. The right profile reveals another and equally successful aspect. When the animal is seen from the front, and particularly when that large head is seen from very close up (Plate 26), the full sculptural achievement which that mask and that physiognomy represent becomes apparent.

The first thing we notice is the tongue, whose complete, fleshy, voluptuous curve was pleasant to touch. It is muscular and, like the back and the chest, it is divided by a groove into two masses. The inside of the mouth reveals an agreeably made concavity, where the texture of the marble, intact after fifteen hundred years, is still visible. This tongue does not stick out of the mouth and then drop, as it does in the other beasts, but is thrust out flexibly, strong and sturdy, and as muscular as all the rest of the animal's stance. The opening of the mouth itself is not so square as that of the lion of Hsiao Hsiu and forms part of a curiously stylized mask: those two flat spirals encircling the nostrils, under protuberant eyes. Certain sharp and well-placed features—such as the way the gums outline the strong, broken canines—show the care and polish that went into the details of this monumental sculptural whole. This lion's mask remains one of the most potent animal faces I know of.

Thus, the type of the great winged lion of the Liang does not, in its various forms, adhere to a single module. At the time when this sculptural form had just won preeminence, it lent itself to individual variants. Some of the "pieces" we have just described are not altogether satisfactory. But like the experts on cathedrals, who would take the choir of Beauvais, the nave of Chartres, and the façade of Reims to form the paragon of the perfect church, in the same way we, by putting together along ideal lines pieces that are not disparate but simply scattered in geographical terms, can express with words what may have been achieved in stone and say that the finest winged lion of the Liang would, in the superb perfection of its form, have possessed the body, the chest, the hindquarters, the general air of the right-hand lion of Hsiao Hsiu, and the mask of the lion of Hsiao Ching.

That would have formed a masterpiece of colossal statuary—which may have existed, and may still exist—smothered, subterranean.

Plate 26. *Tomb of Hsiao Ching. Winged lion. Head.*

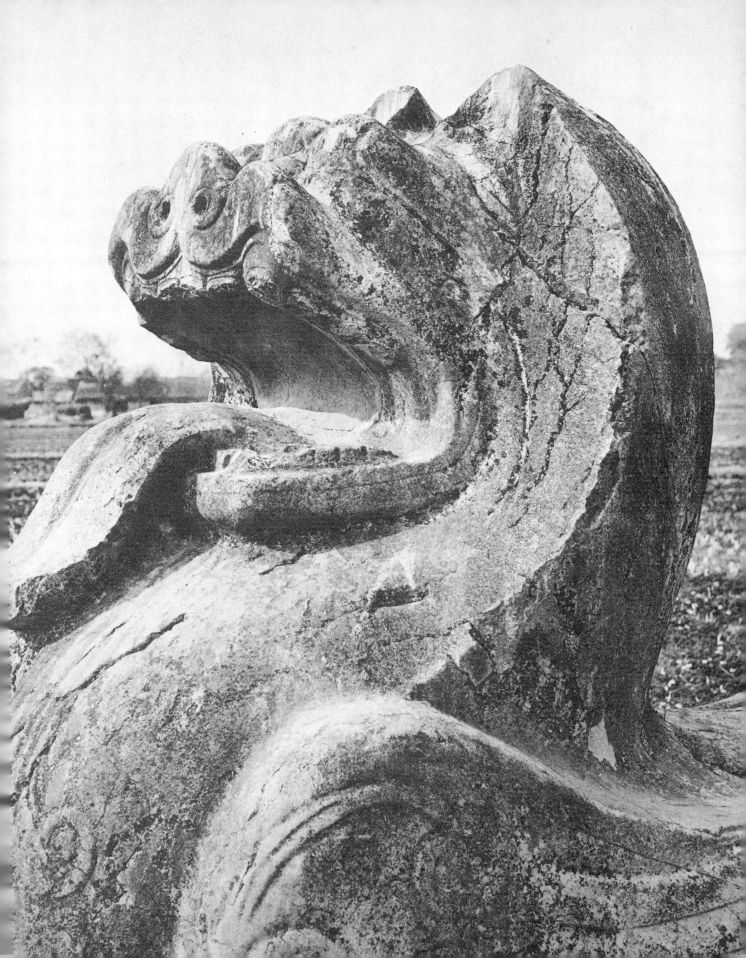

I have said that the chimeras seem to have been reserved for the burial places of emperors, while the winged lions were set aside for tombs of princes only. Each of these animals is characterized by specific attributes, in addition to the overall air and the aesthetic result: the chimera has a protuberant, scaly spine, while the lion's backbone is an indented groove; the chimera is horned, keeps its tongue inside its mouth, and has an inappropriate beard that joins chin to chest, whereas the lion licks its torso; finally, the chimera carries its head high, while the lion's head is withdrawn, back as well as up.

So I was somewhat surprised to find, at the very spot where the chronicles said that the tomb of the emperor Ch'en Wu-ti, buried in 559, existed, a pair of animals that were obviously neither lion nor chimera but the bastard, ill-shaped offspring of the two: the son of a Ch'i chimera treacherously fecundated by a Liang lion! These animals have a backbone that is neither hollow nor convex but smooth. They have no neck, only a mane; the tongue remains in the mouth, but a heavy stud forms a beard and joins the chin to the chest. The rump and all the lines in general are limp, like their mother's. Like any bastard, they are not at all good-looking; and as happens in any cross-breeding, one of the animals resembles the mother and the other the father.

The left-hand animal (Plate 27) has something of the leonine type, but its movement is heavy, despite the very oblique placing of the legs. A thin tongue lolls over the monolithic goatee rather than on the chest. The tail is grim and the spine smooth. Two small, soft ears, like a lion's; but the posterior groove between the two masses of the mane does not begin until the bottom of the nape. The wing is coarse and flat, without quills.

The animal on the right (Plate 28) looks like an aged version of its mother—the fate that alas! awaits any girl! The head is much higher, the neck less arched; only a disagreeable vertical edge recalls the lions' handsome curved edge. The tongue, of which the goatee is a continuation, reaches the chest. No doubt about it: the animal is a caricature of its mother as a stiff old lady.

So in a matter of thirty years, and from the beginning of the ensuing dynasty, this culmination of the two Liang types, of the two specimens of the Hsiao family is completely decadent, in the worst way: not through an exaggeration of certain forms but through mingling of them, out of failure to understand the established types.

I do not really know whether the mason who carved these two figures out of the same gray marble veined with white or red intended to make chimeras or lions; perhaps the mason himself did not know. But slackness, ignorance, the rapid decline of tradition led him into a regrettable compromise. I propose naming these unnamable creatures the bastards of Ch'en Wu-ti.

And yet the recollection of the winged lion of the Liang is so strong that in spite of everything, even these degenerate descendants, when seen from certain angles, retain that handsome arched posture; and seen from a distance in the open countryside, they are still impressive—compared to the forms that come afterwards.

Of the four southern dynasties, the three last have just shown us their monuments, the witnesses to their style. There remains the first of the four, the Sung dynasty.

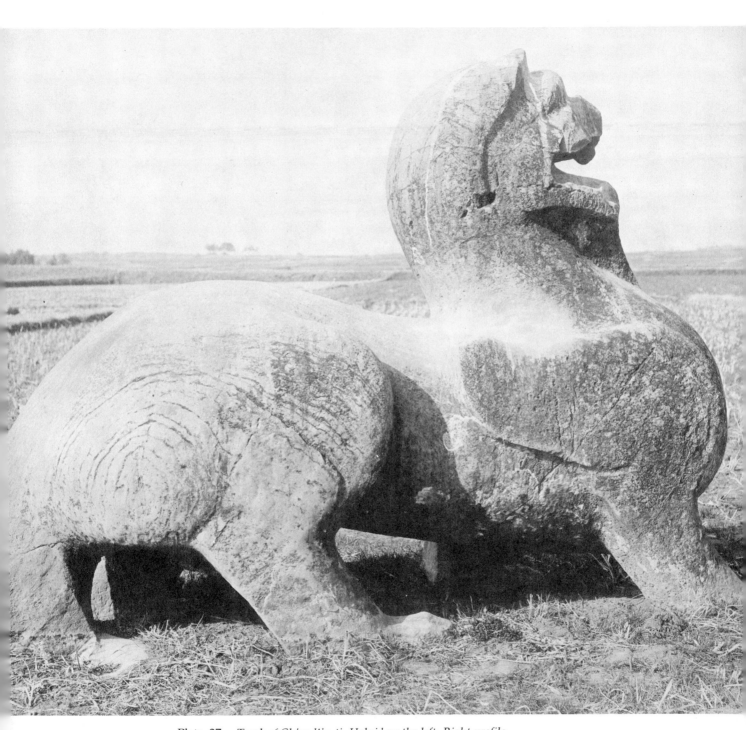

Plate 27. *Tomb of Ch'en Wu-ti. Hybrid on the left. Right profile.*

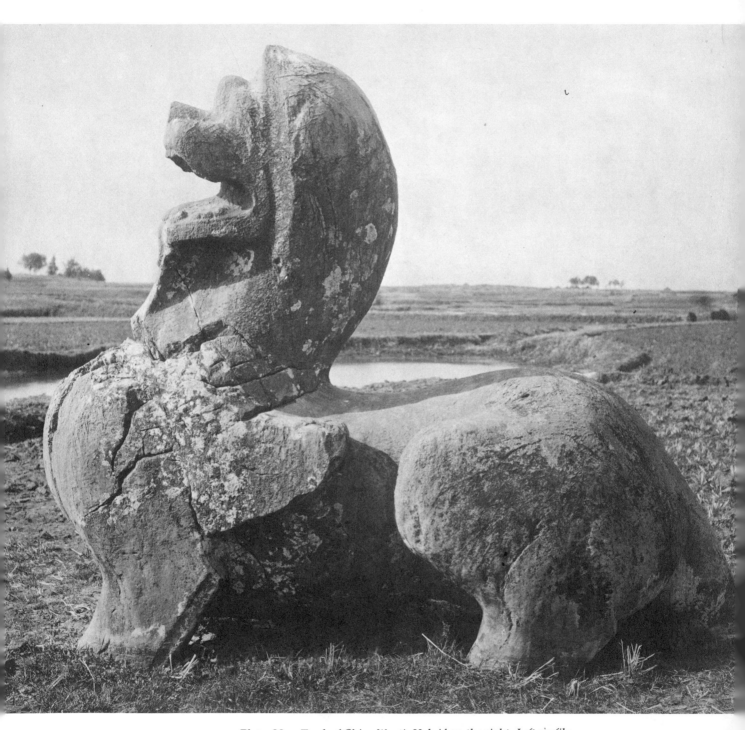

Plate 28. *Tomb of Ch'en Wu-ti. Hybrid on the right. Left profile.*

Every Sung monument must have been erected earlier, and may have constituted the origin of those that followed, but we had not seen a single sculpture dating from the first Sung. We knew the precise name of their burial place: the Tomb of Eternal Tranquillity. Its "historical" if not its "geographical" site was known. The way in which and the date at which Sung Wen-ti had been assassinated were also known, but not a stone from his monument remained. None but Chinese eyes had as yet beheld a figurative Sung relic.

And yet the chronicles indicated that near the Chi-lin-men gate, two stone animals were still visible. Other texts said that one was to the left of the road, the other was drowned in a pond.

The Chi-lin-men gate is one of the passages, formerly heavily guarded, in the superb earthern levee that surrounded the great capital city of Ming T'ai-hu (the Hung-wu who is so well known to tourists, unfortunately). So we had to hasten to the Chi-lin-men gate, wondering all the while: is this animal, which preceded all those we have just seen and described, a lion or a chimera?

Judging from the ritual practice of decorating the tomb of an emperor with a chimera, this must be a chimera. But if the law that applies here is the oft-verified law of "ascending aesthetics," of greater ancestral beauty, then this ancestor will not be a silly chimera but a handsome lion. It is unthinkable that the compromise so unfortunately achieved, in the form of the Ch'en hybrids, fifty years after the lions of Hsiao Hui, should also have been realized fifty years before those same lions. . . . Which will win, ritual or the nature of statuary itself? And will the animal itself, which must be handsome, be a lion or a chimera? If it is ugly and grotesque—what a contradiction that will be of the law of ascending beauty!

Those were the problems that went through my head as we walked for hours from Nanking to the place called Chi-lin-men. Both promenade and problem progressed easily through rolling, inhabited countryside, suburb full of souvenirs of the huge capital that was and that is no longer, that is now only like a great empty water skin. When we reached the Chi-lin-men gate, there was nothing. Not a single stone, not a shard. We had to turn northward, follow the earthen levee for two more *li* until we came to the village of Chi-lin-men-hsia. There at last, submerged, drowned, buried up to the shoulders in a heap of rubble, garbage, tiles, and broken pots, in a wasteland surrounded by houses to the left of the path, we found the chimera of Sung Wen-ti.

For a chimera it undoubtedly was. The princely, imperial law on which we had relied had been observed. The head, which was partially broken or, rather, knocked off, had disappeared; a hollowed-out goatee joined chin to chest. No mane. The spine was not represented as a groove. All that was still visible certainly belonged to a chimera. The ritual, honorific principle was safe; and there was a still truer, still more remarkable thing: the law of aesthetics was likewise confirmed. For this chimera was handsome!

This is what I was able to affirm after some hasty unearthing. A few blows of the pick cleared away the rubble and bricks. The gravest obstacle we faced was a flood of abuse hurled by an honorable dame who owned the site, the debris, the rubble and the nearby house; she bitterly complained that our grave-digging would seriously compromise the drainage of the dirty water from her house. But as our gravediggers were well-paid, they

smiled and went on digging amid the flood of reproaches. And little by little the left wing, that fine piece of stone shown in Plate 29, emerged.

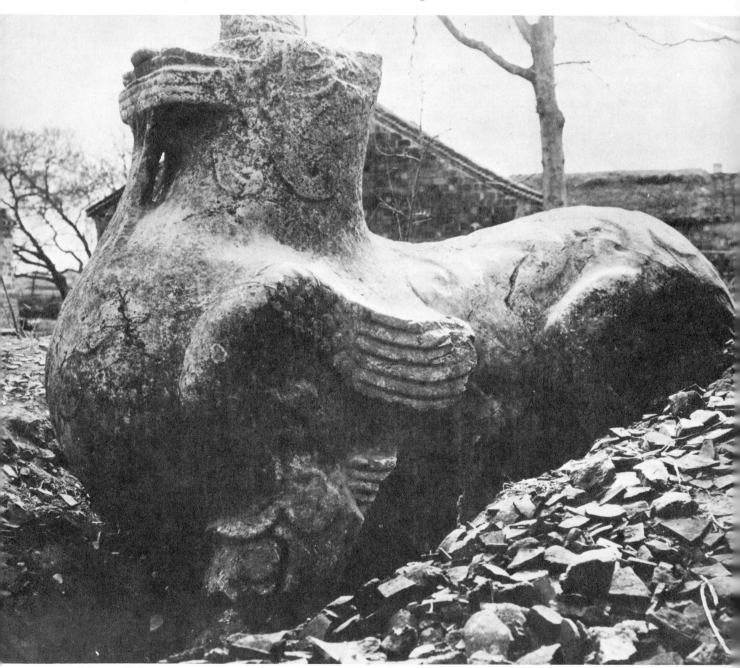

Plate 29. *Tomb of Sung Wen-ti. Chimera. Left wing and chest.*

The style that was immediately revealed was less polished, older, more noble, archaic in every respect. The type is primitive, that of an ancestor.

Undeniably, the neck is not as powerful or arched as in the leonine type, but neither is it as frail as the "chicken necks" of the Ch'i and Liang creatures. The broad chest bears wide, flat spirals, firmly and boldly outlined, which hang down from the head. The neck is linked to the back by a good, flexible line as well as to the chest with its billowing but firmly contoured swell, which succeeds in being round without being soft.

The small, flexuous tongue does not protrude from the mouth. The lower jaw is rectangular. The thinness and uselessness of the small goatee, which is very flattened out from front to back, are redeemed by the evasive manner in which it spreads over the chest, where it dies away in three wide, rich spirals.

Before examining the upper jaw, the forehead, and the crown and back of the head, we first had to find them, some paces away in the mud. Adding to the impression of archaism was the fact that the animal was not monolithic; or else the head had been broken and had had to be made again. But all of the sinciput was added, poised on a vertical stud that gives the animal that skeletal, stripped, fleshless air. A few steps in front of it other parts were buried: the rear part of the brain pan, the long ears turned obliquely to the rear, with little wings that were hollowed out rather than carved away from the overall volume. All the rest of the muzzle was missing.

The right wing, the forward third of which is squamous, then divides into five or six quills indicated by hard shutterlike striations; but the left wing, with the whole left flank and the forward-stretching foreleg, which is visible right down to the claws, form a superb piece of work.

This wing is not clapped on but very elegantly turned, capsuling the entire shoulder. It is attached, not to the forward hollow under the elbow but, rather, to the point where the shoulder juts out, which it envelops and caps with a remarkably supple movement. Squamous at the beginning, the wing is continued by six large quills, clearly distinct, yet at the same time related to the curving whole, formed by back, flank, and belly; the elegant torsion on the surface is a supple and very pleasing movement, no matter what angle we view it from. This is possibly the most "statuary" solution to what I call the "problem of the point of attachment of the wings of flying monsters."*

At the shoulder, which is thus enveloped, commence the twisted ornaments that reach down the leg: simple, full spirals that cover the elbow with an elephantine wad of flesh. The vigorous paw has five clawed digits. The rear part of the elbow and foreleg —clearly visible in Plate 29— is emphasized by a furrow that instills vigor into the roundish forms.

Starting at the elbow is a small five-quilled pinion, gracefully offsetting the wing. All of this flank, this three-quarters view from the front, is harmonious and supple.

The belly is firmly rendered. A broad, flat spiral starts at the wing and descends obliquely. The crease of the groin is clear-cut, elastic. The slightly swelling thigh pleasingly balances the concave form of the wing.

*See page 142.

On the back, starting from the spine, which stands out clearly but is discreetly molded and nonscaly, three broad volutes curve. This time they are not merely symbolic nor there just for show: they are part of the rippling of the muscles. The monster's hide appears to quiver in elegant whirls, just as a flesh-and-blood horse or bull or lion quivers or twitches at neck and flank.

When the beast is viewed from above, from the back, its movement is asymmetrical, shifted onto one leg, as in the handsomest lions. The left foreleg advances, the other is straighter, and the small of the back flexibly reveals the effort being made. That explains why neither the wings nor the flanks are identical, and justifies the fact that one of the sides is more lithe and pleasing to the eye. A clumsy or dubious sculptor, at a later time, would have carved them according to an identical model, making them superimposable.

The head takes part in the oblique movement by turning slightly to the right. The broad rump does not swell like a carapace.

And thus the chimera of Sung Wen-ti, the mother of the ridiculous objects carved in the days of the Ch'i and the Liang, forebear of the degenerate Ch'en hybrids, henceforth the known ancestor of all the frightening animals that invaded the Chinese bestiary, remains a great and noble statue, with its archaic lines, in the midst of that heap of rubbish under which the irate dame will doubtless have buried it again.

As the season was dry, the level of the pond was very low, and there we saw the other animal—similar but upside down and so worn as to be unrecognizable—that used to stand opposite this one.

A few paces away from the lions and chimeras, belonging to the same groups, are the stele-bearing tortoises. Noble and majestic beasts, elegantly stylized despite their imposing bulk; nine feet long, on a pedestal that measures nearly twelve, beneath a stele as high as the pedestal is long.

In life, the original is without doubt the sea turtle. Hence the fins-cum-pinions, the outstretched flexible neck, the streamlined head; but once the sculptor had rendered the features that were once essential to life, the rest was a purely plastic creation. A whole, an orderly conglomerate of beautiful curved surfaces, derived from ovoid shapes and neatly divided, by the stele as by a blade, into two masses; the rearward of the two spreads out the shell. The surfaces are superbly enveloped by the remarkably subtle way in which the sharp edges are cut away. Here it is the lifting, the edges of the shell that succeed to a rare degree in forming the decor. Nothing more; nothing but perfect balance and contour.

The neck, whose single movement is oblique, supports a small head which, though not monstrous, is beveled and incrusted with two large olive-shaped protruding eye sockets. There being only one known type of such tortoises, they are more homogeneous than the four-footed composite Liang menagerie. The one whose portrait I show (Plate 30) is the left-hand tortoise at the burial place of Hsiao Hsiu, the prince who possessed what was doubtless the finest of the lions. The date of this statue and of the stele it supports, A.D. 518, makes them the typical example of the vertical statuary of old China.

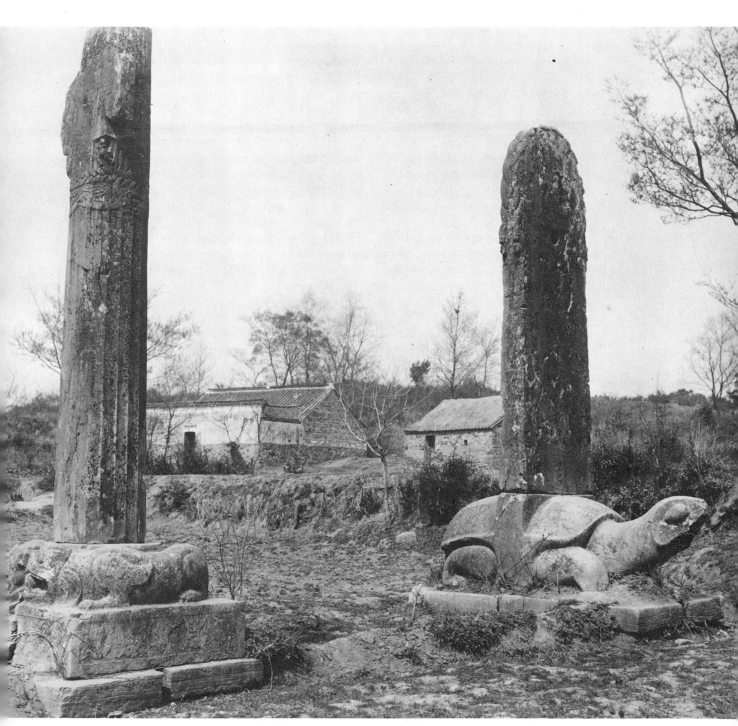

Plate 30. *Tomb of Hsiao Hsiu. Tortoise and fluted columns.*

The Han tortoise—unfortunately it is the only Han tortoise as yet unearthed—of the Fan Min stele is scarcely visible, worn and bruised, roughly but supply carved. The clumsy head is turned to the left. In this case, however, the animal—of outstanding stability—points straight ahead, like a promontory, a blunt prow pushing back everything around it, the frightful flow of mad time, the whistling of the eddies and the trickles and the waves of that impalpable water with its invisible surges: a whole fluid mechanism, so enormously dynamic that it is comparable only to another embodiment of unfathomed energy—to the tidal wave that incessantly strikes every thinking being full in the face and ultimately destroys him. It is only when we contemplate these monuments of the ages, this intelligent rock that constitutes a Chinese stele, this achievement of the brush sculpturally enhanced as to both monument and pedestal that the image takes on its full meaning, its true sense. I heard time pass and stormily roar around the body and head of the stele-bearing tortoise.

The Liang stele—straight, sharp, flat, thin—bears no useless ornament. Though carried by the tortoise, it also goes down lower than the tortoise, wedging it in, bearing down on the pedestal and, from there, on the ground itself. Its ornamental façade bears the immutable motif of the twisted dragons, the only one in this instance to appear on the slab. The stele is pierced by the enigmatic, archaic hole. Its contour is a pronounced trapezoid. As in the old days, the façade is semicircular. But there is one ornament, so to speak, one tablet, as plain as a signboard, with a relief of a few lines; it bears the name of the deceased and the mark of the Liang era. We were to find it again—in a much more developed, more surprising form—on the monument that we came upon at last, unexpected, unfamiliar, unexplained, so close to the tortoises and lions that it merges into their arrangement: the fluted column of the Liang.

This was a cippus between eight and ten feet tall placed on a composite base and whose summit was covered by a broad circular hat that we instantly recognize as a huge lotus flower spread out like a parasol, surmounted by a rearing lion cub, a smaller version of the beautiful Liang lion. Now this does not resemble any known thing anywhere, either in China to date or in any other country. The purpose was obviously to carry that

L. *Tomb of Hsiao Ching. Cross-section of the fluted column.*

ridiculous little label, that monolithic panel which protrudes from the shaft of the column about one-third of the way down from the top, where an inscription written in a suddenly singular way (see page 108) tells us the names and titles of the deceased.

 This forms an elegant, if not a perfect, whole. The column I am using as an example marks the tomb of Hsiao Chi, dated 529 (Plate 31), where the most obese of the lions, the seal-lions mentioned earlier, are also located.

Plate 31. *Tomb of Hsiao Chi. Fluted column on the right. Profile.* Plate 32. *Tomb of Hsiao Ching. Fluted column.*

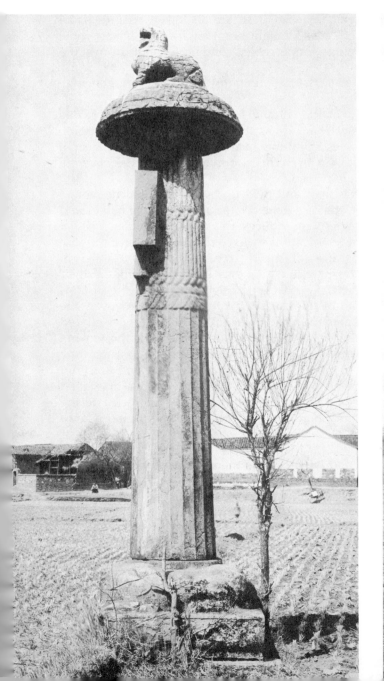

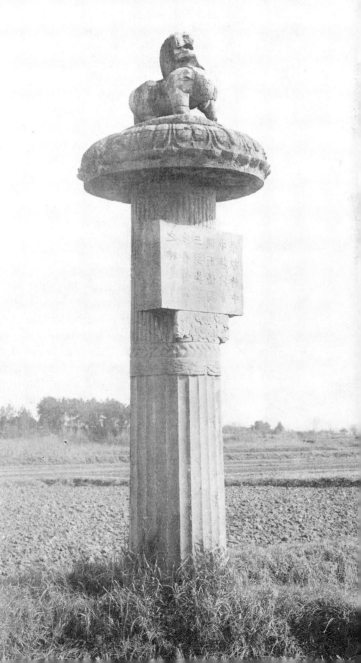

A good, smaller example of the cartouche and the lotus-shaped parasol, surmounted by the lion cub, is provided by the column of Hsiao Ching (Plate 32), thirty paces away from the superb mask of Plate 25. It is a well-curved block of stone, not fusiform but tapering like the trunk of a cone. The cross-section is always very deliberately the same despite the complexity of the curve. In (L), I show a faithful cross-section of it. Though it is a perfectly regular figure, it is impossible to put any simple geometrical name on it. It is close to an ellipse, since we can immediately see a large axis and a small axis. The large axis is always parallel to the way the deceased man's soul travels. So we can describe two large façades—front and exterior—and two lateral façades; these are all linked by four small sides—that, in turn, are linked to the four façades by eight blunt angles. The linear whole is achieved with a single gesture, continuous, impeccable, complicated but always the same.

The flutings, varying in number from twenty-four to twenty-eight, are noncircular grooves. They are perfectly executed.

At two different levels, the shaft of the column is circled by a double-braided motif. The lower one, which supports the cartouche, has the effect of suddenly changing the way the flutings face: each groove becomes a protuberance divided in two. The sheaf of broad grooves becomes a bundle of convex branches. This continues up to the second ring or circle and then disappears under the lotus parasol.

Fitted onto the second level of the shaft and held up by a decor which, though flat, provides as much support as a bracket, the cartouche (Plate 33) sets out the names and titles of the deceased. In so doing, it merely reproduces the arrangement of the flat cartouche on the façade of a stele, and this, which links the columns to the stelai in one and the same burial place, is logical, because of the degree of certainty, classicism, elaborateness, of written "characters" everywhere in China ever since the Ch'in and their beautiful *li-tz'u* writing. But here the characters are backward. Not only must the inscription itself be read from left to right, instead of the usual right to left, but, moreover, the characters themselves are reversed. For a genuine Chinese scholar, this discovery should have been roughly equivalent to discovering a whole world as seen through the looking glass. I am sorry to say that Chinese scholars have paid much less attention to it than the barbarian pilgrims (such as myself) to these ruins. This writing disturbs me and does not reveal its true message. And, yet, perhaps it was merely a stonecutter's idea of a good joke? Or a trick played by a "foreign" architect? This matter should be put back into the crucible and melted down again . . . but not here, in this book about stone born unto space.

We should add that from that latter standpoint, the shaft, the cartouche, the inscription as well as what supports them and what crowns them are perfect monuments, excellent, vigorous statues.

Immediately on top of the pedestal, which adheres well to the ground, is a quadrangular block; it is monolithic or, at least visually, a monoblock, but suddenly it is transformed into a torus, a ring formed by two animals winding around the base (Plate 34). It is from here that the whole column spurts, along with its shaft. Seen from the front—i.e., from the side of the column that bears the cartouche—these animals consist of

nothing more than two square muzzles whose jaws are crudely cut; each of them holds a ball between its jaws. There is total symmetry around a vertical, median axis. The heads are done in strong bas-relief and would seem—in fact, this is the first thing that strikes us—to form a vigorous theme for a coat of arms. But the powerful way the neck is drawn back and the angular position of each leg imply an overall movement, which, when unearthed, is revealed as a handsome one, lithe and vigorous. It is also resuscitated by a transposition of the overworn contours in a new, fictive volume of space.

And in this way, we finally discover a complete torus, geometrically defined as an infinite cylinder infinitely embracing the base of the shaft. The two squat but slender bodies, with their four feet and two wings, are organized from the taut tip of the hindmost toe—which is thrown out as far to the rear as possible, so as to lean more broadly on the like gesture of the other beast—to the tip of the muzzles that face each other. This effort, this double, hemi-circular thrusting, is handled perfectly. We can see how the accessories, the legs, the pinions, and the beards on the jaws are intended precisely to fill in the gaps and how they raise this peculiar problem: given a shaft whose cross-section is nearly an ellipse and which is placed on a circular foundation, relate it by means of some harmonious volume, derived from four-footed nature, to a cubical pedestal, and achieve this without any abrupt or surprising movement, energetically and supply. The problem was solved by means of this stone bracelet originating in an idea of flesh, this muscular collar filling this circular half groove, forming an embrace at once furious and stable, virile and complete, at the base of this strange and perfect monument.

There is some question as to what these handsome creatures are intended to be. As with the *chi-lin*, the denominations vary in Chinese, and misinterpretations of them abound. The most commonly used Chinese term is *t'u-lung*; translating it by "*t'u* dragon," dragon of the *t'u* species, is no more satisfactory than the scrambled Latin spoken by certain characters in Molière. The fact that they are winged and four-footed at the same time makes them rank among the monsters, monsters with large heads but elongated, nonserpentiform bodies: neither scales nor the continuous trunk, the elastic cylinder of the serpent's body nor the spiny body of the all too familiar Chinese dragon.

We cannot identify them by examining their three clawed digits or their flowing festooned tails; but the loins and back and the suppleness of the shoulders are once again those of a feline lying down. In terms of legendary fauna, these animals are the beautiful hybrids produced by a crocodile with a bulldog's head, fertilized by a very long winged leopard. The stance is undeniably that of a feline, and it is this which determines the dominant line—one of linking and coiling between the column standing tall against the sky and the horizontal, earthly block.

We find here, as with any Han statue, the four qualifications: monumental, funerary, historical, and imperial.

As for the "monument," the orderly whole of which these statues were part, it can be easily reconstituted in this instance. True, the monument to the dead man has itself completely disappeared. Of the twelve burial places revisited or discovered in the province

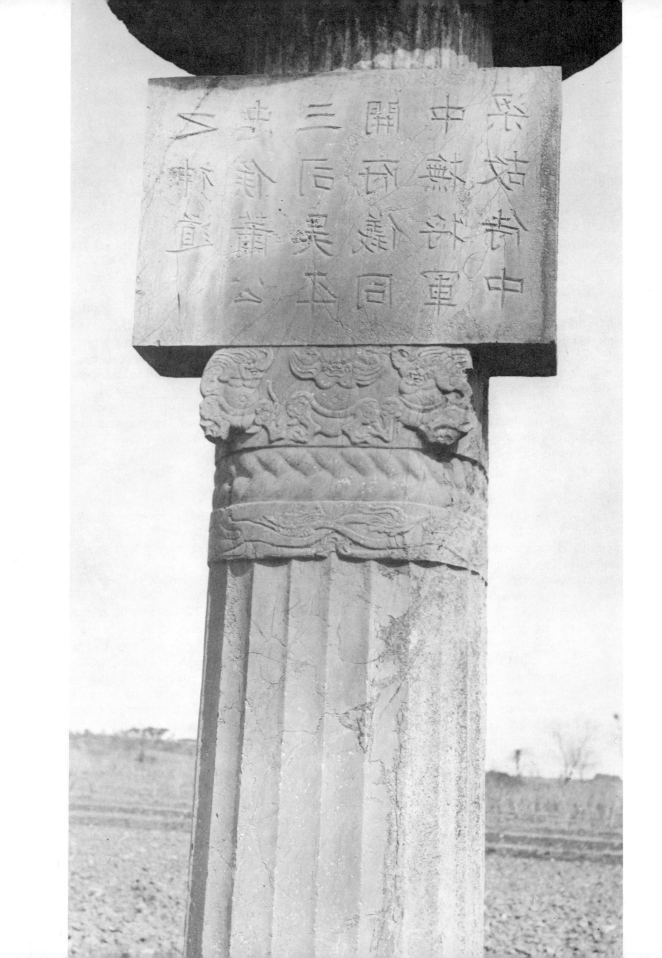

Plate 34. *Tomb of Hsaio Shun Ch'ih. Fluted column. Detail.*

Plate 33. *Fluted column of the tomb of Hsiao Ching.*

of Nanking, not one still has its tumulus; they were indicated only by their statuary and the inscriptions on their stelai and columns.

Consequently, I do not know of a single complete Liang burial place. Nonetheless, while the greatest caution is necessary when it comes to reconstituting a Liang tomb, we can imagine it thusly without making any errors except as to internal variations: a tumulus, one of whose sides is approached by a short, dense, well-provided avenue, always conceived as a double series of four objects on an eight-pointed layout. The tomb I am reconstituting is that of Hsiao Hsiu; six of the eight statues it originally included still exist, intact, and are placed as they were.

The tomb was probably oriented south-north, though this varied under the Liang. I will describe the entire tomb by viewing it in the most logical direction—that of the soul's progress. Every column, be it *ch'üeh*, pillar from the Han era, fluted column or stele in the days of the Liang, ends with these words, either in the inscription it bears or in the texts: *shen-tao,* "way of the soul." This "way" means the only one that the soul can or must choose so as not to be lost, regardless of whether it emerges from or returns to its subterranean site.

But I shall preempt the undeniable right of a living visitor to the tomb over that of the soul and shall consider that the person who contemplates these statues as he approaches them is walking *toward* the tomb. It is on the basis of this same assumption that the statues and the Han pillars already dealt with in this book have been described, and the statues at the tomb of Hsiao Hsiu will be situated in the same manner.

Two winged lions, one on the right (Plate 35), one on the left. The one on the right stands with his weight on one side, and both his neck and his gaze are turned obliquely toward the left; the one on the left, with his weight on the other side, is turned obliquely toward the right. Both are turned toward the approaching visitor.

This gesture, precise and subtle at the same time, is perfectly symmetrical; in order to follow the curve of his gaze, it is the right legs that the animal puts forward if he is on the right, or the left legs if he is on the left. This is important both in sculptural terms—because the result is a marvel of supple, asymmetrical curves—and in monumental terms, for we can see the role that the approaching visitor, the new arrival taking the place of the soul, plays in the way this cortege advances.

Next in the procession are two more stele-bearing tortoises. Then two fluted columns, then two more stele-bearing tortoises. All this fits into a small rectangle, and the overall impression, in proportion to the stature of the two lions, the height of the columns, and the mightiness of the turtles, is that the ensemble is too squeezed in. So many large and beautiful things in so small a space! It is true that there is no tumulus in the background to indicate the indeterminate but distant aim. It is also true that these fine statues lie surrounded, embedded in a little village, huge but precious stones in the midst of quarry stone already used for building or waiting to be used; that the contour of these mighty backs is obscured, cut off; that the lion cub on the right-hand column is worn away and overturned on a rubbish heap swarming with pigs and children, where it is a plaything for some and a source of fright to others. We might also add that the second stele

on the right is not pierced with a hole, that the level of the ground has changed so that the road and the main street of the village are now higher than the hindquarters of the tall lions, which used to stand out freely, and that the lions are buried in earth up to their hocks, but that there would have been no point in having them temporarily dug out. In order to reinstate the columns that have disappeared, it would have been necessary to raise up once again the fallen stelai, raze the village, and heap up the veritable tumulus of the Liang once again in all the vanished swell of its tumular art. Let others come and do it, using cardboard, or make a panorama out of it! Personally, I was content merely to imagine it for a few minutes, new and whole, as on the day the dead man was buried.

Yet, two days' march away from the last resting place of Hsiao Hsiu, prince of An-tch'eng, his no less princely cousin, Hsiao Chi, has still kept if not the entire decor of his tomb at least the most obvious parts of it, preserved in this case with fine symmetry: two lions—which are too massive—and two columns, intact (Plate 23). The traditional tortoises are missing. It is my hope that by reconstructing each tomb on the basis of the other, we will come to know what the genuine entrance by which the living visitor enters the way of the dead man's soul looked like. I have not aimed for anything more.

As we can see, the hundred or so monuments known to us from the Liang period—or, to be more specific, the ornaments of the tombs of the four southern dynasties from the Sung (chimeras of Sung Wen-ti, A.D. 450) to the Ch'en bastards (559)—occupy a period of exactly 109 years, a full, homogeneous period, dense and compact in both time and space. In the great division of China into north and south, it is only just that the southern dynasties, the genuinely dynastic link in the chain, should have caused the great statuary to proliferate around its Chinese capital, known today as Nanking. The fact that statues and burial mounds are accumulated in the countryside around Nanking and two days' journey on foot from that city is an illustration of reigning, imperial reason. If the ghost of the great warrior Liang Wu-ti is still wandering about the region, it can easily travel, by human means, at a mule's gait, from his own burial place near the ancient city of Tan-yang, to those of his cousins and nephews, to that of his nearby father, to those of the Ch'i, his relatives, whom he dethroned, and to those of the Ch'en, who dethroned him. It is possible, by leaving Nanking by foot or by mule at the first light of day and by scorning the brutality of travel by rail—although, unbelievable as it may seem, the train passes by exactly nine hundred paces from the most handsome of the leonine masks—to have peregrinated, before the end of the day, among the various places that are so rich in the statues that were so little known until now. You go beyond the first enclosure, the walled enclosure of Nanking, and you recognize the promontory of masonry and earth where Liang Wu-ti died. You then pass the next enclosure, the earthen levee, the vast roadway measuring two hundred *li* around, at the Yu-hua-men gate. The burial places begin shortly thereafter, in this order: Hsiao Ching, Hsaio Tan, Hsiao Hui, Hsiao Hsiu, and so forth. Coming back to the high roadway that, in one sweeping gesture, surrounds the capital and the mountain rampart, the mountain with its summit of purple gold, you follow it to the tomb of Hsiao Hung; a gray column in a clump of trees indicates its location on the plain. You come back to the levee until just before the "Chi-lin gate," Chi-li-men. There, in the little "village of Chi-lin," Chilinpu, lies the superb winged animal from the tomb of Sung

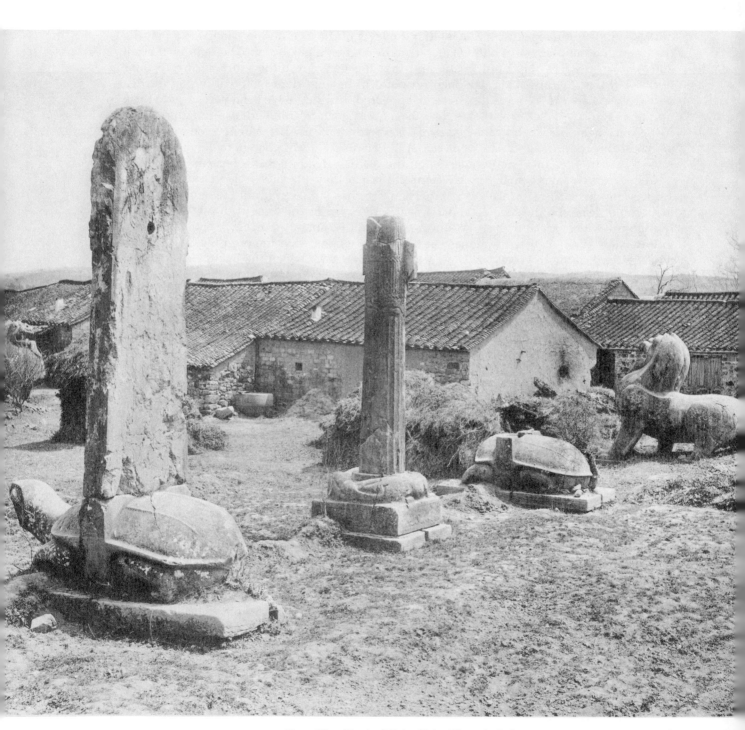

Plate 35. *Tomb of Hsiao Hsiu. View of whole.*

Wen-ti. In the evening, you come back by the imperial highway and the Chao-hua-men gate, having taken in, in a single day, the tombs of the principal burial places, including that of the youngest conqueror, Hung Wu, of the Ming dynasty, whose all too familiar burial mound with its too well-raked paths is the joy and honor of the guides who stop at its menagerie.

Carefully arranged in space, compactly grouped in time, Liang sculpture as a whole constitutes nonetheless a very mysterious episode in the great Chinese statuary. We now have to consider its origin. We have seen how logically it progresses: in the beginning, the archaic, liberated masterpiece; in the very center, the works that are already sure of themselves; finally, degenerate works, impotence, the end.

But where does this art come from? It is in China itself that we must look for Chinese predecessors to this great Chinese art. In the foreground, a breach, which was not irreparable, surely: that of the Ch'in. Further on, the distinct self-assured style of the eastern Han. Further still, the archaism of the western Great Han, which is unique of its kind. Now, the Liang style of statuary cannot be fully related to any of the statues thus far accounted for. Doubtless the idea of the stele-bearing tortoise, which is eloquent of ancient China, was Chinese; and seen in that light, the Fan Min stele is outstandingly important, since it offers the prototype of a monument that was going to spread its progeny throughout the vast realm for two thousand years. The Liang tortoise-stele is derived directly from the Han tortoise-stele, with more grandeur in the style, more amplitude, a simplification drawn from the stone itself, a certain curtness as to the surface planes and more roundness in the round surfaces—which point to a more confident art and a certain overriding scorn for the original model, the ordinary sea-turtle.

But the fluted columns remain, as we have said, unheard of, unexpected, inexplicable, unexplained. . . . There can be no doubt that their function in the overall arrangement was to be *Ch'üeh*, in other words, funerary name-bearers. They are used the same way and occupy almost the same place in the motionless stone cortege: they are preceded by statues of animals, separated by stele-bearing tortoises, but neither their curve nor their decorative motifs nor anything about their summit justifies any attempt to link them to a Han monument. Like the *ch'üeh*, the Han pillars had appeared to be solitary but complete; similarly, the Liang columns stand out against the Chinese sky without any tradition whatsoever. Yet the model, or rather the module, from which they stem is so accentuated, with such clear and curving contours, that they cannot be attributed to an individual sculptor; it must be assumed that they are the outcome of a certain tradition. We must admit that their shafts barely take root in the Chinese soil; they immediately bring the western column to mind—the Doric and all the Hellenistic influence in low Latin. Yet they are strongly tied to the soil of China by their powerful base, their torus of lithe elongated felines, this handsome pose, this embrace. There is a story to this, involving ancestors, perhaps. . . .

And, indeed, not far from the stele of Kao I, near Ya-chou, within the same site, I stumbled upon three slightly blunted limestone blocks, suggesting exactly the same motif of felines intertwined. I recognized a sort of tiger-dragon—but only one, achieving the circular winding movement all by himself—a Han feline, beyond any doubt. Although the

texts did not mention it, the local tradition had it that these blocks had been "dug up at the same spot as the stele." The stance, though achieved in this case by a single animal, was absolutely the same as that of the *t'u-lung*, winding around the fluted column. With this muscular collar, ancient China bound to its cubic, solid, generative soil the fluted column that was born on different soil—as a careful consideration of the parasol is going to make increasingly clear.

Although this parasol is crowned by the Liang lion cub, it is made of a flower that, while it is not a foreign element introduced into China, is used here sculpturally for the first time, namely, the lotus in full bloom. The entire summit, which can be accurately measured on the fallen column of Hsia Hung (Plate 36) and stretches four feet in diameter, is one enormous lotus. No doubt about it: the underside represents the petals in bas-relief; the upper surface, which is convex, sheltering from both rain and sun, is swollen with the same bulging petals, extremely well-drawn and executed. This can point to only one origin: India, where the lotus is so symbolized, so stylized, that it has become as much of an architectural element as the Greek acanthus leaf had been.

Here then is an excellent indication of exotic influence. This fluted column, this surprising monument of quite consummate, homogeneous elegance, is made up of various levels. The shaft, in fact, probably has remote Mediterranean roots. The characters on the cartouche make it strictly Chinese. The lotus summit brings India to mind. Only the feline garland at the base manages, in a powerful gesture, to unify this equivocal monument, link it with the pedestal, and give it an accredited Chinese function.

There remain the chimeras and the lions. We know about the forebears of the two Ch'en bastards and need not talk about them any more. The lions—the handsome winged lions of the Liang, characterized by their stylized manes—had no ancestors under the Han. In the Han feline, even in the one and only Han lion—that of Fan Min—balance between the bulk of the forequarters and the bulk of the hindquarters is inverted. In any animal statue dating from the Han period, no matter how majestic the torso, how arched the neck, how far thrown back the head, it is always the hindquarters, with their powerful life-giving organs, that dominate. Whereas in the strongest, the most male of the Liang loins, it is the forequarters, the outsized chest, and the two great masses of the mane that dominate and overwhelm the whole. The size of the animal (nine feet tall, nine feet long) with its lithe and rippling body is awe-inspiring compared with that of the ancestral tigers. And yet its contour is a sinuous, quivering curve. The strength of the Han tiger—energetic, small but strapping, choleric—is in its back. The strength of the winged lion of the Liang is spread through all its sinuous bulk and can be felt even in its oblique gaze, its disdainful, crushing way of leaning its weight on one side. The two eras form, in this case, two schools, two periods of sculpture, as separate as two traditions can be in the same country and still follow one another, without any apparent intermediary.

The chimera of Sung Wen-ti, suppler, though more archaic than the lions, is perhaps still less explicable. The way the beard is attached to the chest, which fits naturally into its overall stance, links it to the Han statues, but never did a Han sculptor manage to render the muscles this way, almost visible under the hide, or the hide itself aflow with great arabesques. The wing attachment is altogether different, but perfect in this instance:

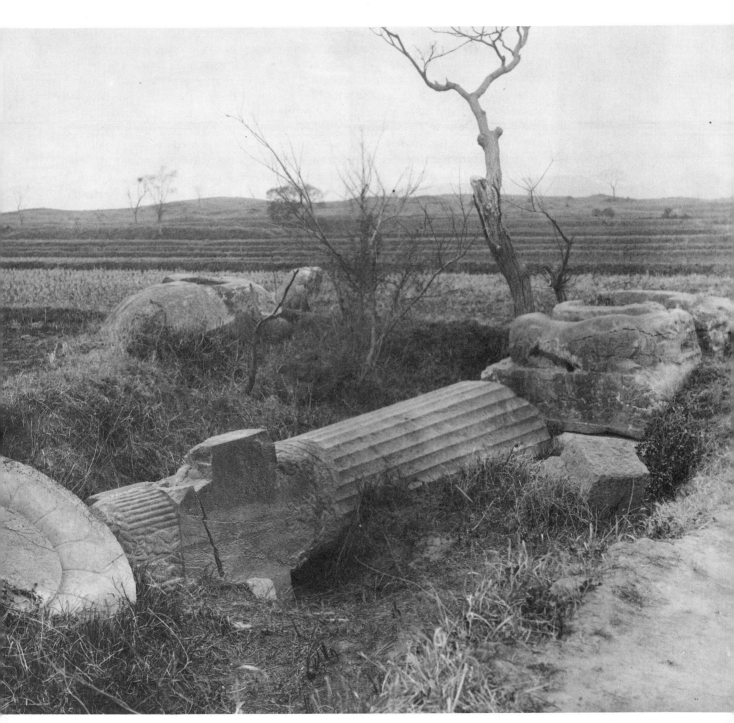

Plate 36. *The fallen column of Hsiao Hung.*

the wing is fitted flat against the shoulder in the case of the lions; where the Han felines are concerned, on the other hand, it starts from the chest, more decorative than carved, more an appanage than a functional part. The chimera of Sung Wen-ti has a stubby but noble pinion, suited, by its very nature, to beating time or matter equally—a legendary wing with its two floral motifs that cap the shoulder joint and descend onto the foreleg.

But neither the handsome chimera nor the ridiculous chimeras nor the finest Liang lions—all of which are inexplicable enough as it is in terms of strictly Chinese ancestors—are any better justified if assigned remote western correlations. I consider it undeniable that the fluted column is an evocation of some non-Chinese example, for a column, a shape derived from that of a wooden post, carries the mark of its styles within it. But where is the original example on which these lions are based, always so perfectly, distinctly executed, always in the same pose? Where can we find a model for it—where in Egyptian or Greek or Persian statuary? For the second time we are asking the question.

For lack of precise references, we cannot but conclude that a masterpiece of Chinese statuary was created in the midst of China itself. The Liang lions, all consistent, bear all the marks of it.

The Buddhist Heresy

Now that we have looked at this schismatic era in the history of the northern and southern dynasties, we must go back and consider it from a different angle. Having seen how legitimacy was perpetuated in southern China, we must observe how the famed but intruding dynasty of the northern Wei invaded the entire territory.

The reader may have been surprised at seeing that the words "northern Wei" had not yet been pronounced in this book on statuary, whereas for must admirers of Chinese stonework, those words embrace the delicate, idealized, outstandingly important body of work, the "masterpieces" of which our museums consider themselves honored to display the remnants sold them by rapacious merchants. In this chapter, the northern Wei and their successors are introduced—at long last, and almost out of turn—only so as to be excluded once and for all from this book, which is devoted, I repeat, to the great Chinese statuary. Now, all the works thus far known to date from the northern Wei are Buddhist in both spirit and execution and therefore profoundly foreign to the Chinese genius. The art from which stem these statues and all those that are to derive from them is so remote, so exotic, so waning, that if we were to set them off to advantage in these pages we would seriously contradict and compromise the principal purpose of this book, which is to exalt the pure, intrinsic, inherently Chinese nature of the genius of ancient China expressed in three-dimensional stone.

The northern Wei appeared on the northern fringe of China, at the border of present-day Shansi, at the end of the fourth century. The people they encountered called them "men-with-their-heads-tied-up" because they braided their hair into small plaits, but they called themselves "masters of the earth." In waves of successive hordes, they came down from the tundras of Siberia, then from the sources of the Yenisei and the Lena. The blood of the nomadic Tungus flowed in their veins. They reached Lake Baikal, spread out in latitude by means of battles or alliances, so that by the third and fourth centuries they had managed to occupy a vast area stretching from east to west—this corridor of incessant ebb and flow, this itinerary of throbbing movement that chance made the link between Upper Asia, Turkistan, and eastern Mongolia. This is why when they came, as masters

even then, to the gateway of the north to found their new capital, P'ing-ch'eng, they were already rich in foreign products: sculptural art that was very specific as to the body, dogmas that were no less specific as to the mind.

Those dogmas were not unknown to the literate Chinese; very far from it. They composed the very developed Buddhist Law, the north canon of the "great vehicle," the only law that China has ever known.

Already, long before, Confucian and Taoist China had welcomed the Lord of the Law. We need not go back to the legendary, marvelous, miraculous tales; we need not even believe it demonstrable that under the Han, Buddhism had a genuine Chinese existence; we need only accept the fact that as far back as the second century, extraordinary missionaries had brought the teachings and they had already borne fruit, even in the most resolutely Chinese circles. All in all, the Chin were better Buddhists than many T'o-pa Wei. Among the Legitimates in the south, the same Sung Wen-ti whose fine chimera we have admired was a Buddhist. As for Liang Wu-ti, emperor of all the lions, we will see how readily he could be bought and to what extent he set an example.

Nonetheless, it is impossible for us, here in this book, to take an interest in Chin Buddhism for the simple reason that we do not know of any handsome statues from that period. It is the northern Wei who must be acknowledged as the initiators in Buddhist iconography. The images they bequeathed they had themselves received from central Asia, and it was in the Greco-Buddhist art of Gandhāra that they chiefly blossomed.

So, the first Buddhist sculptures were carved at Yün-kang, on orders from the princely Wei family. Penetrating later to the very heart of classical China, they were to spread, by way of the Lung-men cliffs, to virtually all of China. Yün-kang and Lung-men were the two starting places for the iconographical dissemination of Buddhism.

Separated by an interval of one hundred years and by a distance, north-south, of six hundred leagues, these two Buddhist "lodes," Yün-kang and Lung-men, follow the Wei invasion route. Yün-kang is only a short way from their first capital, near Ta-t'ung-fu, at the gateway to China, while Lung-men is thirty *li* south of the truly Chinese capital that was their second stopping place, Lo-yang. After which, spreading out again latitudinally as they had done before, the "northern" Wei, who now occupied a central position, split into the eastern and the western Wei, like the Han before them.

Yün-kang, where the first work began in 414, can be ascribed exclusively to the Wei. Lung-men, where the earliest date is 495, owes them its foundation and its beautiful works. Later, the powerful T'ang contributed to Lung-men and launched vaster undertakings.

"Lodes" or "veins," rather than "monuments," is the term that such vestiges in stone deserve. Vestiges full of piety, steeped in faith, yet they are not a temple; grazing over one huge side of the mountain, they do not form a façade, and still less a methodical "monumental" whole; though of royal origin, they do not resemble a palace nor a purely Chinese work of art since, despite the fact that they are covered with characters, the shapes they outline are foreign! What I call a "Buddhist lode" the Chinese texts call *Ch'ien Fo yen,* a "cliff of a thousand Buddhas," an indescribable thing because figures swarm so disconcertingly over it.

A *Ch'ien Fo yen* is indeed a cliff, a mountainside, a promontory honeycombed with hundreds of small man-made caves or with a few large, natural caves. In them, human figures: the Master and his disciples, or else the Master, his disciples, and two Bodhisattvas. The iconography is certain despite the absence of any inscription. The dates are sure, the intention is obvious: most of these caves are *ex voto*s bearing the donor's name and sometimes a bas-relief picture of him.

Although these statues are still imprisoned in the matrix of the rock—which, at Yün-kang, is a reddish limestone and at Lung-men is a fine black marble striped with gray and rose—they are carved with sufficient roundness to make them statues in the round. Their motionless quality, their geological adherence, prove that they are made of good Chinese stone. They are carved from the midst of China itself. And the period they belong to is very close to that of the Later Han, contemporaneous with the Sung chimera and the Liang lions—a period that has its brilliance and its artistic mastery beyond the Great River. Now, whatever the reasons of overpure sentiment that may be invoked, when we look at these statues in terms of sculptural reasons only, which is reason enough for our purposes, we cannot call them beautiful. Neither beautiful nor Chinese.

Repetition of one monotonous type. Countless replicas of a model that quickly becomes familiar: a round, beatifically handled face, smiling, weak lips, eyes often downcast, ears that are superadded, robe with methodical, crimped folds.

Where is the outspoken freedom of the Great Han? Or the majestic bearing of the Liang lions, their contemporaries? For the second time we have been looking for a human face—so elusive, so unavailable until now—and there is no denying that here we have an abundance of human faces, but we are quickly satiated: we see the same face everywhere, always the same eyes, the same forehead, the same smiles with no hint of laughter. . . .

After contemplating these hundreds of "visionaries," of "adepts," of "sages," and "princes attaining unto wisdom," I often found that I could have wished for the terrifying, unknown, areligious face of a human being in the days of the Han—or the thick lips and suffering eyes of the trampled Hsiung-nu, or even the muzzlelike heads of the pillar caryatids! And yet the critics ecstatically repeat: it was Buddhism which in spite of everything introduced the human face into Chinese art! Where statuary is concerned, it would have been better to depict the barbarian mask—and that alone.

Not only are these statues not beautiful when taken individually but also, even when grouped three in a loggia or cave and when those caves are gathered or rather massed together by the hundreds on a single promontory or a single cliff, their abundance does not confer any pleasing orderliness upon them.

When the prince or the king had decided to honor the Master, a propitious cliff was selected. There were two criteria: the surface had to be very visible and the rock must not be too difficult to carve. The central cave, which was the largest, was soon surrounded by satellite grottoes and courtier niches and alveoli soliciting celestial favors, all haphazardly placed along the former cow paths or goat paths zigzagging up the mountain and among the folds of the rock formation. Then, without once giving any thought to the overall or architectural effect, without any thought for the cliff itself, although, in its original state, bare and pure, it was a superb natural monument, the stone-carver went to

work, scooping away stone crests, hollowing out corners, chipping and pounding away more incoherently and indifferently than any borer insect. The whole site became a place of pilgrimage. Crowds thronged. Stunning conversions took place. And the pure mountain, with its cross-sections, its laws, its architectural coherence, was no longer anything but an empty sponge, a once-living core putrefied by the hand of man.

Not everything was ugly. We must remember first of all that these great caves, which today gape like a mouth without lips, used to be masked and sheltered by a whole set of architectural features (curving roofs, tiles—which were yellow even then, lacquered posts: the features of a Chinese palace or temple); forming a sort of canopy, these elements undulated down the steep slope. The cave itself was invisible, a recess within the monastery, the image of the Master, accessible but shaded.

Lung-men was "going full steam" by the time the Wei reign ended; when the swell of hymns, the scent of flowers and perfumes, and a great breath of universal hope filled the space housed under its vast roofs, like tents, the unfortunate effect produced by those stereotyped statues could be overlooked. But this orchestrated architecture does not excuse the statuary for having been so ugly. Today, nothing remains of those palaces, but we can assume that they were imposingly arranged and that they would have been further enhanced had they contained masterpieces. Now this book is to deal only with great works, if not exclusively with masterpieces; and, alas, the only thing that is great about the thousand Buddhas of Lung-men and Yün-kang, some of them sixty feet tall, is the span of their wide-open hands!

That their origin is Greco-Buddhic is undeniable. But how can the unforgettable Greek carver have brought his style, his mark, his school, above all, to the northeasternmost horn of civilized China, across a physical distance of ten thousand leagues and a temporal interval of over five hundred years, across the full breadth of the broadest continent?

The statues belong to the Chinese rock in which they are carved. Are we then to believe that the Greek stone-carver himself came to China? Or that a Wei sculptor went to Greece and there apprenticed himself to a master carver?

Neither one. Here and there throughout that paradoxical stretch of time—from the Attic genius of the fifth century B.C. and the Wei invasion in the fourth century A.D.—there were relays, so decisive as to be almost a second origin.

We know where those relay points were; the nearest was Tun-huang, in central Asia; and the other, which was fundamental, was in the ancient province of Gandhara, in the extreme northwestern portion of India. All of the statues in the round that we see at Yün-kang and Lung-men come from "the Gandhara school," that Greco-Hindu center produced by Alexander's conquests in the first century of the Christian era, but no attempt at rapprochement between those statues and the great Athenian period can be taken seriously. Close analysis of this hybrid art, this strange coupling between pure Hindu thought and decadent Greek art, shows that as soon as the art of Gandhara began genuinely to flourish—in the first and second centuries A.D.—it was already of mediocre, secondary quality, illustrating the real decadence of the antique Greek tradition through

vagabond Hellenism. It is an art of degeneracy, a cosmopolitan proceeding that the Roman conquest, more military than scholarly at this point, spread along with its colonies. The trite formulas, the misfits, the repetitions, and stone clichés that seven hundred years of Hellenistic activity had sown everywhere, in the form of masterpieces or failures—this is the source on which Bactria drew in order to illustrate the new faith.

Yet certain Buddhist relics achieve an undeniable beauty. It is easy to see that this beauty never stems from the initial tradition but instead, in every case, is ascribable to these two non-Buddhist causes: local art or profane art. To no other masters than the Chinese painters can we attribute the supreme harmony of the large bas-reliefs of the donors, both men and women, in the P'ing-yang cave at Lung-men, faithfully echoed, though in miniature, at Si-shan-kuan in Mien-chou (Plate 37).

Plate 37. *Mien-chou. Si-shan-kuan. Lady donors.*

The austere, aristocratic northern Wei statues of Bodhisattvas at Lung-men can be considered successful, thanks to various particular—possibly ethnic—sources of inspiration.

Slender, vigorous, their legs crossed so as to form a double X, these distinguished figures with their pleated garments and elongated necks sit in state as if they were not supernatural beings but grand princes of this earth amid the plump, assembled sages. A new type of guardian lion, the "Fo lion," lies oblique and tense at their feet. Its face is mutilated, but the unforgettable expression remains.

Similarly, at the opposite end of China, in Szechwan, we find another fine figure of almost equally desirable value and bearing. I mean the Bodhisattva with its legs crossed that belongs to the Buddhist group of Ma-wang-tung (M).

M. *Chia-ting-fu. Ma-wang-tung. Statue of Bodhisattva.*

The drawing of it that I give here may be more faithful than any photograph, for it is impossible to step back to focus on it: this handsome statue overlooks the sheer cliff face from twenty feet up.

The lithe, slender-waisted body is sitting on the edge of a wall, leaning over slightly toward the river, the right leg crossed horizontally over the other. The way the two arms (which are missing) were attached to the torso is very well done. The torso itself is bare except for a scarf thrown over the left shoulder; a draped tunic covers the stomach and closely molds the thighs and legs. The hair is done in a high and richly ornate style. The face has been destroyed by deliberate mutilation but is still framed by two fine coils of hair.

Although there is neither inscription on the rock nor specific indication in the texts, there can be no doubt that this handsome statue represents a Bodhisattva. It is a superb example, and one of the most remote and unexpected examples, of Greek drapery clothing a Hindu-style body.

The Buddhist iconography that appeared in China at the time of the Wei did not disappear with them. Its real period of expansion was the long T'ang dynasty. But before them, under the "half dynasties" that preceded the unification of the empire (the Chou and the Chi), then under the Sui, who did unite the empire, there was stonework, examples of which remain at either end of China, in the characteristic form of *Ch'ien Fo yen.*

There is no authentic northern Chi statue, but two Sui *Ch'ien Fo yen* have now been recognized and described: one in Shantung, described by Chavannes, and the other in Szechwan, described by our first mission.

The Sui style (Si-shan-kuan, Mien-chou) is characterized by an undeniable archaism. The fact that there are few figures, the lithe vigor of the pedestal ornaments, and the general shape of the niche makes this style somewhat similar to that of the northern Wei monuments.

Then the T'ang succeeded the Sui, and ushered in the culminating period for Buddhist art, a time of glory, fortune, and expansion. The "wheel of the Law" rolled over the entirety of the conquered empire.

The T'ang empire was so imbued with Buddhism that the T'ang Buddhist school that had its "headquarters" in Lung-men covered the rock faces of China with countless *Ch'ien Fo yen.* Many of them were destroyed, but their sites have been found, and far too many are still visible. In Szechwan, it had not yet been possible to undertake any search for them. We therefore, with deserving zeal but without the slightest curiosity, had to find most of the *Ch'ien Fo yen* that still survive in that province and take note of their inscriptions, their history, and their statues. They are to be found, lined up like grains on a stalk, along an axis that starts at Lung-men, follows the main road from Shensi to Szechwan, and ends for the time being at Chia-ting. I do not know how many statues still exist; thousands, no doubt. We will never know how many millions of them were made, how many rocks were hollowed out, how many taels spent, how many vows uttered. What remains is a ravaged and melancholy site.

The decline from the T'ang to the Sung was more serious, and graver still the decline from the Sung to the Ming. . . .

Yet some of these statues may have been incomparably majestic, such as the great

Chia-ting Buddha, tall as the cliff itself, a hundred feet high, at the back of a broad natural recess in the cliff, flanked by two Cramanas which, gigantic though they are, come up only to his waist, while their feet and the foot of the mountain too fall straight into the swirl and whirl of the Min rapids. His face is turned toward the confluence of the Tung and the Ya—toward the Omi, ultimately toward Tibet, which he could have seen by raising his eyelids the size of rice boilers in a refectory big enough for two thousand monks.

Had this statue been handled in the best possible Liang manner, it would doubtless have been the masterpiece of Buddhist art on a gigantic scale. Despite the crumbling stone and the plants that overgrow it, despite the horrible repair job on the face, we can sense its probable beauty.

So we have two far-reaching schools of sculpture contemporary with one another but separated by the Great River as by a midway point. Throughout the divided period, one of them (under the Wei, the Chi, and the northern Chou) occupied the northern hemisphere, while the other (under the Sung, the southern Chi, the Liang, and the Ch'en) occupied the southern hemisphere. Two worlds of stone existing simultaneously, as unlike as they could be: the exotic, pious art of the northern Wei, abounding in representations of the human face; the profane, funerary art of the Liang, with its robust, unforgettable animal creations. Both of them "god"-less, in the strictest sense; the second one confined to a not very extensive territory but, from that starting point, eclipsing the first one. Was there no correlation? Were there no sculptural analogies?

The Wei certainly had their non-Buddhist statuary, their funerary statues. *The Book of the Wei* and *The History of the Northern Kingdom* indicate that Shao Hsü, who lived in the first half of the sixth century, placed such figures, along with commemorative stones and pillars, on his father's burial field.

I do not know of a single one that is still standing. Consequently, we cannot say anything about the influence the Liang may have had on the Wei. What we can definitely rule out, however, is any Wei influence on the Liang. The works of the latter are numerous and distinct. By definition, even, they are separate: the Liang did not owe anything to the Buddhism of the northern Wei, Gandharan Buddhism.

And, yet, when we reexamine the most inexplicable elements of the Liang creations, we find singular episodes, particularly on the stelai, and here and there a recognizable ornament: the lotus. The lotus reigns at last, its full blossom crowning columns. Now, the lotus, though unheard-of in the decorative art of the Han, was fundamental to the flowery architecture of ancient India. The lotus, which came from so far away, brought its style wherever it was applied. It must be acknowledged that the numberless flowers on which billions of Buddhas sit enthroned could not have come to China and suddenly emerged in stone if they had not come from the original Buddhist country: India. But the lotus's way of blooming, its style, its location, all indicate the way by which it came: no longer the great northern route (three months overland) but the southern route, by sea. For a hundred years, much longer perhaps, sailors from all the Far East Asian countries had been joining Ceylon to the Chinese coast; and pushed on by that new wind strong enough to enwrap the universe—the Buddhist faith of the giant

Plate 38. *Right-hand pillar of P'ing-yang. Front. Buddhist decorations added in Liang era.*

apostles—they swept into the mouth of the Great River, under full sail, and easily reached the capital. There—and this is a mark of devotion of which no other creed in China has ever been able to boast—Wu-ti himself, the emperor who was contemporary with the handsome Liang lions, was twice bought back by his ministers and his people from the monastery he had voluntarily entered!

The temples rose, on sites that are still famous. The whole southern empire was inspired by a voice which was possibly more beautiful, loftier, than that of the messengers in the north. While we cannot say that at that point there were two Buddhisms, like two kingdoms, we can certainly state that the images of Buddhism differed. The Gandharan style in the north contrasted with the Hindu statuettes, of a style which Japanese replicas have made familiar to us, but no large statue corresponded to those statuettes: the dates of the *Ch'ien Fo yen* in the Chiang Valley, even south of the Chiang, do not go back as far as the Liang; they barely date back to the Sui, the T'ang, and thereafter they are invaded by the Gandharan hordes.

So it is permissible to attribute certain things that really cannot be accounted for by the Chinese chisel alone—fluted columns with their crowning elements, the ornamentation on certain stelai—to this immense foreign influx brought by sea from the Western world. The rest remains intangible. The turtles are certainly indigenous. The chimeras are all linked to the majestic Han. And the lions, the handsome Liang lions? As they cannot be related to any other known lion, they remain, to this day, the purest and most mysterious proofs of the sculptural achievement of ancient China.

Under the Liang, the Buddhist substratum itself was to submit to the dictates of Chinese art to a singular degree. The example is too unique for us to make of it a general law, but it is so strange that it warrants a detailed description; it involves the only Buddhist

127

"lode" as yet discovered in Szechwan. The "monument" itself boils down to approximately thirty little niches which, incredible though it may seem, are not hollowed out of the rock but out of the shaft of a pillar dating from the Shu Han, the pillar of P'ing-yang! We must assume that in the days of the Liang, it was considered as a monument that was no longer of any importance, as building stone, stone to be engraved! (Plate 38).

This overlay of decoration, executed some three to four hundred years after the pillars were erected, cuts crudely into the lines and the original decor at many places. The Buddhist gashes attack chiefly the shaft, where they lay waste a fine Han frieze of chariots and decapitate the colonnade of vertical surfaces. Once we have noted what irreparable damage this has caused to the monument as a whole, there is no denying that there is much to be learned from the Buddhist work considered in itself.

The date, 529, is the most ancient known Buddhist date engraved on the sandstone of Szechwan. The niches which are hollowed out of these pillars and which justify the votive inscriptions are small but extremely curious. The T'ang niches are always rectangular, and the Sui niches were always surmounted by the circumflex Wei arch; but here, for the first time, we come upon the pointed or Gothic arch. Now, never on any Chinese Buddhist monument has that particular curve been found, clearly drawn. But it is to be found, and very distinctly too, on a few non-Buddhist Chinese monuments dating from before the period when the Hindu iconography penetrated China, as, for instance, in certain Han funerary vaults in Szechwan.

Another clue, just as precise and just as unexpected, is the content itself of these pointed niches: a single figure, standing, with loose-fitting garments. Since the heads have disappeared, it is difficult to identify them with any certainty; we can assume they are Bodhisattvas. But one thing is obvious: the style of the clothing, of the drapery, is totally unrelated to the million examples of Greco-Buddhist statuary. For the first time, these figures stand out from their cognates. Yet, they are Buddhist without a doubt. And if we examine them closely, just as the pointed arches of the niches that hold them actually come down to Chinese shapes, Han shapes, similarly the details of the garments—the horned ends of cloth, the loose, unpleated drapery, the symmetrical points—are undeniably related to the Han style, and we needn't look for examples any farther away than the style of the underlying sculptures that decorate these same pillars.

Thus the same monument which offers us what may be termed the sole example of the Buddhist style of the Liang in Szechwan gives us precise indications, at the same time, as to its origin.

I am sorry to have talked for such a long time on a topic whose very nature, as we can see, excludes it from this book. But this had to be done in order to restore the development of genuinely Chinese art to its pure genealogy, give it a good straight backbone. It was also necessary in order to take stock of and evaluate thereafter, under the T'ang, what this Buddhism in stone was going to contribute to that composite era, for here is an end to the original virtue. And, finally, it had to be done in order to challenge and reject the lyrical admiration with which that "art" had been treated.

Third Period of Statuary
The T'ang
(Seventh to Tenth Century)

The T'ang dynasty reigns, and from now on unity will be lasting, the kingdom will endure. Without interrupting our list of monumental blocks of stone, of stone fauna, we must place at the beginning of this chapter, as if to guard it, the new leonine type of feline that has suddenly appeared: the personal lion of the T'ang (Plate 39), represented by the lion at the tomb of Kao-tsung, third emperor of that dynasty, who died in 683.

All of a sudden, without any analogy with the previous era, without any intermediary link, the animal has straightened up, assumed a firm, propped-up sitting position. Is this the same animal? A lion undoubtedly, but no longer a monstrous one: gone are the wings and the arabesques of hide or mane, replaced by elaborately curled hair and beard.

For the third time in the development of the greatest statuary, the "lion" as type had been petrified in a new form. Of the same carnivorous blood, the same feline species, as the noblest animals under the Han or the Liang, here is its third Chinese incarnation.

Once again it is a very large and very handsome piece of sculpture. Seen from very close up, the beast possesses and dominates the soil where you are standing in its enormous shadow (from pedestal to ears, it is eleven to twelve feet high) and majestically stands guard. It is very squarely seated on its rump, with the tail angrily curled up on its back and the forelegs taut and oblique so as to bear the weight of the enormous neck. The posture of the entire block, compact and noble, serene and tense, produces a satisfying impression. The neck is slightly withdrawn and appears somewhat globular because of an altogether new type of mane, in an unfamiliar style, curled all over as with a very large curling iron; there is something naïve about these complicated, pretentious tufts swirling down from ears to shoulders, as if intended to be ornament and hair all at the same time.

The overall attitude is skillful, almost cunning—the eye seems to wink and the head nods slightly to the left—but there is no shifting of the weight, as before, to follow the gaze. Every detail we have noted is so precisely the opposite of the details of the precursors we have already considered that in order to describe this great lion, the T'ang lion, we must take apart the classical Liang lion piece by piece. The eye is no longer pedunculated; the ear no longer forms the summit of the skull, but instead a perfectly distinct lobe; above all, the mane is no longer divided into two masses, but is formed by a conglomerate of curls.

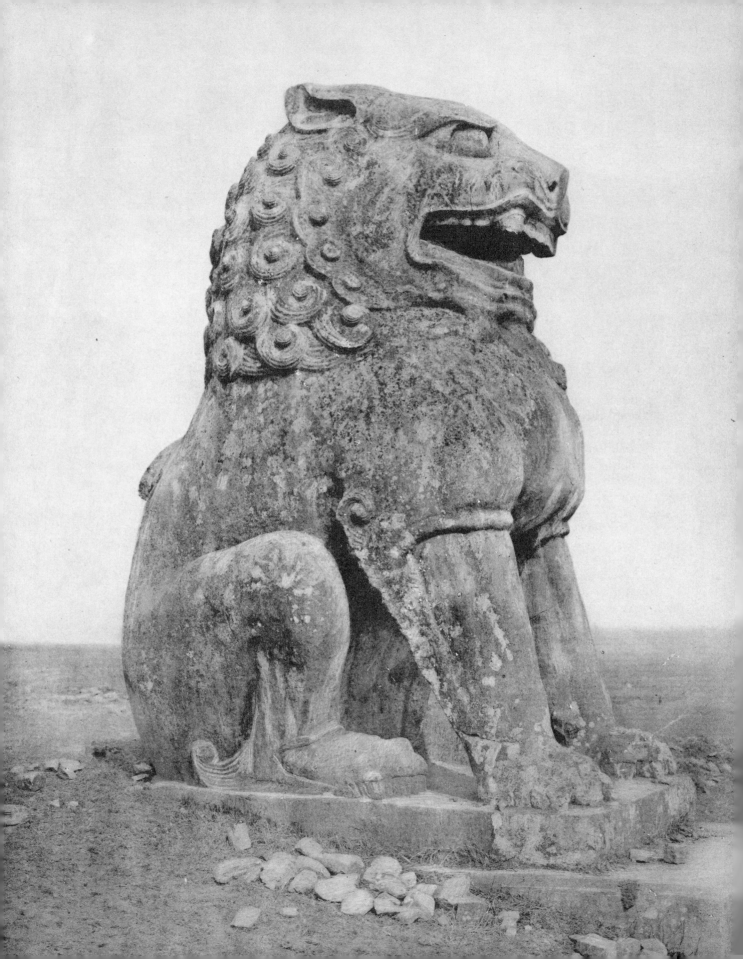

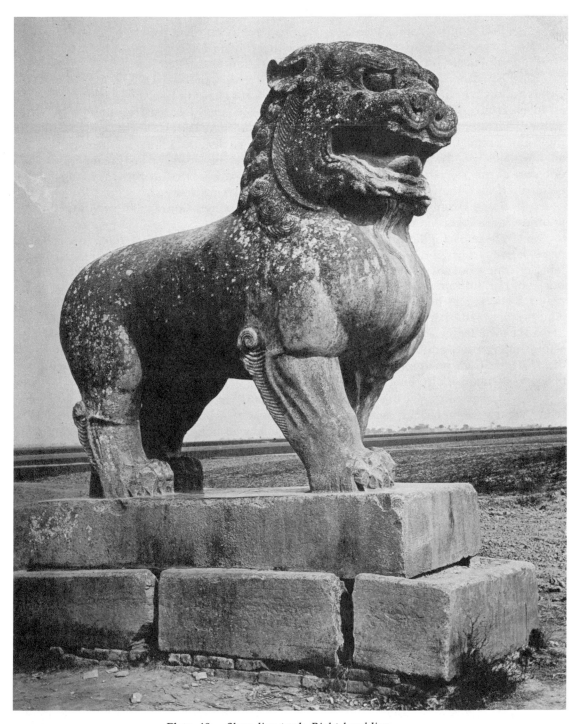

Plate 40. *Shun-ling tomb. Right-hand lion.*

Plate 39. *Burial place of T'ang Kao-tsung. Seated lion.*

This leonine statue, such as it is, in its new form, remains a thing of great power. From the ground to the tip of the irregular cone that this statue scoops out of the air, it is even swathed in majesty, in a strong and elegant succession of fulfilled, continuous curves.

The funerary function of this statue dates it very precisely: 683. Forty paces to the east is another statue, its twin, absolutely symmetrical as to intention, slightly less successful as to execution. The tomb of T'ang Kao-tsung—one of the largest groupings of T'ang statuary—is situated on the hills north of Chien-chou north of the Hsi-an-fu plain, the plain of the T'ang capital, Ch'ang-an. And there, scattered over a distance calling for one day's march, are the majority of the burial places which are the pride of this third and last great period. Their dates are as precisely delimited as the area in which they are located; as with the Liang, and far better than with the Han, the principle of grouping was carried out.

Some twenty examples of this neo-type of seated lion are known. But there is another, far less certain type: the pacing lion.

These pacing lions are found quite near by, at the "Shun-ling" tomb, a vast burial place of truly imperial dimensions, which the empress Wu, of tragic memory because of her tenfold crimes, but so filial and sainted in her ancestral devotions!, had erected in about 700, in honor of her mother, who doubtless died from the horror of having given birth to so monstrous a child. The purpose was pious; the statues are abundant and of unequal quality. Among them, the lions are handsome. Here is the right-hand lion (Plate 40). Enormous, and appearing larger still because of a double, stepped-back pedestal, it rules over the plain astonishingly, and although there are only the vaguest of geographical landmarks to indicate its location, one would have to be blind or really inept to fail to see this burial place in the vast expanse of rolling land.

We can recognize this animal as a close relative of the seated lion of Kao-tsung: same mane, same gaze; but in this case, the easy movement of its bulk is successfully rendered. The whole formed by these lines and planes, these solid and hollow parts, the way air is free to circulate beneath the belly, the perfect obliquity of the four half-ambling limbs and the fifth prop formed by the sturdy tail characterize these very noble felines. To a degree that has rarely been equaled, this burial place succeeds as a monument through its uncongested and, as we shall see later, quadrangular arrangement, and its raised level. May the terrifying Lady Wu be forgiven for the murder of her husband, of her son, and of so many others, and for all her lustful excesses, in exchange for the four fine, immortal lions dedicated to her venerated mother!

Unfortunately, the same burial place also includes seated lions, but they are more rough-hewn than the animal that adopts the same pose to guard the body of Kao-tsung. The rictus becomes a sneer, the curly locks are now frizzy, and the eyes now sparkle instead of crinkling.

It is when you see these creatures that the realization suddenly comes: so that's it! That is the origin of the cursed Chinese lion, the circus animal, the child's plaything, the little beast irritated by its enormous proportions, which henceforth will be found at every street corner, at the gates of every *yamen!* Official lions, idiotic lions, become animals no longer but symbols, become—compared to their source—what a scrivener's signboard is to a nobleman's coat of arms! And for fifteen hundred years, throughout a territory as large as one-fourth of

Europe, the clumsy, tame lion-dogs were going to grow and multiply like rabbits or rats. They were even going to acquire the dumbfounded facial expression of the Pekinese dog: the very round staring eyes and pug nose; and submit to wearing a collar, with a pretty little jingle bell on it, around their necks; and hold a complicated sort of globe under their front paws; and accentuate the sidewise gaze, and preen and mince and all in all become that indecent animal that one would like to kick away from all Chinese thresholds; and even become those two clawed and comical poodles guarding the main door to the huge palace of Peking. In the end, they would become all those curio-shelf trinkets, all those convenient pocket-sized monsters that the European tourists, ignorant of the original article, imagines to be typical of the Chinese genius and has dubbed "Chinoiserie."

Now we can see where the Chinese monster comes from. It is a distant descendant of the T'ang lion.

The date should be carefully noted: A.D. 700. Prior to that date, not one form that was not majestic (except for the Ch'en bastards, but their deliriously burlesque style was so sterile that there were no offspring); after it, under the ensuing dynasties, millions of examples were spawned of what was for too long the escutcheon of China.

This was what was to come, through degeneration, of the Shun-ling lions and their noblest relative, the lion of T'ang Kao-tsung.

Now that we have seen it in its novel pose, we must look for its ancestors. This curly lion is so unexpected that we might ascribe its paternity to what had become the reigning influence, that of the Buddhist sculptors; but that does not account for much. Suppose we compare a T'ang lion to one of the Buddhist lions at Lung-men, to the small lions carved in the round at the feet of the Bodhisattvas of the Lao-chün cave, or, better still, to the more voluminous animal that occupies the P'in-yang cave (Plate 41). There is no close cousinship. Whatever analogy there is stems from the type itself, but it was not willed by one and the same chisel. The lion of the P'in-yang cave is radically different from the three known types—the Han lion, the Liang lion, and the T'ang lion—because it shows a fourth stylization of the mane. It is composed neither of large locks nor of two masses, nor is it a frizzy switch of hair; instead it is fitted together from plates or slabs embedded around the neck and shoulders like an armor-plated collar. In short, what is characteristic of this animal clearly leads us to the opposite conclusion—for it comes from Gandhara. Assuming then that the other influence —southern India and the sea journey—had been at work, I looked for the origin of these lions in that country. But the Hindu lion does not look the same: it has a rounder snub-nosed head; it is related to the Greek lion or the Babylonian lion, all the lion heads that are more animal-like than monstrous. So the abrupt originality of the T'ang lion does not hark back to either type of Buddhism, the southern or the northern, and cannot be explained by either.

This then brought me back to Chinese soil and forced me to consider whether the preceding works had not been forerunners of these. Inevitably, I was brought back to the Liang. If we compare Plate 37 to the picture of a Liang lion, we find that these pachydermous wrinkles, elegantly handled as ornaments, as well as this rim around the shoulder, starting from the armpit, as it were, and going around to the line of the tendons, could also be found at the articulations of a Hsiao Hsiu lion or even at those of a chimera of Sung Wen-ti. But where

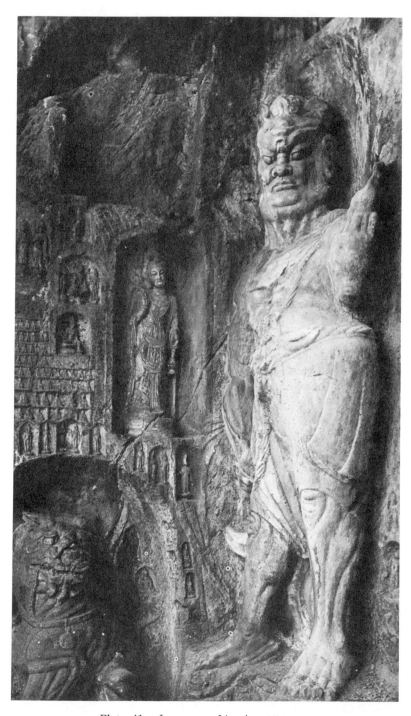

Plate 41. *Lung-men. Lions' grotto.*

was the original model? For the Han did not depict such a wrinkle or such a padded rim. The workmanship of the clawed fist is closer to that of the Liang than to any other. And, in fact, when we take a closer look at what seems at first to be quite new—the way the mane is composed of heavy, pointed coils—and if we touch it with a finger, we can feel it and recognize it on the chest of a Liang lion that I did not photograph because the stone was in bad condition. Or, again, the way the coiled beard is rolled up in exaggerated little comical curls. Or, even more pertinent, the unhesitating, impeccable line of the mane, its beautiful curved cleavage of space, which we might look upon as the way the manes of the Liang lions place their stamp upon the air, is found only once in a T'ang lion, and in an abortive form, limited, pitiful, a mere accessory, barely a crease; yet the gesture is there, the curve recognizable.

So it would seem that the great seated T'ang lion, the grave ancestor of the comical creature to come, sire of the most monstrous line of descendants, can pride himself on inheriting a few features from the great Liang lion.

And yet perhaps we can account for the startling look about it, and for that equally startling, indefinable property of carved stone, that incrustation by a new chisel, by the incessant foreign influence which was so important in China in the days of the T'ang, and which is unequivocally acknowledged this time as Buddhist.

After the lion came the horse once again; it seems to have disappeared since the time of the Early Han. No image of a horse is known to have been made under the four southern dynasties, and the clear arrangement of the eight-point Liang funerary monument does not allow us to hope that any will be discovered. Nor is there any indication of a funerary horse under the Later Han, despite the minuscule, runaway cavalcades that crown the pillars. Under the T'ang, on the contrary, we find abundant examples of horses, faithfully and sometimes well handled. Such examples are always of saddle horses; in fact, of horses that are saddled, bridled, tricked out with pompons, mane or tail plaited, well-groomed and shown in an advantageous light, the favorite steed, sometimes so personalized that we are even told its name! One striking example is the set of six fine bas-reliefs at the tomb of Chao-ling, near Li-ch'üan-hsien, showing the "six famous war-horses" of T'ang T'ai-tsung (Plate 42).

T'ang Tai-tsung was only the second emperor in the dynasty. The founder, Emperor Kao-tsu, left no traces of his glory in stone. In the history of great statuary, his name is only a vacuum. Moreover, it seems that he was mediocre and narrow-minded. His son, Li Che-min, who was to become emperor T'ai-tsung, was of greater stature. He was a tireless horseman and good fighter, and, thanks to this, we have those "six famous war-horses." Their appearance in Chinese statuary marks a more memorable date than that of any reform edict; it is almost the act of a genuine founder.

It is to the Chavannes mission in 1907 that we owe the discovery of this handsome imperial stable. A Sung stele had told us the horses' names and how they were arranged, but that was merely a line drawing which indicated nothing about their volume. One day, Edouard Chavannes found himself standing in front of them—to his great surprise, for he thought they had been lost.

In a few lines whose restraint reveals the excitement behind them, the master explains how, when he was visiting Chao-ling, the tomb of Li Che-min, Emperor T'ang

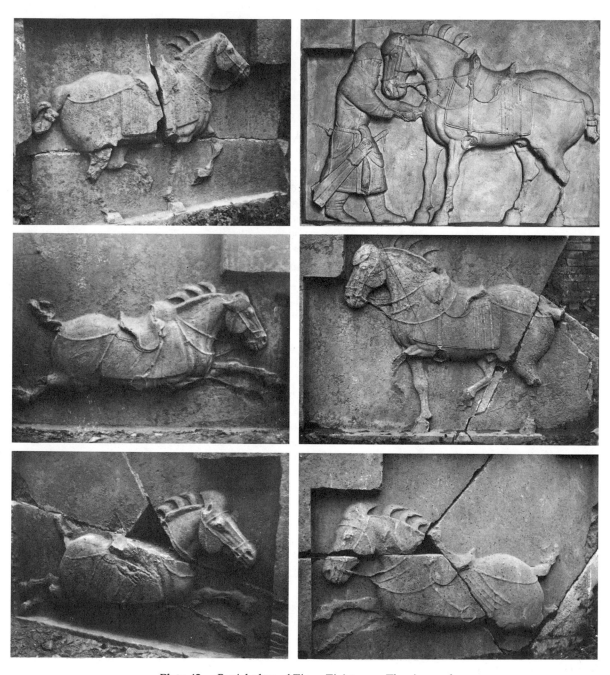

Plate 42. *Burial place of T'ang T'ai-tsung. The six war-horses.*

136

T'ai-tsung, he came upon a dilapidated building, a sort of sagging hangar; and there, inside it, were the six celebrated coursers, not intact but forming a marvelously complete set.

They are done in high bas-relief, thicker than a hand, half life-size. There are two series, two cavalcades, rushing at one another: one from the east, turned toward the left and showing the left flank, while the other, from the west, shows the right flank. But their present position is different from the original arrangement, which we know nothing about.

From the center to the extremities, the calm pace becomes more rapid. The first horse is simply standing, held by a groom. The second shows a trotting or diagonal gait; and the third is going at a "flying gallop." The western frieze is still more animated: the first steed is already trotting, the second is galloping, and the third and last is carried away, a four-footed fury.

In each case, without exception, the movement is robust, the effort precisely delineated. With their mighty hindquarters and necks, these animals would be, in literary terms, "fine horses," but experts judging them at a track would classify them as "large ponies." They all have full saddle and harness and are ready to be mounted, and the name and exploits of each one are indicated. We have the most historical certainty, therefore, about these war-horses.

The T'ang horse, which owes nothing to any of its sculptural predecessors, is an accurate image of a living horse. It is a stocky animal with rounded contours; the forehead is straight and the muzzle large; the lips are heavy but not drooping; the mane is braided in three separate tufts; the croup is firm and full; above all, the neck is so short that the pommel is not far from the ears, and if you were riding this horse, you would have the dizzying impression that you were about to slip off over its head. This heavy, muscular animal was typical—and was to be typical for some years yet before the various peoples were mingled and the various species had interbred—of the "large Chinese pony" of northern China. It was on just such animals, with their defective necks, their brutal masses of muscle, their short reactions, that we rode to visit their stone ancestors, just such animals that carried us about, or carried us away, or threw us to the ground. . . .

This fine T'ang steed is not only a faithful image of a horse; it is also a good example of comparative horsemanship and even of saddlery throughout the ages. We notice how well the elegant saddle, placed atop a wide blanket of leather or wool, fits the back, but all this is shown in excessive detail, and this harness-maker's advertisement, as it were, is a little bit damning, for the horse is so completely described that we forget to see how it goes racing through the stone! No description, no matter how detailed, should preempt the rights of the carved stone itself. In this case, however, the sculptor was fully justified: round lines are more than abundant, the postures are vigorous, the whole is animated, and the intention —providing stone portraits of the six famous steeds of T'ang T'ai-tsung—has been carried out. The main thing was not to lose for posterity the image, the gestures, the gaits, the reactions of the six valiant horses that had carried Li Che-min at a gallop through the battles early on in his reign and so to the throne. This may explain the lavish detail. It is better to preserve the memory of an historic mount in a skin of stone, even if it is prettied up, than to make a work of taxidermy of that same horse and place it under glass next to the wax model of his emperor rider in full uniform, as did the curators of the Peter the Great museum in Russia.

As these portraits of horses are the oldest T'ang stone carvings, it is logical to look into the way the same animal continues to be depicted under the same dynasty. The next one in succession, made forty years later, is a monster of stupidity, to put it mildly. I am talking about the harnessed horse at the Chien-ling tomb, burial place of the T'ang emperor Kao-tsung. (Plate 43), or, rather, about the horses, for unfortunately there are six of them! So little time after the equilibrium successfully achieved in the stone stable of T'ai-tsung, here, on the contrary, in this prosaic performance, we have the denial of beauty.

These are creatures that have barely taken shape, with a silly head at the end of a limp neck; four-footed animals obviously, since we can count four limbs, placed very straight or, rather, glued so hard to the pedestal that they would collapse if detached from it. The hindquarters—or what are supposed to be taken for them—are rounded, without any modeling or planes. Nothing beneath the belly. Nothing on the chin. A single edge or line descends from the ears—which never existed—to the crupper; a stance that is not a gait; a bearing that does not even put a bold front on the matter; an air of not really existing. This is not even the phase in which the block of stone is rough-planed, prepared for something, even if only for decadence, downfall. This is nothing at all.

On the other hand, there is a wealth of precise indications. What we are given here is an episode: the very thing that must never be made explicit in a lyrical work, the very thing that must not be carved in stone. Once again, we see full, or nearly full, saddle and harness; the horse is all tricked out and ready, the mane is plaited, the saddle ready, pommel and cantle, stirrup, fly net. . . . In short, a reiteration in stone of the dynastic predecessor's horse shown in bas-relief, a three-dimensional translation of the real founder's spirited steeds. . . .

But the lesson to be learned from this copy, as from any other, is a hard one, and the example is fatal. What provided moving, tense, dynamic ornament in three-dimensional "engaged" stone becomes cumbersome or dangerous when used in absolutely "free" rock; the impression of ardor is gone. This horse no longer gallops, dares not trot, does not even walk. The bridle is missing—which is rather embarrassing in a horse standing by the mounting block. The mane scratches the sky. Finally, the animal's whole stance is stupid; it is not so much carved as frozen. For never would a live horse have chosen to be embodied in stone with its four hooves thus drawn together. And as the climax to this art which makes such miserly use of chisel and audacity, the saddle—that curving saddle whose pommel and cantle stand out so sculpturally in space—is covered by a sumpter cloth draped baldly from the fastening of the stirrup leather, as if the sculptor had feared the effects of rain and weather on this decomposable statue. The saddle wears a slipcover, like an armchair that is not to be used!

Here is what that free and fiery art of the runaway Mongolian pony was rapidly reduced to. This is the source from which a whole series was to flow, a parade of similar sorry mounts, all saddled, all tricked out and braided, all ready for the most unspeakably foul of sculptural rebirths. This saddled and pseudo bridled horse was henceforth to decorate all imperial burial places.

Yet under this same dynasty, the monstrous type of animal was to afford us what the more true-to-life horses—aside from the bas-reliefs we have already seen—refused, namely, a

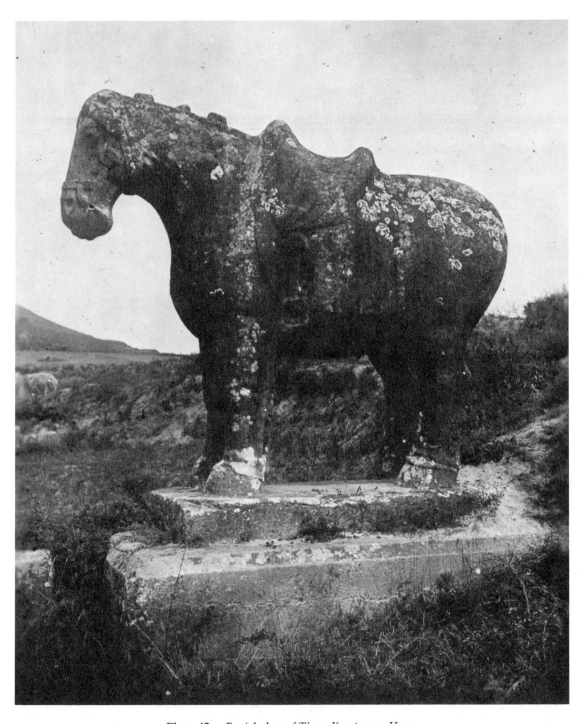

Plate 43. *Burial place of T'ang Kao-tsung. Horse.*

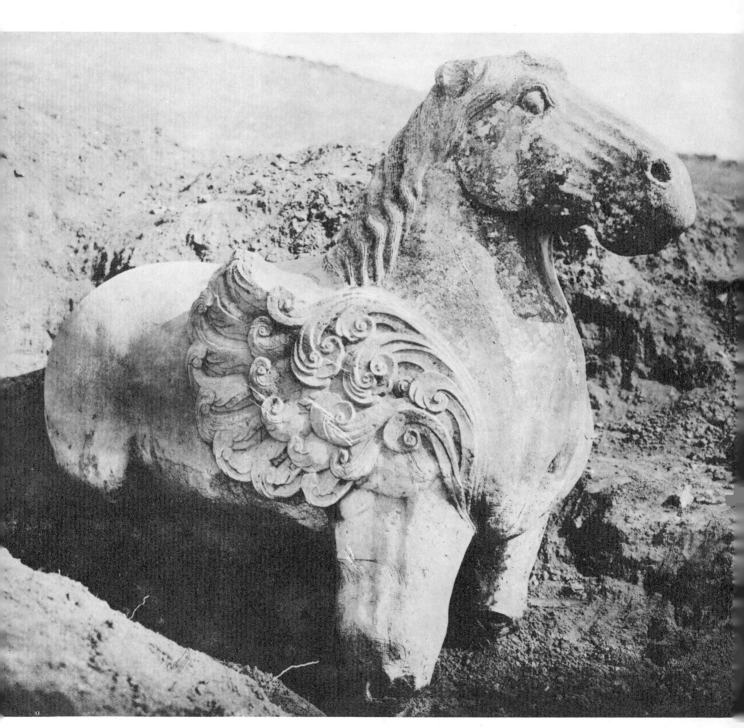

Plate 44. *Burial place of T'ang Kao-tsung. "Winged horse-dragon," or unicorn.*

masterpiece. I am referring to the "winged horse dragon" of the tomb of T'ang Kao-tsung (Plate 44), a few paces away from the six lamentable horses just described. By analogy with French usage, I have given it the heraldic name of "unicorn;" hence, the unicorn of the tomb of T'ang Kao-tsung (683).

In 1907, when Chavannes passed that way, only the head emerged by the side of the "way of the soul." The rest of the body was smothered by the full weight of the slope as the rains had washed it down. Yet the only visible parts—head, mane, and neck—were so noble that Chavannes mentioned their beauty in passing and would have liked to disinter the animal totally but was unable to do so, for the China of those days would not have allowed any stranger to use a pickax on Chinese soil. And so the beautiful head continued to wait, buried a little deeper, imprisoned a little more, with a gleam of hope in its large and sympathetic eye, an imploring way of holding the head, hidden promises; and visible just at ground level and curving back into the ground was an enticing swirl of wing. . . .

By the time we came along, seven years later, the greatest empire under the heavens had been overthrown. And just as necropolises can be ploughed under on the occasion of every dynastic mutation, in this case it was a modest republican prefect who had full powers to overturn and upset everything. So that when Gilbert de Voisins—who was the first to reach this element of the funeral cortege—decided to have it unearthed immediately, the modest republican prefect did not dare refuse. Republican soldiers, coolie-soldiers despite their weapons, came to watch our peasant-coolies work. Next day the sun came out, drying the mud on the beast's belly, drying the stains made by clay and once again shining and dancing on the crystalline facets of the most beautiful wings carved in stone that the whole T'ang dynasty can boast of; and here at last was the winged horse, the unicorn, visible in all its beauty down to the knees. The head, the grooved face, the well-modeled round eye, the simply braided mane—all these have not lost anything by being linked, even by so mighty a neck, to the scarcely curving croup and the shoulders with their vertical sheaves of muscle. The animal is not seen to best advantage when viewed from the front (can anyone, in fact, ever have looked at a living horse, face to face, and not have been appalled by the stupidity of that long, flat head) or in profile, for the fact that the back hardly curves gives it a certain heaviness. But the animal was not intended to be seen from the front or in profile. We must not forget that it was part of a very long and motionless cortege. It comes third or fourth in a double aisle, ten to twelve paces wide and a thousand long, and every "subject" in this aisle has another opposite it. Actually, if we walked down the middle of this aisle as we are supposed to, with our eyes looking straight ahead but our field of vision wide enough to take in each of these statuary couples, two by two, before we passed them, the only possible view of each subject would be from a three-quarters position.

It is only fair, therefore, to consider this unicorn from its "functional" angle. That must be and will be the angle of greatest beauty.

In the overall aspect—squared and sturdy, thick chest and round croup—one important detail, which is supposed to be only a detail, acquires an extreme, somewhat insistent meaning: the wing. This wing, as flowing as a beard, is made of a series of enspiraled floral patterns in which we can make out three main stages—at first they are nothing more than coiled ornaments, while in the third stage they are transformed into curling pinions and

lance-shaped tips. It is a "fine piece of sculpture" that betrays no hesitation or groping. The chisel plays, takes amusement in the plane surfaces as well as on the edges. Biting into the stone, which is handsome in itself, the chisel sharpens lines, polishes the various planes without the slightest clumsiness, moving from geometrical whorls to wing quills, making a fine pennate beard out of what was a mere linear element, curling like an ostrich plume what begins as a feature of architectural decor and ultimately becomes a spearhead. All of these parts—quills, feathers, beards, spirals—are energetically gathered, fanlike, to a single point of origin from which spring the three strong but slender sprays, brought together, which gush from the hollow under the elbow, so that the entire wing, as it appears to spread and splay unrestrainedly, springs from a single place, a single recess, a single joint. This is indeed "a very pretty piece," a success. Too pretty perhaps, too successful. A real contest entry. But the untrammeled freedom of the shoulder muscles under the wing, the size of the polished and abundant rump, the absence of any other ornamental scheme on the bare hide, show that for the first time there was a deliberate intention of focusing all of the quadruped's decor on one place, the wing, the monster's appanage.

This specific "moment" of Chinese statuary, which took the palpable form of this wing, is decisive. Skill has certainly been acquired in this case, perhaps even a little too acquired. The suppleness becomes disturbing. This rippling, lacy art is irreparably far removed from the austere and virile effort of the previous generations. At the same time, it foretells, prepares for, and leads to the imminent degeneration. It is just the right vantage point, therefore, from which to look at the variations of Chinese statuary since antiquity. The changes in the wing of the four-footed monster will clearly and schematically outline for us the principal phases in the entire sculptural development.

In the following line drawings I have schematized, accordingly, the major types of wing, from the Later Han to the T'ang (N)—six examples, falling into three series. We will find that they succeed each other in simple, clear, orderly fashion.

Schema 1 shows the left wing of the "winged feline of Feng Huan" (A.D. 121). We do not know of any feathered motif that is older. Because the forelegs are missing, we do not know how the wing was attached, but the four wing quills, the general shape, the vigorous and noble curve, are well-preserved and well-marked. Oblique from top to bottom, the wing sweeps upward in a concave movement that is good stylistically. We should note the flat ribbons, as it were, which emerge from its extremity and which wind decoratively over the entire body, to the haunch. Schema number 2 is more complete but at the same time rougher. It belongs to the tiger of Kao I, made a hundred years later (A.D. 209). The curve has grown thicker. This time, the point of implantation is visible; this wing is placed on the shoulder and does not seem to be articulated from the chest. It bears eight broad feathers, in two series.

Two hundred years later, both form and style have changed completely. Schema 3, the left wing of the chimera of Sung Wen-ti (A.D. 453), is a flagrant example. The wing is no longer a sort of quilled symbol, simply stuck onto the shoulder, but instead is like an additional limb, harmonious and musculo-decorative, so to speak; it is not only attached to but envelops the shoulder; its squamous feathers accentuate the movement; its wing quills,

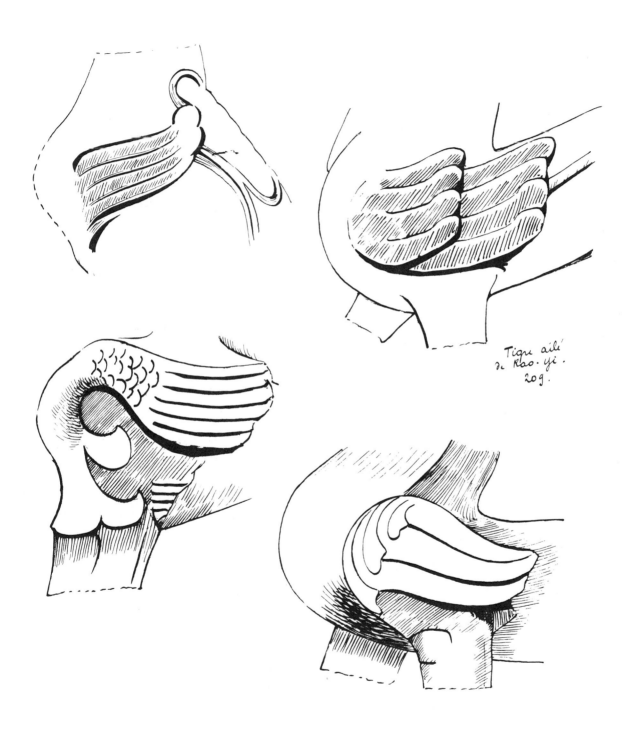

Tigre ailé
de Kao-Yi.
209.

143

Licorne de
T'ang Kao-tsong.
683.

Tombeau
De la Mère de l'Imi
Wou
vers 700
chav. 463.

N. *Six schemata of wing variants, from the Later Han to the T'ang.*

which are a little more numerous here and far less stiff, beat against the statue's flank in a propellerlike movement; lastly, the lower point of attachment caps the joint of the foreleg and decorates it with very large and beautiful swirls. Everything about this wing with its scapular implantation—movement, function, curve—is most harmoniously linked to the overall volume and posture.

Seventy years later, under the Liang, this fine supple movement has become bloated and dry, or, at least, of all its many qualities, it has preserved only the linear beauty. The full, fleshy, savory volume, the controlled quivering, have disappeared from the wing of the lion of Hsiao Hsiu (A.D. 518). All that remains are the lines; it is true that they are superb and faultlessly related to the edges outlining the neck. Once again, the wing caps the shoulder, but this time by means of flat, sweeping lines, elegant in profile but nonexistent in volume. The number of wing quills is reduced to three.

The first wing in the third series is that of the unicorn at the tomb of T'ang Kao-tsung (683). Its characteristics are striking even when schematized and seen in profile: the way it is attached no longer to the shoulder but to the chest; the way it bursts forth from under the elbow in a tight, fibrous, vigorous sheaf and spreads out in spirals, covering a broad area that originated entirely in one acute angle. This wing in turn differs as much from those in the second series as they did from those in the first.

Twenty years later, an already deformed version of the wing of Kao-tsung appeared at the tomb of Wu's mother (700). These spirals are undeniably of the same school of sculpture, but they are simplified, out of laziness. Possibly the aim was to make something big, monumental in size, for the unicorn in question is almost twelve feet high.

I do not think so. What we see is a motif that has become banal. At the same time, the wing rises straighter, stands out clearly above the level of the saddle, catches at the sky. But what is more serious is that this wing, which seems to be stamped out with a punch, is simply stuck on to the animal, without either logic or integration. It no longer bursts from the chest or the hollow under the elbow. There is no longer anything about it that would allow the animal to pretend to fly, nor does it really cover the shoulder. This was not done out out of a spirit of invention or sculptural justification but is doubtless the result of the stone-carver's carelessness and stereotyped approach, as he imitated the "essential features of the predetermined schema" at random without bothering to "compose" or articulate them.

We can see then that from the second to the eighth century, the great periods of Chinese statuary, what took place was not "evolution" but "mutation." Three types of wing stand out, separated by long intervals: under the Han, the scapular wing, stuck on, with few wing quills, ribbons leading out from its vigorous contours, as seen on the winged feline of Feng Huan. On the chimera of Sung Wen-ti, a flexible, scaly, fleshy wing, decorative but independent of the overall decor. On the unicorn of T'ang Kao-tsung, a pectoral wing whose volutes are abundant, broad, and curly. Each of these examples therefore inaugurates three series corresponding exactly to the three great periods of statuary which I, for the sake of simplification, have labeled the Han, the Liang, and the T'ang periods, thus showing in detail how true it is that there are divisions of the whole. Each of those examples, moreover, is the head of a series. Plates 2, 4, and 6 are merely examples selected, not at random but among others, so as to show the extent to which less successful copies occurred alongside the model of the particular type. The heavy wing of Kao I corresponds to the vigorous wing of Feng Huan. The hard outline of Hsiao Hsiu corresponds to the superb wing of Sung Wen-ti. Wu's gigantic feat of inlaid work is to be compared with the expert repetitiveness of T'ang Kao-tsung. Now, in each of these series, the model, the masterpiece, is old, and the less successful work is more recent. Whether over a century or a matter of only a few years, the "law of ascending beauty" continues to apply, not from one period to another but within the intimate development of each one of these periods. This is what I have chosen to establish on the basis of so restricted and so particular a feature as the wing, which comes as such a surprise in a four-footed animal.

Of all the examples of wing, the masterpiece, in my opinion, is that of the chimera of Sung Wen-ti.

If, in this descending series, we continue our examination of this particular feature, we obtain a preview of decline, as the wing provides a clue to the total decadence to come. As shortly thereafter as the year 820, at the tomb of Emperor Hsien Tsung, under the same dynasty, a sort of stone block-cum-horse—where the space between the legs is replaced by a pile of clouds as crude as a heap of bowels released by an overburdened belly—does bear the airy symbol of wings, but they are reduced to three quills, badly attached and badly conceived. Then, under the Sung, most important of the subsequent dynasties, the wing is reduced to two strips coming out of the chest—a mere shadow of a symbol, betraying the indolence of the chisel. Later, under the Ming, the wing suddenly reappears but with hardness, like remorse clumsily expressed, a caricature of what it

should have been. This is not an appanage any more, nor an item of decor, nor a symbolic element; it is barely a mechanical attribute from which all art has vanished.

The list of funerary animals depicted under the T'ang is not restricted to apterous lions or unicorn-horses with wings; suddenly it includes another animal whose presence in this cortege is really unexpected: the ostrich. There is no denying that the form reproduced in (O) does show the usual posture of that idiotic animal. It stands tall on its heavy legs with outstretched neck and feathered but stubby tail, leaving us no room for hesitation as

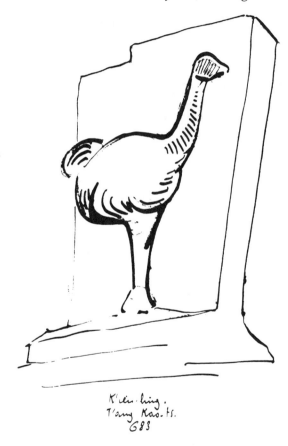

K'ien-ling.
T'ang Kao-ts.
683

O. *Burial place of T'ang Kao-tsung. Ostrich.*

to either the model or its crude reduction in stone: what we see is indeed the ostrich's naïve bearing as too capably reproduced by a conscientious workman rather than a sculptor, by a stone-carver who was more dexterous than creative. Furthermore, the motif was certainly imposed on the carver, not freely chosen by him. Doubtless these animals were among the offerings made in distant tributes, and it was for that reason that they were included thereafter in the motionless procession of T'ang Kao-tsung.

Another, more mobile animal of the same species scratches its leg—or perhaps it is hiding its head under its wing—at the burial place of T'ang Jui-tsung, who died in 712 (P). Though suddenly fashionable, this bird was an intruder in the parade of beasts. It

Khao-ling.
Jouei-tsong. 712

P'ou-tch'eng h.. chōu l.

P. *Burial place of T'ang Jui-tsung. Ostrich.*

was more foreign to China than the lion which had had its letters patent, its module, its access ever since the Han. The ostrich we see here, carelessly rendered in bas-relief, is mere official imagery, nothing more. Perhaps we can give it credit for the most mediocre of the qualities proper to the great statuary: a "living" resemblance with the living animal from which it is derived.

Before turning to the human figure as depicted under the T'ang, we can exclude from the heading of sculpture as such the abundant, generous, complete, figurative monuments that decorate the pagodas, crowd the palaces, and still show their nicely

147

carved façades—but their façades and nothing more, for I am referring to the stelai, which rightly belong to the art of the brush.

As for the pillars, a few lines suffice to describe them. They are at once the decadent culmination and the total sterilization of their predecessors, the perfect and complete columns we have seen. If we look here for descendants of the Han pillars or the fluted columns dating from the Liang, all we can find in the cortege—and rather late (712) at that—are rudimentary columns of the shapeless cippus type, without any clearly defined purpose or design, without inscriptions, without any "reason." The shaft is octagonal (Q), like that of the Liang columns, but shows no trace of fluting. The summit is a protuberance of no particular style, soft as to outline, stifled as to shape. There is no inscription.

Q. *Burial place of T'ang Jui-tsung. Column.*

Accordingly, we can rule out the possibility of any earlier influence, decide that the beautiful, elegant Liang tradition has been cast aside, and conclude that here an initial element in a series appears for the third time: the blind, blunt cippus, which is to reproduce and multiply under the subsequent dynasties. I do not know what it signifies. The limpness and absurdity of its form which, far from improving, are to become still more pronounced, discourage me from looking into it further.

For the third time, as a third experience, I must bring in human faces and forms
after having reviewed a set of animal forms and muzzles. What the Han nearly offered us,
what the Liang period refused us, the T'ang provide us with in abundance, but we cannot
help acknowledging in these very first lines that they do so with such rank coarseness,
such inadequacy, that we miss the vacuum that preceded. I do not know of a single human
statue under the Liang; I know of one under the Han, but it has been decapitated, and two
others are dubious. Suddenly, we have a profusion of them, and the result is the same:
disappointing. The oldest ones go back to the tomb of T'ang Kao-tsung.

As soon as you have crossed the area guarded by the unicorn and the horses, you
go up an aisle consisting of twelve stone officials facing each other, thus forming six pairs
or stages, backed against the pylons. We first see them, from a distance, in full profile.
Now, that profile is not handsome. It is even ugly. They look neither human nor animal.
The silhouette that stands out against the sky is that of a stone post or stake, an immense
one, true enough, ironically made in the shape of a devil or a man with a hair style that is

R. (left) *Burial place of T'ang Kao-tsung. Official with "chignon."*

S. (right) *Burial place of the mother of the empress Wu. Official.*

doubtless official but here takes the form of a ridiculous chignon (R). These are mischievous, awkward "little fellows," hardly carved out of the rock. The head is too large; the enormous sleeves are too heavy; there is not a single fold to the tunic; the robe trips up the feet. Only the shoes show any indication of a particular fashion, of their style, almost; they are triangular, rounded, with long, upturned, pointed toes; shoes recognizable for their ceremonious distinction.

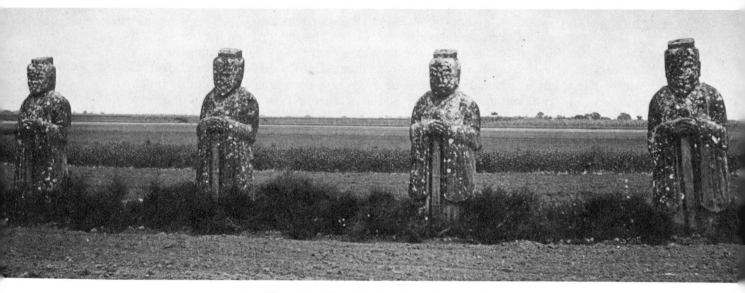

Plate 45. *Shun-ling. Eight officers. Photo Chavannes.*

Some twenty years later, this type asserted itself in the figures at the tomb of the mother of the empress Wu (S). Here we have total rigidity. The hood that surrounds the face has a noble air but more pronounced stiffness; the hands exist merely to reinforce the position of the sleeves. The pedestal and the lower edge of the robe merge into one and the same erection of stone. This second example, seen from a three-quarters angle, leads us from a profile to a full-face view. To tell the truth, we might conclude that it hasn't a human face. The full-front view is no more revealing than the previous three-quarter or profile views. The hair style and the point of the cowl are as important in this case as the expressive traits of the physiognomy, which forms a living shield. Mouth, nose, eyebrows, the orbs of the open eyes are all indifferent, lifeless, more petrified than the stone itself. These stone men do not wish to express anything human. They are not so much men as functions. There they stand, bored participants in the procession. It cannot be said that they "take part" in the procession. They are bored. They are genuine officials, civil servants. That is why they hardly exist.

There are others, many others! The eight "officers" of Shu-ling (Plate 45), though buried up to their ankles, give less of an impression of having been stood there like

ninepins. They are more human, but that does not make them much more handsome. They display the same remunerated rigidity, the same respectful bearing, denoting the successful performance of a function. In fact, we must not call these men or images of men, but mere semblances of men in stone. . . .

They prompt us to wonder once again whether that which even the greatest eras of profane Chinese statuary withholds from us—namely, the modeled expression of the intelligent human face—should not be sought, once and for all, in Buddhist art. There we find any number of faces, which their admirers and the texts deem "expressive." All I see in them, however, is one long, monotonous repetition of the same stiff ecstasy. If I have to choose between the two efforts—one signifying nothing more than the resigned attitude of officials, passive as cattle, the other offering a stereotyped reflection of an ecstasy vast enough to enwrap all worlds in its smile, the ineffable smile of Siddhartha verging on the ultimate goal—then I prefer the passive cattlelike attitude. For in the last analysis, it doesn't make us fall from so high up; it marks a lesser degree of ridiculousness; it is less of a betrayal.

Other statues of human beings betray still less. These are the tribute-bearers—or, better still, the tribute-paying princes—at the tomb of the emperor Kao-tsung, which has already given us the fine unicorn, the ugly horses, the pious men, and the great curly

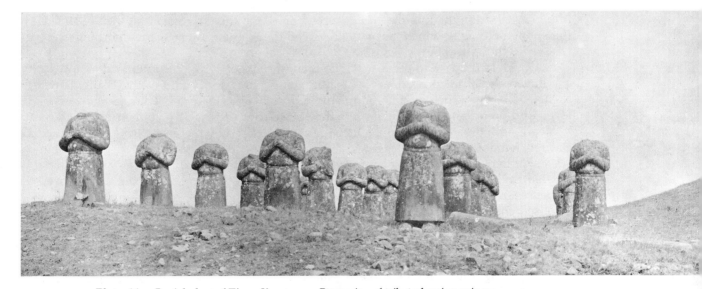

Plate 46. *Burial place of T'ang Kao-tsung. Procession of tribute-bearing princes.*

lions. In a cross-shaped formation on either side of the principal aisle come the two perpendicular groups of tribute-bearing princes, decently kept at a distance (Plate 46). As they advance by square battalions, they appear heavy, powerful, brutal in their short

151

belted robes cut off straight at the ankles, robes for walking, not for ceremony, recalling the simple, archaic, foreign, remote garb of the Gudea figures. This is "simple and brutal as is the way with Chaldean art." It is perhaps no mere coincidence that that comparison should come to mind. This double procession, arriving from both east and west, reveals influence culled from a genuinely foreign world.

All or nearly all of the heads are missing, which spares me no doubt from having to describe them as being rather ugly, judging by one head that is, unfortunately, three-quarters preserved.

Taken individually, these statues are heavy, almost crude, despite the very elegant but artificial way the hands join in an arch where the sleeves come together. Only the entire double battalion as it stands out against the sky, a wave rising on the loose soil, can be considered a clever and successful composition. This art is not so much a matter of sculpture as of the strategy of volumes well-arranged on the ground, clearly silhouetted against the sky and truly, in this case, symbolic.

We would have been forced to leave this third era—the last of the great eras in sculpture—behind us without having been the least bit gratified by seeing a handsome statue of a man, had not chance, more than the texts, introduced us to the "Guards of the Bell Tower of Shen-chou."

These two enigmatic statues face each other. Several things make them unfamiliar and uncertain: the look of the stone, which imitates cast iron; their period and style (doubtless T'ang); their ample and generous lines and the expression on their faces; lastly, the spontaneity with which they were revealed to us, one waning winter morning, in a city where we thought there was nothing left to discover.

Here then stand these two little men (three feet high), each perched on a pedestal and the pedestal in turn on an entablature, under the north gate of the Drum Tower or Ku-lou, the belfry such as is found in any important city (Plate 47). They are above our eye level, and proud and imposing despite their size. They are exactly symmetrical. Each wears a knee-length broad-skirted tunic, its wide sleeves raised by the gesture of respect, the two clasped hands. They wear leggings, and on their heads are very clearly shown helmets with side flaps. The modeling is of rare quality, energetic, with fine planes and, especially, pronounced edges. Although the faces have been eroded to some extent, they are still well-preserved enough: heavy eyebrows above two large eyes, a strong hooked nose, the upraised chin jutting way out, all this under the haughty helmet. Accordingly, the carriage of the head is almost fierce, befitting guards halting suspects as they pass; but the rounded elevation of these statues, and their saluting hands and sleeves, add a respectfully unctuous note, reminding the beholder that, between these two guards, processions and even the emperor could pass. Each guard, sturdily placed on slightly spread legs, its weight on the rear of the pedestal, forms a solid pyramidal volume from the top of the helmet to the "ground" on which it stands.

This is how we perceive the guard shown in drawing (T) with his two hands clasped and raised. He is the eastern guard. Drawing (U), giving a three-quarters view of the western

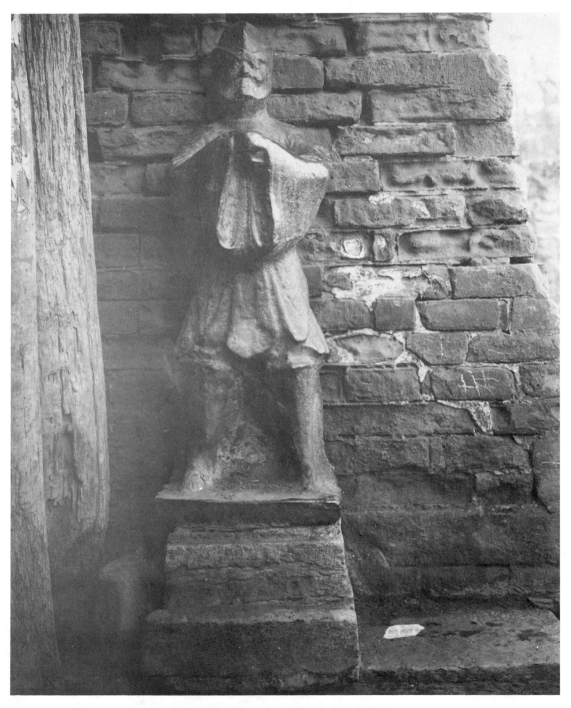

Plate 47. *Shen-chou. Guard of the Bell Tower.*

guard, shows how clear-cut the contour lines are, how the sleeves project freely and the hands are separate from the torso, and how the head and the helmet are thrown back. We can also see how supple the entire movement is. Finally, the next sketch (V) comes back to the eastern guard, showing his profile reduced to the main features. There is no personal interpretation in this schema. All I had to do was follow in space the clearly traced contours of the sharp edges formed wherever the various component volumes met at acute, visible angles. We can see the handsome design of the helmet as a whole, and how its skullcap is divided into two segments. We can especially see how the lower portion —leather or metal?—is lifted upward, producing a fine visual effect, and is accentuated by the same lines, the edge of the ear, the jaw, the cheekbones.

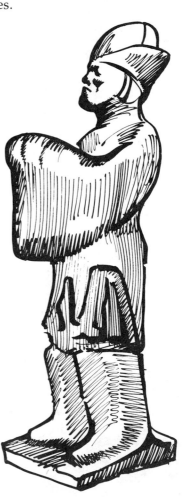

T. *Shen-chou. Guard of the Bell Tower.* U. *Shen-chou. Guard of the Bell Tower.*

Profil du
Gard. à l'Est.
V.S.

V. *Shen-chou. Guard of the Bell Tower.*

 This lithe abundance of volumes and lines is far from the stiff, stonelike expression of the Kao-tsung officials. Regardless of the angle from which we view these guards, their posture remains the same, their bearing that of respectful defenders. These are two fine human monuments.

 What first struck us as we gazed at them unexpectedly in an archway over a public road, without having read any hint of their existence, was their "physiognomical" resemblance to certain T'ang Buddhist statues at Lung-men. At the entrance to the sacred caverns, there are several guards, but they guard other worlds—heaven or hell. They have the same eyes, the same nose, same defensive profile, the same irritated and robust facial protuberances as of good watchdogs conscientiously doing their duty as gatekeepers: not letting anyone in. But the Buddhist guards at Lung-men are on parade as much as they are on guard. They look like a cross between demon-kings and circus performers, with their muscles bulging fit to burst their armor, their limping, twisted posture, and sometimes an air of being flushed with a fear that they exude but do not cause us to feel. Here, at the

Shen-chou bell tower, the gesture of the majestic guards consists of simply, nobly, raising their two hands. They convey the same message: only the worthy can enter here. The resemblance leaves us with this first impression or conclusion: that these two statues must be related to the art of the T'ang. From their noble, human stance, we can deduce that this is no longer the art of the Buddhist T'ang but civil art, and that the world they are guarding is that of ancient imperial China: that of elegant knowledge.

Unlike other, earlier works, these two fine statues, complete and striking as they are, are not in danger of imminent decay. Sheltered from the rainy winds from south, east, and west, they receive only the dry north wind. Accordingly, there is hope of finding them again.

Decadence
The Sung
(Tenth to Thirteenth Century)

Three important dynasties—Sung, Yüan, and Ming—stand between us and the fourth, that of the Ch'ing (Manchu), which was our contemporary, and which distinguishes itself from the others by having succeeded in producing a mediocre and even an ugly style of sculpture. The Yüan stand apart as well, but for different reasons. There remain then two styles to consider, two periods of a bad period, but they are recognizable: the Sung and the Ming.

In the midst of the severest internal revolutions, the Sung dynasty was founded in 960 by the principal army officers, who came together to name their commanding general, Chao K'uang-yin, as Son of Heaven. This dynasty was never fortunate in war. Under constant threats from the north, that immense frontier weakened by four thousand years of the yellow race living all along it, and harried by the Ki-tan Tartars, it was gradually forced to give up all of the fine farming land in the middle, the entire Yellow River valley, all the terrain north of the Blue River; in other words, all of classical China. Its movements were chiefly retreats. The capital, P'ien-liang (K'ai-feng-fu today), had to be moved to today's Hangchow, south of the huge rampart of water formed by the vast delta of the "Great River," "the River," that is, the Chiang; camped there on the edge of the unlimited expanse of sea, the city was like a last point of departure of these fugitives who could not turn back. So this warrior dynasty was a family of conquered men, routed for three hundred years from north to south. Yet that was a fine age for philosophy and letters. When one's brutal enemy is stronger than one's own brutality, it is fitting to take one's revenge in matters of the mind.

Under the Sung, the art of stone sculpture was not characterized by any innovation or originality. The lowest, clumsiest T'ang examples, whose decadence we have already noted, seem to relive in this period, to have founded a family. Sung funerary sculptures are merely an aggregate of overfamiliar forms, in heavier versions, with no indication of either rectification or regret; the evolution of their predecessors' defects with no innovation added. As if they were a downward curve on a graph, certain statues seem to have reached the rock bottom of unintelligent ugliness. Others are bearable, but not one is beautiful.

The clearest examples we know of, found closest together, are the score or so of large sculpted objects decorating the Yung-chao-ling, tomb of the emperor Jen-tsung, who died in 1063. The first monument is an octagonal monolithic pillar topped by a sort of peaked bonnet that is hardly separated from the shaft by a flange. No specific proportion. No decorating form. No inscription. We can barely recognize in this the "degenerate substitute"—a post instead of a great tree—for the Han monuments, analogous and perfect.

A new figure in statuary in the round depicting animals is introduced here: the elephant. It is known to have been used in ancient decorative art, for it appears in the Han bas-reliefs and is to be found in the tribute-paying processions of all the various periods. As shown at the Yung-chao-ling, the elephant is an animal of only mediocre stature (even relatively speaking, for it hardly reaches the shoulder of its neighbor, the man armed with an ax); it indicates a lazy, cumbersome art.

Then come the *chi-lin,* tigers or rams. It is not the first time that rams have appeared in the cortege. There were stone rams under the T'ang and already, as befits this ovine physiognomy, they were flat-nosed. Here the form is still more bastard and blunted (Plate 48); the stone block has hardly been rough-hewn; only the horns form a battered, spiral edge, but the line is awkward. It is an indistinct caricature of an animal. Enormous knees, the dull hunk of chest, the flabby slope of the back. So much weight and stone expended in vain, to represent an animal that is noble in itself, and which certain Han had depicted to good advantage! Right now, as I write, I have before me a small bronze ram barely as long as my hand. It used to be an incense burner, under the Han. Its posture is the same as that of the ram of Jen-tsung. It is minute and powerful, slight and vigorous, with the horns forming harmonious curves, the ears lifted, the line of the neck and the overall bearing very noble, the swell of the shoulder showing great style. Of course, I am excluding from this book any comparison between the weighty matter at which one chips away with a chisel and the fluid bronze cast in a wax mold. But stone too has its compensations and its power; and in this instance, no question of technique can excuse such smug inertia.

The *chi-lin* is the ugliest of all; but at least it has the excuse of being a monster. For that matter, I think we can say that the chimerical style did not do the Chinese any good, despite the excessive use to which the most recent dynasties have put it. Originally, their dragon was a muscular, four-footed serpent; in our own day, it has become a sort of lizard, bristling with spikes, thin, skeletal even, with the large head of a shaggy old man. It laughs or drools as it dances a celestial jig. And we have already seen what a disappointment the chimerical chimera was, after the lions of the great Liang period! Never since has it been able to take on a pleasing aspect. Instead, its decline has brought it lower and lower, if indeed it is possible to fall any lower, in sculpture, than the squamous barrel on four sticks, preceded by a pig's snout, which is exhibited in Plate 49.

There remains the tiger: a sheep without wool or horns, with blunt claws, a few fat creases at the joint between shoulder and foreleg, and on its face a rictus which, though intended to be ferocious, is merely watered down. We know where it comes from: from the T'ang period and much further back in time. But in those days it was modeled in depth.

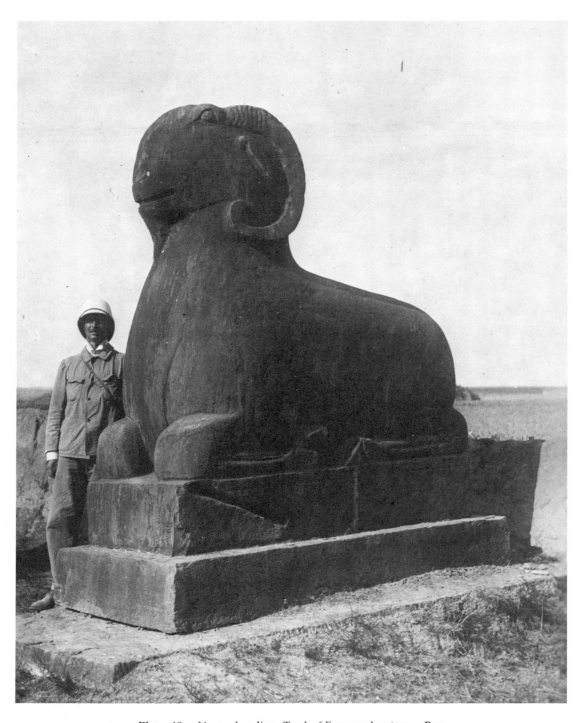

Plate 48. *Yung-chao-ling. Tomb of Emperor Jen-tsung. Ram.*

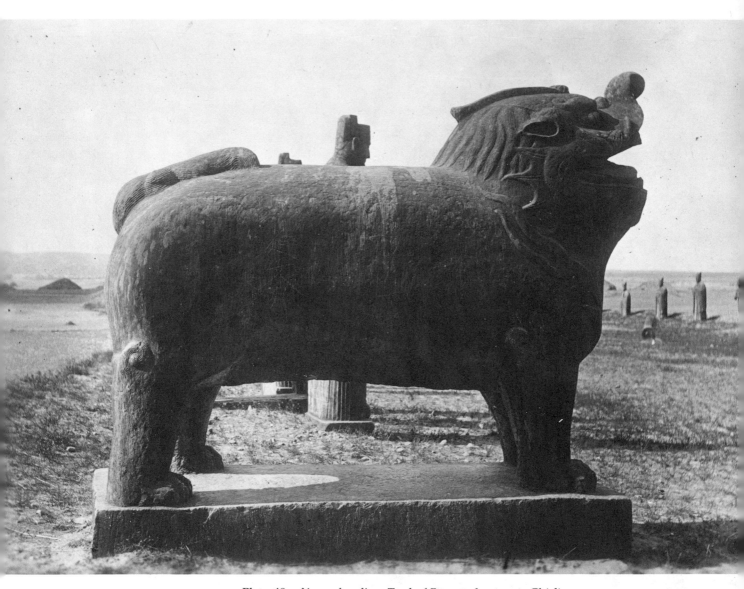

Plate 49. *Yung-chao-ling. Tomb of Emperor Jen-tsung.* Chi-lin.

The lips were pulled by the fierce muscles of the jaws; the eyes roared, so to speak; and the tongue protruded. Like the great mask of the handsome Liang lion. Whereas what we see here (Plate 50) is a mere transfer of barely incised features onto a surface that is already lifeless enough in itself. A vague, wavy sign that is supposed to suggest "frightening mouth" has been placed on the stone, but it conveys nothing. And the T'ang ostrich has by now become an imaginary bird: the bird with the golden wings which, in the legend of Hindu origin, is famed for its struggles against the Nagas.

160

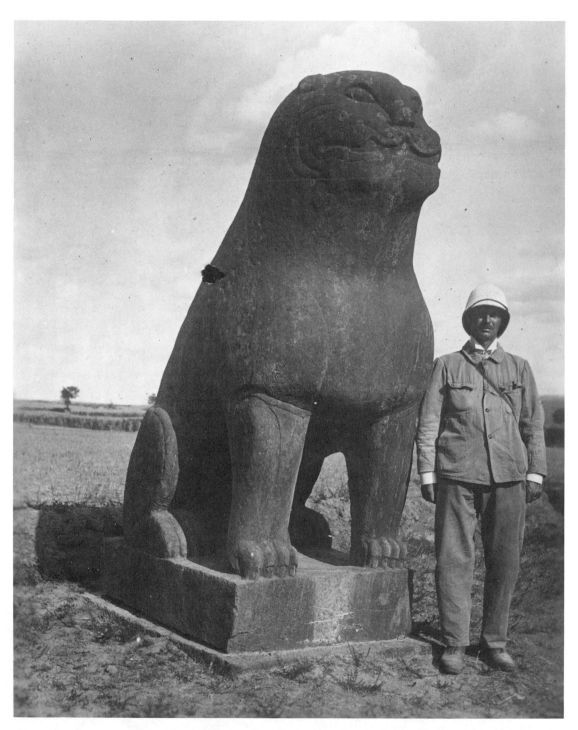

Plate 50. *Yung-chao-ling. Tomb of Emperor Jen-tsung. Tiger.*

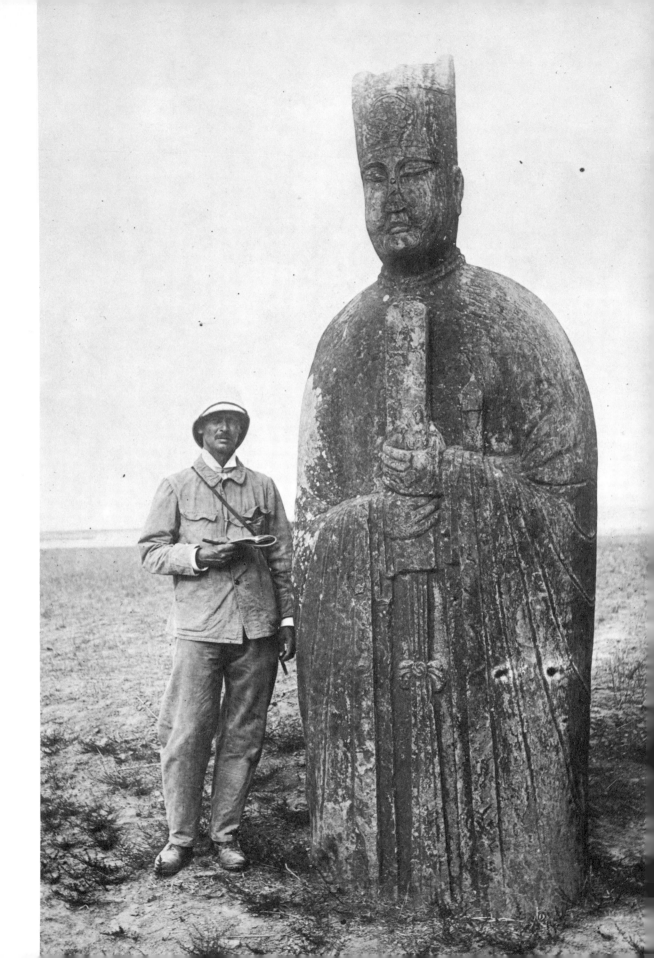

Thus, under the Sung, the sculptural representation of animals was bastardized through two processes that are urgently recommended to the official sculptors of our own day who are looking for a ready-made personality:

1. A lazy enlargement of the forms. This process imitates archaism but deceives only the "scholars." Had the Jen-tsung statues not been discovered by so discreet a Sinologist as Edouard Chavannes, I would not have been very surprised to see them catalogued among the masterpieces of primeval simplicity.

2. The transformation of appanages already used by earlier masters into clichés, stigmata: the feline rictus is one example. If the assignment is "to make a legendary monster," then, on a calflike body, the sculptor reproduces the scales, the flames, the marvelous streamers that the littérateurs have described but no man has ever seen with his own eyes. If the assignment is to carve a terrifying tiger, then the insignia of its role are somehow stuck on to its face. The sculptor pays no attention to the rest and finishes off as best he can.

Lastly, man himself. There is no lack of human beings in the parade of Sung creations! They are immense statues twelve feet tall, less "post"-like than the T'ang officials at the tomb of Kao-tsung. Here the lower part of the robe is wider (Plate 51), giving "the human monument" a more flared shape. The wide folds of the real robe, the one that was actually worn, would have lent themselves to an ample sculptural treatment; but they have been shown by a mere incision, and even its curve is not attractive. The sleeves are skimpy, the hands atrophied. The inert face expresses neither ardor nor gentleness; it no longer even has the diabolical look of the stone officers of the T'ang. It would seem that the Buddhist complacency of the pious statues that were so widespread under the Sung influenced profane sculpture in this case. What we have here is no longer ecstasy embodied in millions of copies but bland self-satisfaction on these civil servant faces.

In addition, here and there throughout the vast Chinese empire, there are reports of, and one can in fact find, a few tombs of small princes or lesser officials in the days of the Sung. They are indistinguishable from the numberless Ming hordes; only through the texts, when there are any, can they be identified. What we gain in terms of history is mediocre, since we have epigraphic proofs independently of these statues. What we gain in terms of statuary is nil.

Yung-chao-ling. Tomb of Emperor Jen-tsung.

163

Decadence
The Yüan (Thirteenth and Fourteenth Centuries)
Mongol dynasty of the Genghiskhanid

The last, lamentable Sung emperor, the pitiable eight-year-old Ping, was enthroned in 1278, only to die in 1279. The descent toward the south was total, the measure of shame was not yet full. The Chin themselves, formerly masters of the north, had disappeared before the fearful Mongol avalanche. Several years had passed since Temuchin had proclaimed himself the Khan of the Strong—Genghis Khan—and, dashing from one end of the largest continent to the other, had razed the peoples, pillaged the walls, picked the Indian flowers, dominated the most enormous territory that had ever existed in one piece, and had then died. His sons kept up the fight to extend his empire. It was to Ogodaï that the succession of the Sons of Heaven was granted. That is why, in a non-Chinese book, the dynasty whose Chinese name was "Yüan" can revert to its old Mongol name, its patronymic inflection, "Genghiskhanid."

Not since the northern Wei had foreigners been seen that were so foreign to China. One crucial difference is to be noted: history does not recognize the northern Wei, who took over the civilized heart of China and went from Ta-t'ung down to Lo-yang, as having obtained the dynastic mandate. They are not included in the regulation histories. Although accoutered with Chinese names, they were not authentic Celestial Sons. They continued to be on the outside, the fringe, to be usurpers. They borrowed little: a ready-made administration and the signs of the language. They imported and imposed creeds and images. When the T'ang expelled them, the race disappeared—but the images remained.

The Mongol invasion was altogether different. Genghis Khan's great cavalry scouts and dashing officers brought with them nothing more than their sabers and the fists in which to wield them. They had no images of a god whose essential characteristic was that he was the "Tengri," the heavens; a god that was not national but simply "god." In a day when every nation strove to define its god by assigning it attributes, power, these rough fighters were perhaps the only ones to speak so fervently of a god who was just simply god. They did not make images of it.

From the Chinese, they took the framework: the entire method, the whole machine already in working order. The court became a rendezvous for diverse types of

people—Christians, Nestorians, Jews, Buddhists, and Moslems. Men did fight each other a little—with words—while the Mongol, slightly drunk, looked on with a benevolent smile. So the Yüan were neither Buddhists, for their empire was indeed of this world, nor Taoists, alchemists in search of longevity, for when the life of a great cavalryman nears the end of three score years, it tapers off toward rest, toward fairly and well-earned "leave," just as an old soldier can opt for retirement after thirty years' service, twenty wounds —and these valiant men counted them all. Nor did they consider—far from it!—becoming Christians, adopting a dogma which teaches that it is wrong to kill, to rape women, even foreign women, and that another man's property, even if won at sword point, is an ill-gotten gain. They remained as they were. The only reminder of the steppes that they brought to China, their only relaxation, their sole innovation, was that of theatrical plays. Under the Yüan, Chinese theater suddenly heaved with a new breath from the outer world, and when they were gone, it sank back again.

There is no denying, however, that, in their life-time, the descendants of the Khan of the Strong, when they acceded to the throne, became excellent Chinese officials. The great ancestor had appointed good scholars and wise advisers to his entourage. His descendants seem to have wished to acknowledge the lesson by becoming obedient pupils. But this was a matter of government, and of Chinese-style life. Death made them Mongols once again.

In that respect, they went back to the great ancestor Genghis Khan, whose death happened to occur while he was traveling in the so very Chinese province of Shansi, and whose cadaver, we are told by the texts, expressed its own wishes. The tradition was to carry the body on the chariot "with the five flags" to the cradle of the horde, the holy city of Karakorum. But the chariot that bore the mortal remains of Genghis Khan refused to move. Not, in truth, that it wished to settle in China and (like the people he was getting ready to dethrone, those Chinese emperors, those yellow ants, those worker bees fit only to toil and produce) leave its bones to be crushed by an earth mound, placing horses and tigers of stone like so many toys along the avenue of the burial place. No, it simply refused to proceed toward Karakorum. Then it was that the Chinggis' old comrade in arms, the "valiant" Kiluken Baghator, addressed the motionless corpse: "Lion of men, sent by the Eternal Blue Heaven, son of Tengri, o! my divine and holy master, is it then your wish to abandon the whole of your faithful people? To foresake us? Everything is over there, that way—your native country, your wife, high-born like yourself, your government based on sturdy foundations, your carefully established laws, your people by the tens of thousands. It all lies that way—the place of your birth, the waters in which you bathed, Deli'un-boldaq on the Onon where you were born! It all lies that way—the prairie of the Kerulen, the place where you ascended to the throne as Khan of Khans!"

At these words, the chariot began to move, and it rolled on toward Deli'un-boldaq.

It is in terms of this hereditary, patronymic gesture that we must interpret the funerals of the Yüan emperors and account for what, in this book, after the vacuum of inadequacy and ignorance, the vacuum of the Chin dynasty, must be termed the Mongol vacuum. There are no imperial statues decorating the tombs of the Yüan emperors. At no

time during this adventitious dynasty, which for some eighty years, and not without glory, occupied the place on earth and perhaps the heavenly throne of the Sons of Heaven, is there any Chinese historical tomb.

We can go over the descriptions of the imperial burial places one by one. Nowhere within the Chinese territory as such do we find sites marked off, land reserved for that purpose, statues arranged in rows. It would seem that there is no such thing as statuary under the Yüan. Each one of the emperors went away—ever a nomad, ever en route for the other country—to be buried at the place of dynastic birth. Each one of these great deceased was a fugitive from empire. To each of them the voice of the most faithful counselor seems to have repeated, "You are dead, Son of Heaven. Everything lies that way, far away."

Yet, although their bodies went away, the Mongol emperors appear to have left their spirits to the Chinese, as a sort of pledge, a half-acknowledgment of the rites; for in the capital was the "temple of the imperial ancestors" and within the temple the tablet signifying "seat of the soul" of each ancestor. It is true that instead of being made of light, discreet wood, as befits men of letters and classical sages, the tablet was a heavy one of melted gold, showing altogether foreign, barbarian ostentation. This was an unsuitable gesture, and heaven punished it: in 1346, thieves sacked the temple and took all the tablets. "Precious metals must circulate," says the Chinese proverb. . . . Not even a sumptuous copy of the Chinese ceremonial could turn out well for these nomads!

All it really signified to them was putting on a show for government's sake. These newly arrived Mongols adopted the Confucianism of the ancient Chou or the subtle opinions of Chu-hsi, arbiter of suitable thought under the Sung. With one hand these great desert foxes protected Buddhism and with the other they beckoned to Christianity. But this did not prevent their bodies from taking refuge in the land of their origins. That is why it is pointless to try to find a single truly imperial Yüan tomb anywhere in the huge yellow country. No tigers or horses, no statues of men, be they Chinese or Mongol. . . .

The texts tell us that far from decorating their burial places with statues or sculptures, far from covering with a tent the bones of a man who had reigned over other men, the Mongols hid them from all eyes. Once the skimpy coffin, just barely embracing its cadaver, had been lowered into the grave, all the earth was hastily put back into place; and since a hump, exactly the size of the dead man, was still visible from the outside, the entire mounted Mongol horde came pounding over the mound to flatten it out, so that the grass of the plains would grow evenly and nothing would give away the site of the imperial burial place. Without having to fear posthumous visits, these great nomads had the rare privilege of being able to ensure that their remains would rest in peace under the ground.

Decadence
The Ming
(Fourteenth to Seventeenth Century)

The Ming were those genuinely Chinese Chinese who, in the second half of the fourteenth century, rose up against the permanent Mongol invasion, against the family of the Genghiskhanid who had become Chinese and the reigning family under the Chinese dynastic name of Yüan.

Through his descendants as well as through his ancestors, the founder of the Ming dynasty, Hung Wu, was the center, the link, the reason behind everything that is the topic of this chapter.

His destiny was singular. As an orphan, he was alone, free, master of his fate: he chose to become a monk, or rather valet to a monk in a Buddhist temple in Nanking. But at seventeen he sensed what was coming and fled. The times were restless. The empire was buzzing like a swarm of bees about the hive. His uncle, leader of one band, took him in and gave him his daughter. When Hung Wu became leader himself, he had generals whose names, as unknown as his own, were to become famous within ten years: Fu Yu-te and Hsi Yü-ta. He controlled them perfectly, launching them into battle or reining them in, while the last Mongol emperor, Togon Temur, fled to the edge of the Gobi Desert.

Even before he was master, Hung Wu decided he was victorious and chose Nanking as his capital, calling it "Necessity of Heaven"! There he made his headquarters and had formidable walls erected. Then he did indeed become master, Son of Heaven, and for his dynasty he chose the most brilliant of all the characters, the one that casts a shadow neither by day nor by night, "Ming," the light of the sun and the moon gathered into one light! Then one capital was no longer enough: he must have three capitals—Peking, capital of the north, wrested from the Mongols at last; Nanking, capital of the south; and, something that was unheard of in Chinese history, a capital of the middle: Fung-yang-fu, his native city. The latter capital he wished to raise up, create out of nothing. The city was ancient but poor; he made it into an imperial city. A palace and enormous walls arose. Then, when all was completed, when the long series of halls awaited their host, he did not come to live there. The city of the middle remained empty. But when his father died near the city, Hung Wu gave him a noble burial place a few leagues to the south. This ghost of a real city seems possessed by the ghost of the deceased ancestor.

Then he turned his thoughts to his own living capital, Nanking. He ringed it with imposing walls, or completed them, rather (they measure ninety *li* around, and on the south side are often more than sixty feet high), but this other capital is also empty. The pocket formed by those walls is enormous, enclosing the longest, hugest, emptiest of all cities. The disappointment is historical. We must fill this empty belly, as it were, swell it a little with its memories of grandeur, just as the spirit of a great man haunts the cold space in which he lies and through which palpable beings pass, unseeing. This tremendous void surrounded by battlements is the metropolis of the Grand Ming, first dynast of the Name.

Then Hung Wu gave orders concerning his own tomb. He placed it very close to the eastern rampart, so close in fact that we are surprised, for the others—his precursors or his successors—acting out of decency or prudence, placed their burial fields farther away. . . .

He must have been proud of his capital, and especially of the beautiful hill which stood out alone on the plain, long known as the Mountain Whose Summit Is of Purple Gold, and it was there that he directed his burial place to be made, having found that the *feng-shui* was good. It is there that we can examine his cortege of animals.

For all these historical deeds are also moments in statuary: as Hung Wu buried his ancestors, he erected the mausoleum of his father, Jen-tsu, near the capital of the middle. When Hung Wu acceded to empire, he created his own tomb: the tomb of the Ming in Nanking. When his descendants—and particularly the superb usurper Yung-lo—transferred his power, along with his remorse, to Peking, a site was chosen north of that city, and it was there that the last thirteen emperors were to be buried.

The advantage of describing these Peking sepulchres, dating from a period of sculptural decadence, is that we can take in at a single glance the imperial form of what a burial place was fully conceived to be, and that our glance takes in what is indispensable to Chinese statuary, namely, its site.

Not one example of Chinese stone sculpture that has come down to us is separable from a very vast whole which springs from the site itself; that is, from an immense, penetrating architecture of countless facets that takes in, along with the terrain as such, the cardinal points, the mountains, the winds, the ancient fluids; in a word, a whole geomantic science.

The site of the tombs of the Ming near Peking is superb. For someone coming from Peking, the best way to reach them is by the ancient imperial road; widened by barely ten paces, it leads to a majestic white gateway with five openings (Plate 52), the broadest, most honorific of all the millions of such gateways in China. The land slopes steeply up to it over a distance of twenty paces, so that from the road, and from very close up, you can see what this gateway encloses, but you cannot see what it opens up. With its few pillars, it closes an entire valley. Placed at this precise, carefully chosen point, it overlooks the whole site. You approach it, you climb up the slope and, at the very last pace, if you rise up a little in the saddle, the horse's last movement brings your eye just on a level with where the sweep of valley is to be taken in—a great sweep of valley skillfully reduced to this entrance, this ritual and strategic key, the gateway crowned only with the name "Ta-Ming," the Great Ming.

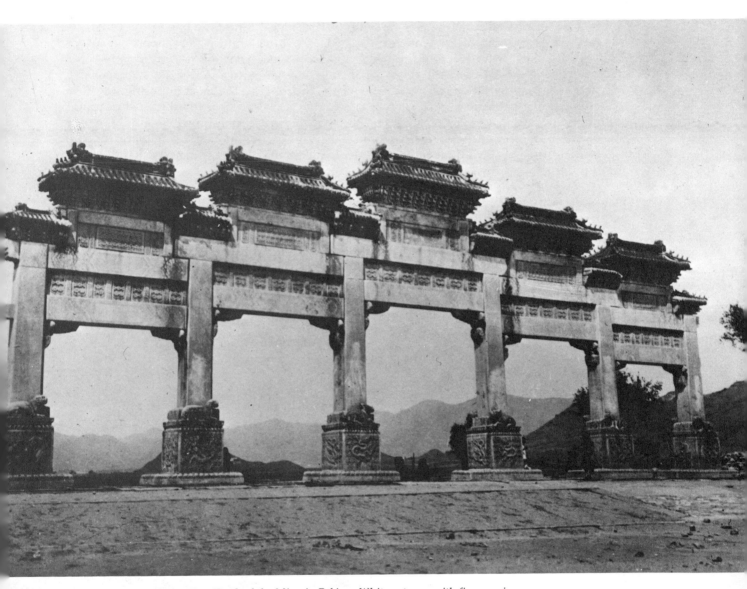

Plate 52. *Tomb of the Ming in Peking. White gateway with five openings.*

That is when you can really embrace the natural enclosure of this dynastic burial field. Every fold of the ground, every ravine, every secondary valley opening into the vast amphitheater has its tomb, the tomb of an emperor. You can count almost all the harvest-yellow roofs. There are a dozen of them, forming a great synod. A thirteenth stands somewhat off to the side, like a poor relation: it is the tomb of Chuang-lieh-ti, whose unfortunate reign put an end to the dynasty (1644): the Emperor who had hanged

himself was excluded from the great assembly. The hugest tomb, the one in the center, is the Ch'ang-ling, tomb of the emperor Yung-lo. It was he, third Ming emperor, usurper and grand prince, who reversed the whole dynastic series from south to north and came here to choose this site. He still reigns over the entire gathering. All of the statuary is so aligned as to lead to his funerary palace, which is the longest, the most imposing, of those that remain in China and perhaps of all those that ever existed. It is not the most beautiful of the tombs, but there is no denying that the way this procession is orchestrated, the way all of these objects encircled in the same valley are set in motion, as it were, by the spectator's walking toward them bear witness to a very moving art, a majesty that does not disappoint.

First of all, from the gateway to the end of the valley extends the pathway of the soul, the *shen-tao;* for here everything is focused on the soul of the deceased. Surrounded, protected by the site just described, the soul is to dwell here, exist here, arrive here.

If ever the soul of the deceased ancestor were to leave its monument and have to return to it step by step, here are the landmarks, or rather the motionless escort, which it would encounter, and which the visitor, the pilgrim, the person approaching will also encounter all along these avenues.

After passing through the gateway and crossing a three-arched stone bridge, a sort of passageway over the waters, the visitor comes to the "great red door" two *li* farther

Plate 53. *Tomb of the Ming in Peking. Avenue of animals.*

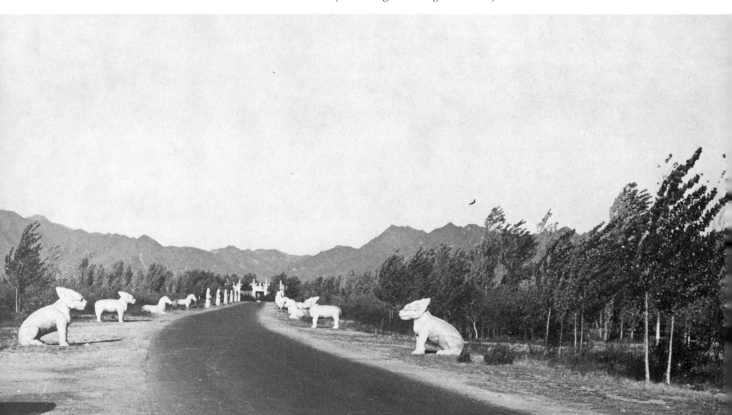

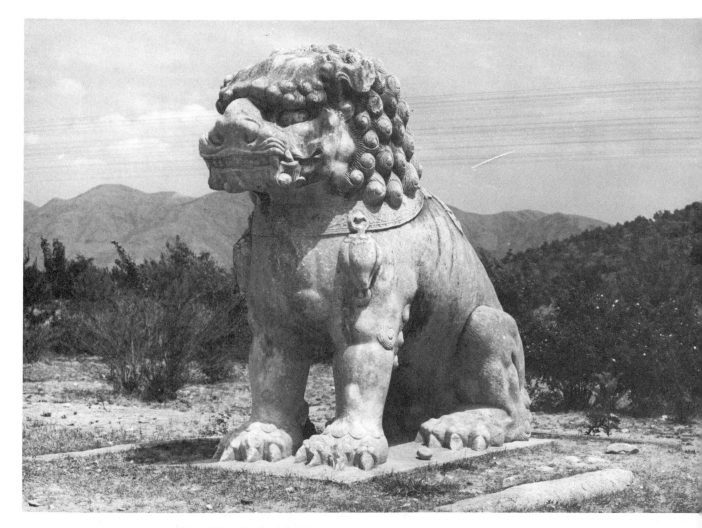

Plate 54. *Tomb of the Ming in Peking. Lion.*

on. There a stele commands, "Here, officers and other persons are to dismount." So, the visitor dismounts.

A flagged roadway, vertebrate, so to speak, like all the great roads that were not intended for carriages but were instead honorific, roads to be followed on foot from palace to palace, from capital to capital by chaise-bearers, runners, and satellites, leads to an immense stele-bearing tortoise sheltered under the remains of a pavilion.

The avenue continues, flanked on either side, first by two columns, then by animals placed twenty paces apart (Plate 53) and facing each other: four lions, four *chi-lin*, four camels, four elephants, four *chi-lin*, four horses. And, finally, by men: four military officers, eight civilian officers.

171

I do not know which of these beasts—some products of fantasy, others real—are the most to be pitied or scorned. The fantastic ones do at least have the excuse of their bizarreness. Very little was required to make them fantastic: in the lion's case (Plate 54), it is the mane, curly as a circus poodle, and the little bell tied about the neck. The legs and claws would not be bad if they were not so rigid; the scowling face is as shriveled as that of a leonine duenna. It is seated on its hind legs, the body like an elongated sack; and it has the slanting forehead of a stupid, angry animal.

The *chi-lin* (Plate 55) that follow the lions are merely uncombed monsters. None of them bears the slightest trace of a wing.

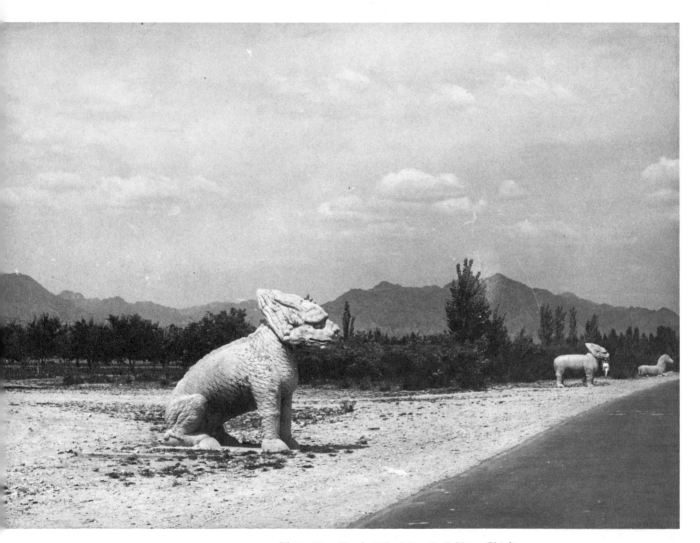

Plate 55. *Tomb of the Ming in Peking.* Chi-lin.

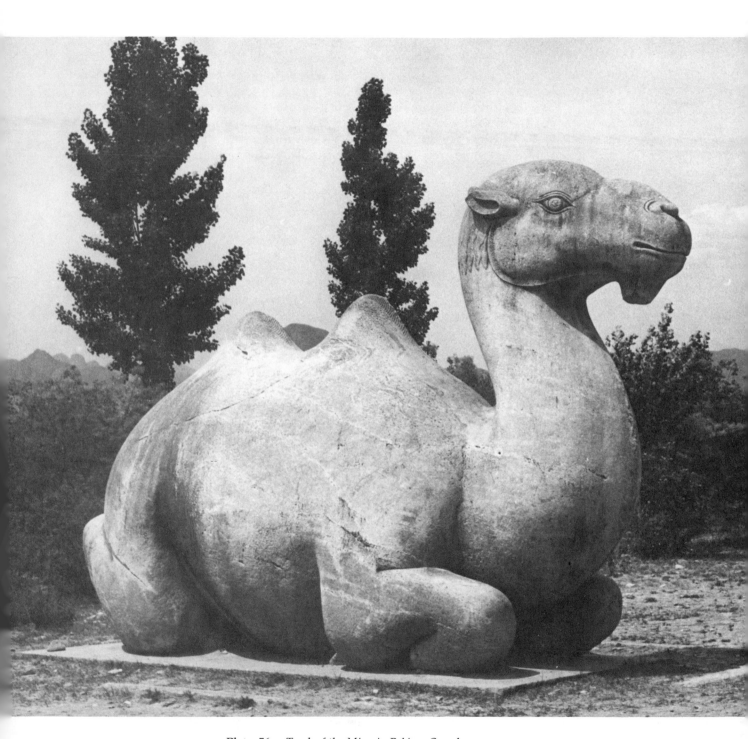

Plate 56. *Tomb of the Ming in Peking. Camel.*

Then come the camels (Plate 56), with their round unemphatic humps. The neck is round, the head is round, the legs are limp. Only the belly is well-rendered, with all the wobbling rotundity of the dirty gray water skin, always full to bursting, which that animal does in fact carry processionally between its four legs.

The elephants (Plate 57) are less hideous. The rough stone has enhanced their heavy shape. The trunk, well-framed between the two tusks, and the energetic ears are good details. But there is no statuary "effect." These animals are strictly symmetrical, and the boredom induced by the rectangular base on which each one is made to stand is visible in its entire stance.

Plate 57. *Tomb of the Ming in Peking. Elephant.*

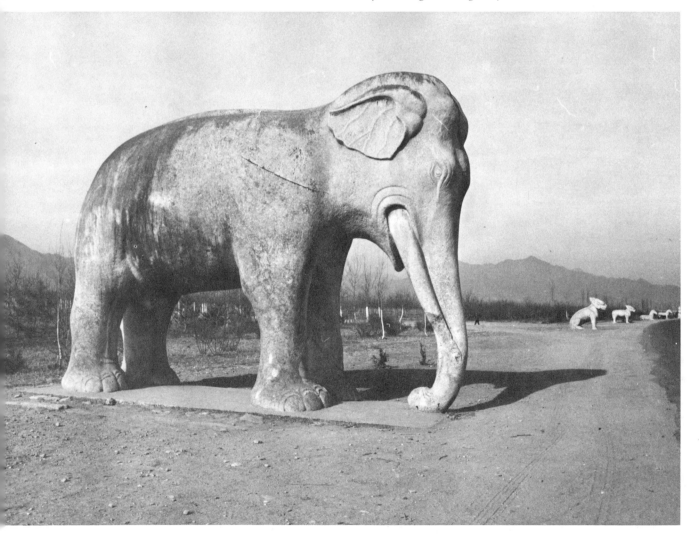

Last of all, the horses (Plate 58), so miserably rounded that we cannot more than glance at them here. Everything about them is soft, round, limp, symmetrical, weak. They all stand bare, with not the least trace of bridle or harness.

All of these statues are carved out of limestone with a shiny grain. Some of them are enormous in terms of height and volume: the elephants are over twelve feet high. Evaluated in terms of cubic meters or bushels as building stone, this has its importance. Each must weigh about ten tons. But the smaller pieces, judged on their paltry contours alone, are ridiculously petty and mean.

Plate 58. *Tomb of the Ming in Peking. Horse.*

So, the statuary at the tomb of the Ming near Peking, is guilty, lamentable, base; but aesthetics in China always have two aspects: the site, and statuary art as such. Here the site is powerful and complete and is worth discovering as a whole.

Let us come back to the avenue, after passing the last statue. It ends at the "gate of the dragons and phoenix." And from there, we walk directly to the sepulchre of Yung-lo, the immense Ch'ang-ling, spreading out four *li* farther on (Plate 59).

Plate 59. *Tomb of the Ming in Peking. Tomb of Yung-lo.*

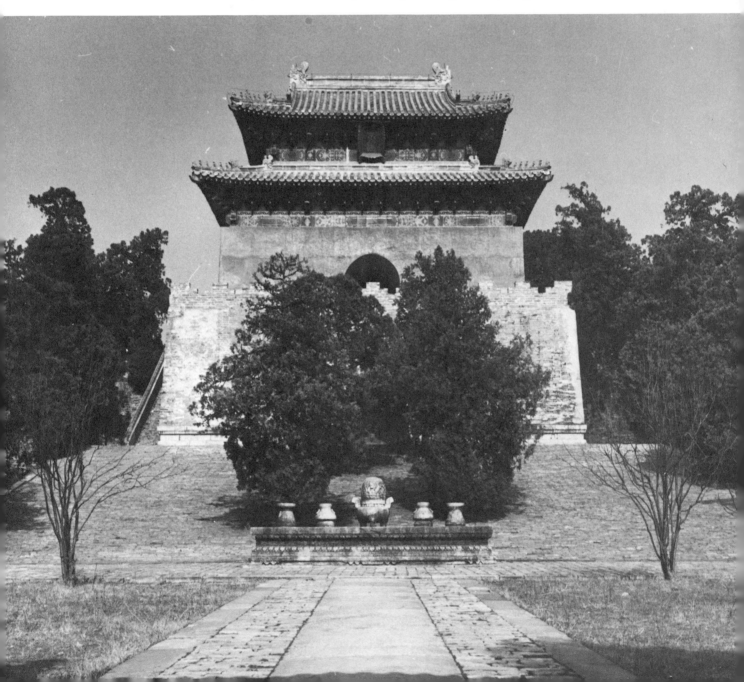

An impeccably rectangular enclosure, much longer than wide, extending south-north, its northern end terminated by a circumference, wider than itself, which encloses the tumulus: such are the layout and design of what the visitor will see.

Entrance into this enclosure is possible through a massive, three-arched gateway. The visitor sees a first courtyard, a perfect rectangle; in it stand a stele and two urns for burning offerings. Then a second door—symbolic this time, as it has no closed walls—gives access to a third space, which contains but one monument: the entire Ling-en-tien, or Palace of the Blessings Conferred by the Spirits of the Imperial Departed.

We must stop to examine this ancestral temple of Yung-lo, for it is the most beautiful monument of wood, brick, and tile remaining anywhere in China. It is the largest, give or take a few feet, as well as the one that is most sure of its line and its roof.

One hundred eighty feet long, the building stands on a triple terrace of pinkish-yellow marble. The three stairways, to right and to left, provide the usual steps by which to climb up; in the middle, is a long slab where dragons are carved in bas-relief. Sculpture of a late date, no doubt, in a very decadent style, but certainly superior to the statues we have just left behind. Phoenixes' gestures are interlaced. Dragons snort in the heavens. At the same time as the art of sculpture fully in the round had declined sadly, the art of bas-relief remained noble.

The hall itself is a vast hypostyle edifice. Its forty enormous columns are forty lofty cedar trunks from Yunnan, in the south, which two men with outstretched arms can barely girdle. These pillars still exude a delicate scent of ligneous, essential sap, and soar thirty feet up to support the polychrome framework, with its sober and scrupulously detailed lines.

Although China did not know of, or perhaps scorned, the framework using rafters, the triangle shape which cannot be deformed, and although Chinese architecture superimposed its posts, its round bars, and its horizontal beams in tiers, nothing has sagged or warped in five hundred years. But the roof does shower its tiles of gold into the courtyard.

Upon entering, one finds the volume of the hall disconcerting. What dizzying space is guarded by these hordes of polished, round, straight, extremely tall columns! They are arranged in eight transversal rows, thus creating nine bays: nine, the figure of honor *par excellence,* the utmost number that heaven itself cannot exceed, since there are only nine levels in the firmament. Yes, all this vast enclosure would seem unreasonable did we not know what the reason for it, the center, is. The center is a tablet of red wood, barely one cubit long; in faded gold letters on its old blue background is the dynastic name of the emperor "who reigned during the Yung-lo period."

It is a light, frail tablet, placed on—not affixed to—a pedestal which is hardly decorated, where three steps lead under a canopy endragoned in dusty gold. The tablet is meant to contain the essential soul of "the perfect emperor" whose useless bones occupy the heart of the mountain a little farther off.

Here, as we can see, is the point where the whole procession of the axis, the vertebral movement, strikes and affronts this fluidic geomancy. . . .

Then the march to the tomb continues. We come out a rear door into a last courtyard planted with silver-skinned trees, which have unpolished highlights, white leaves.

In this final courtyard, a final gateway, of white marble, leads to the *Shih-t'ai,* a stone table, the table for offerings, on which stand an incense burner, two flower vases, two candlesticks. All of them are made of stone, and all are so symbolic, so functional, that the stone gives off a scent as of stone, that we actually see a stone bouquet, see a stone flame leaping. Only our gaze can spring over this altar; our steps must go around it. And finally we are before a crenelated castle, Tower of the Soul, opening the passage and barring it at the same time, backed up against the tumulus.

The tumulus is circular and relatively small. It is a cone covered with low-growing greenery, pines, and surrounded by a wall.

And all around are the mountains forming a natural wall that encircles the man-made walls, the tumulus, the ancestral times, the alignments of men and animals, the stelai, the doors, the bridges, and closing their enormous claws over the initial gateway which opened up the passage and the prospect!

And all around, round about, farther away than the mountains, the Great Wall—its immense length of five thousand *li* defending the land of the empire against the hordes—and farther still, the ring of tributaries, defending the imperial colonies against the unknown, the nontrue, the unmeasured and unrecorded . . . the countries that were less than barbarian, neutral, vague, that were never talked about!

Thus, in coming to this tomb, we have come farther than the tomb. The soul has returned to its home. The journey, the procession, the march have been completed. Each one of the statues has taken part in it. Now we can see how rational has been the order in which they succeeded each other.

The Ch'ing (Manchu)
(Seventeenth to Twentieth Century)

The Ch'ing, those barbarians from the north, had no other virtues than that of copying most of the previous laws, making them insipid in the process. The tombs of the reigning dynasty (for the republic is nothing more than a passing rebellion) merely plagiarize those of their predecessors. The *Ta Ch'ing t'ung li (Repertory of the Rites of the Great Ch'ing)* is a poor and not very faithful copy of the same book under the Ta Ming. If there were such a thing as a compendium of the arts under the Ch'ing, extension of the Ta Ming, it would reveal decadence everywhere. This is undeniable, even in literature. Indubitable in painting. Paradoxical but rigorous even as concerns the art of great porcelain-making, which was born under the Han, reached its peak under the Sung, was bedecked with Five Enamels and the most beautiful shapes under the Ming and, with K'ang-hsi of the Ch'ing, went into its brilliant, flitting decline. What of statuary? As the great statuary of the Ch'ing was never invented, it could not perish.

Afterword

Victor Segalen was a figure to whom René Grousset often liked to refer in the course of conversation. A quarter of a century ago Grousset wrote, "Few men will have been so gifted. Few will have paid for their gift so splendidly. A life whose fullness made up for its brevity as if fate, knowing that Victor Segalen's days had been stingily counted out, wanted to enable him to succeed immediately in whatever he undertook. For he had an exceptional and incomparably rich nature; in every field he left behind him achievements of such stature that only one would have sufficed to perpetuate his memory." A poet, he placed a lasting imprint on everything he touched. He left us archaeological reports to which the study of the statuary and ancient monuments of China still owes the best of its conclusions. Chinese archaeology is indebted to him, therefore, for one of its finest ornaments.

Of course, the Chinese had been interested for a very long time in their national antiquities. They compiled handsome catalogues of them, illustrated by abundant rubbings, ranging from the catalogue of the emperor Hui-tsung's collection (1101–1126) to the *Garden of Metals and Stones,* published in 1846. Detailed descriptions (*chu-lu*) and identifications (*k'ao-ting*) were given of the collected objects (*hui-chi*), and at the same time the uses to which they could be put (*ying-yung*) were also studied. Beginning with these objects and with the efforts made to classify them, the Chinese science of the past grew up. It was based essentially on typology and epigraphy. A few rare archaeological excavations had been dug in the past, but the practice was not really adopted until the beginning of the twentieth century, when important exploration campaigns were led by foreigners. So began the era of modern archaeology. In central Asia, there were the memorable explorations by two Germans, Grunwedel and von Le Coq, by Sir Aurel Stein, by the Russians Berezovsky and Koslov, by the Japanese Otani and Tachibana, by Jacques Bacot and Paul Pelliot. To China itself, starting in 1907, came the Americans Berthold Laufer and Torrance, the Englishman Dudley A. Mills, the Japanese Sekino, and the three Frenchmen: d'Ollone, Chavannes, and Segalen.

The second step came in 1920, when geologists and prehistorians joined efforts to examine the prehistoric deposits; the great names of the Swede J. G. Andersson and of Father

Teilhard de Chardin are linked to this day with the Geological Survey of China. Nor did the Chinese scholars remain inactive. The impetus given by Wang Kuo-wei, Lo Chen-yu, Wu K'i-ch'eng, and Kuo Mo-jò lay at the origin of astounding discoveries: in An-yang, where the excavating begun in 1928 was directed by Dr. Li Chi, head of the archaeology department of the Academia Sinica; in Ch'eng-tz'u-yeh, in Hsün-hsien; finally, the discoveries in Shansi, which shed light on the Han era. At about the same time (1930), the Society for Research in Chinese Architecture was founded, and led by Liang Ssu-ch'eng. This was the culmination of the earlier work by Chavannes and Segalen, which, similarly, inspired research of prime importance: Maspero's research in Chekiang, as well as G. Ecke's and P. Demiéville's remarkable study of the Buddhist pagodas of Zayton.

By 1936, on the eve of the war, the Academia Sinica could pride itself on having laid the scientific foundations for the paleolithic and neolithic studies and revealed the existence of the great royal tombs of the Yin (fourteenth to eleventh centuries B.C.) in the old capital of An-yang (Honan). While hostilities raged, the Academia, despite exodus and general scarcity, courageously sponsored the work that led to the discovery of the royal tomb of Wang Chien (eleventh century), whose sarcophagus is decorated with magnificent high reliefs, and also to the discovery of the Buddhist grottoes of Ta-tsu (seventh to thirteenth centuries), with their many sacred or profane scenes. Then came the civil war that followed the torment of battle; it marks a new hiatus.

Once the young Communist government had become master of mainland China, it undertook an extremely fruitful series of archaeological campaigns, highly organized along the lines of the excavating done in the USSR. Since 1950, a number of specialized reviews such as the *Wen-wu-ts'an-k'ao tzu liao* (abbreviated hereafter as W.-w.), the *K'ao-ku t'ung-hsün* (abbreviated as K.) or *K'ao-ku hiue-pao* (abbreviated as K.H.) have been reporting on the numerous discoveries which have clarified or rectified the knowledge already acquired. Victor Segalen would doubtless have been overjoyed at such a harvest, and it would probably have altered his own outlook. Unfortunately (and we must remember this), as the author died in 1919, the conclusions he reached predated the great period of excavation. They are a monument, so to speak, of the prearchaeological Chinese age. It is for that reason that, although it is not my task here to draw up a balance sheet of Chinese excavations, nonetheless I think it would be appropriate to recall, briefly, the discoveries relevant to the text of this book.

The digging at An-yang, capital of the Yin, has brought to light the subfoundations of pillars and fragments of marble statues which make it possible to state that major statuary existed under the Shang (fourteenth to eleventh centuries B.C.). It is true that the dimensions of the only entire statue known at this time are small; but from fragments we can reconstitute a kneeling figure about fourteen inches high; moreover, a sheep's head nearly twelve inches high proves the existence of life-size statues. Also known are large wooden statues of dragons, with their tongues hanging out, which stand four feet, seven inches high. Discovered at Ch'ang-tai-kuan in 1956, they date from the third and fourth centuries B.C.

At the tumulus of the most prestigious emperor of China, Ch'in Shih Huang-ti, no extensive archaeological excavation has yet been undertaken. In 1932, however, a clay funer-

ary statuette was found three feet deep in the earth about two hundred feet away from the base of the mound. At Ch'üeh-chia-tsun, in 1948, two clay statues of seated figures were found, one a woman thirty-one inches high, now at the Cultural Center in Lin-tung, and the other a man twenty-seven inches high (W.-w., 1964, 9), now in the Peking historical museum. As they are almost life-size, these figures give an accurate idea of art in the third century B.C. They possess all of the elements of observation and all the realism that gave Han statuary its greatness. The same workmanship and finesse are apparent in the wonderful goldsmiths' work that the most recent diggings (W.-w., 1972, 1) have just revealed. But neither those two figures nor the brick and tile fragments found in 1961 and 1962 can as yet be attributed to the emperor's tomb. It has merely been measured anew. The mound stands 142 feet high; from north to south, its base measures 2,223 feet, and from east to west, 1,122 feet. Every side of the first enclosure except the south side has a gate nearly thirty feet wide, and the enclosure itself measures 2,223 feet by 1,883 feet. The second enclosure, with gates thirty-eight feet wide, is 7,053 feet long by 3,166 feet wide (K., 1962, 8). The dimensions of this tomb make it worthy of the great emperor, but we must still wait patiently to find out how it was constructed and what treasures it contains; for the time being, we are no further ahead than our author.

Victor Segalen's second revelation, the horse of general Ho Ch'ü-ping, the first genuine representative of Chinese statuary, remains first known of its kind, but it now has many companions. Since 1955, new statues have been unearthed before that same sepulchre, including a recumbent elephant, an ox, likewise lying down, a horse, a pig, and a fish; all in all, sixteen pieces forming a homogeneous whole (W.-w., 1964, 1). The curious thing is the lack of stone statues before the tomb of either the Han emperor Wu or the other great dignitaries, all contemporaries of the general. Segalen had a premonition that this tomb was really a unique tribute to the great conqueror of the barbarians, the great liberator, we might say. Specialists are perplexed about the somewhat unpolished workmanship of his horse, compared with the finesse of the funerary statuettes dating from the same century. Although Segalen preferred to consider that its origin was indigenous, the proponents of the foreign-prototype theory can point to new discoveries in support of it; and today there is no overlooking the ties that existed between China and the steppes.

Although the great funerary statues in the Siberian steppes were discovered long ago, they have only recently received close attention. We need only compare their style with that of the horse of Ho Ch'ü-ping to realize that there is a close relationship. A discovery made at Huo-ch'eng, in the Ili Valley, in 1953, supplies additional evidence (W.-w., 1956, 8): four statues of human figures. Three of them have a barbarian cast and are related to the Siberian statues of the Tagar period (700–100 B.C.) placed before the sepulchres in the form of tumuli (kurgans) (cf. S. V. Kiselev, Drevnjaja istorija juznoj Sibiri, Moscow, 1951). The fourth looks more Chinese, and its workmanship is closer to that of the Ho Ch'ü-ping sculpture, of the Teng-feng (Honan) statues, and of the statue nearly six feet high found at Ch'ang-an (Shensi) (W.-w., 2, 12). North of Kuldja, on the banks of the Borotala, another statue, disinterred in 1961, should be added to that group. Still other recently discovered animals are related to the style of the horse of Ho Ch'ü-ping—a recumbent lion, for instance, found in Ch'ing-hai, sixty miles west of Hsining (W.-w., 1959, 3).

The value of these discoveries is that they establish landmarks, milestones, between the Chinese types of funerary statues and those of the nomadic Hun or Wu-sun, who held the pasture lands in the Altai or Tien-shan mountains. It is with that latter mountain chain that the commentators on Han history (Han-shu) identify the Ch'i-lien-shan, which was General Ho Ch'ü-ping's theater of operations, rather than with the present-day Ch'i-lien-shan, located at the edge of Kansu. This means that the Huo-ch'eng site held the Kuldja passes through which ran the traditional road from Qara Shahr to Sogdiana (W.-w., 1956, 8). Thus, as the nomadic horsemen's bronzes would lead us to expect, we have a continuity in the relations between the world of the steppes and the Chinese world. In the latter world, examples seem to be confined to the territories that were often occupied by the barbarians. In 1957, for instance, at Tai-yüan in Shensi, a stone tiger measuring fifty-four inches long was found and is considered to be the oldest example of statuary in that province (K., 1961, 12). In Shensi itself, north of Lin-tung, on the shores of She-chuan-ho, the statue of a crouching ram was discovered in 1964. Both its dimensions (forty-one inches high) and its workmanship are almost identical to those of the Ho Ch'ü-ping horse, which stands only thirty miles away from it (W.-w., 1964, 5).

So, the number of examples of early Han statuary has increased considerably in recent decades. But they do not controvert the author's conclusions, a half century and more later. His imagination did not lead his science astray. What would it have been if he had had an opportunity to look on the treasures which those tombs contained?

A single discovery can give an idea of what Segalen's vision enabled him to perceive above and beyond his appraisal of the greatness of the statuary of that distant empire. I refer to the diggings carried out in 1968 at Man-cheng, in Hopei Province. There, two tombs had been hollowed out of the solid rock: that of Liu Sheng, Ching prince of Chung-shan, who died in 113 B.C. (four years after Ho Ch'ü-ping), and that of his wife. Liu Sheng was the brother of the Han emperor Wu, and his funeral was undoubtedly conducted as ostentatiously as that of Ho Ch'ü-ping. The sepulchre was not placed beneath a tumulus but hollowed out of the rock. By and large, the plan of it is similar to the plan of the tombs that Segalen had studied earlier in Szechwan. But this tomb is more imposing—157 feet long, 112 feet wide, and 23 feet high from floor to ceiling. Every available surface was covered with offerings and extremely varied objects: pottery, bronze vases, statuettes of both stone and terra cotta, lacquer ware, astounding vessels of gold and silver, jade, glass, lengths of silk, all in all nearly three thousand objects of astonishing quality. What a pity Segalen could not admire a wonderful lamp in the form of a seated person holding high a lantern with movable shutters by which the intensity of the light can be varied! The lamp-bearer is clothed in a sweeping robe that softly envelops all the angles of the body; its thick collar and long sleeves are so many strong points punctuating the servant's elegant form. His face is full of serenity—precisely the expression which characterizes faithful servants, armed with patience and devotion. This is a masterpiece of Chinese statuary, just as the funerary statuettes are.

In 1969, an equally important discovery, at the Lei-tai site at Wu-wei, in Kansu, yielded an impressive set of twenty-two large bronze figures, including horses. The beauty of one of those horses in particular reminds us of the "light-bearer" of Man-cheng. To emphasize

the soaring movement of this galloping horse, only one of its hooves is poised, on a swallow. Its movement is further accentuated by the way the head is turned slightly to the left, neatly offsetting the right foreleg, which is thrust foreward, and by the tail streaming on the wind and the pricked-up ears. Raised and outflung by opposite pairs, the legs are the very image of an exceptionally harmonious equilibrium. This horse, possibly more animated than the lantern-bearer, shows the progress made in the plastic arts between the second century B.C. and the first and second centuries A.D., between the animal handled familiarly and with rounded lines and planes and the flamboyant animated style, with whose rapidity we are already familiar through rubbings of carved slabs. Compared with this horse, the T'ang horses are more imperial but also heavier; so perplexing is the speed of movement that we cannot but connect it with the art of the steppes.

The statuary of the Later Han was enriched by the two statues at the tomb of Wang Hui (W.-w., 1957, 10): two figures standing nearly fifty inches high and forty-three inches high respectively, found near slabs bearing the dates of Yung-p'ing (58–76) and Yang-an (89–105); their style harmonizes perfectly with that of Kao I (W.-w., 1957, 9). In Shantung, at Ch'ü-fou, country of Confucius, two more large beasts were found, carved in stone. One is six feet tall, while the head of the other measures twenty-nine inches high and eighteen inches wide. Their style is more refined than that of the Shensi animals, and a nearby stele allows us to date them from A.D. 171 (K., 1964, 4). Another important discovery was a horse with his rider, a stone statue thirty-two inches high, found at Wang-tu (Hopei) in a tomb dated A.D. 182 (W.-w., 1957, 12); its style is identical to that of the small funerary statuettes. The same is true of the stone statue of a farmhand holding a large spade that was found at P'i-hsien in Szechwan, in 1955. Almost forty inches tall, it is in the same style as a comparable statue, only half as high, found in a tomb of the Later Han near Ch'eng-tu, at Tien-hui-shan (K., 1959, 8). These examples testify that, even better than in the preceding period, the stone-carvers' works give us an idea of the great statuary of the Later Han.

When it came to the ensuing period, that of the Chin, Victor Segalen found it a vacuum; but his premonition was right, statuary did exist. As of 1955, we have had examples of it: three lions passant found at Pao-wang-ts'un (Shantung) (K., 1958, 8). So much for the Chin vacuum. The Yüan vacuum has also been filled: in the area of Ch'ü-fou (Shantung), a funerary avenue with three standing officials has been dated, thanks to an inscription, as from the year 1312 (W.-w., 1958, 1). Thus the three periods that Segalen singled out for attention are no longer separated by periods of vacuum but have instead been linked, as with other art series, and new discoveries have provided a wealth of examples to illustrate them.

This, very briefly, is the harvest reaped by recent archaeological investigation in the country through which Segalen rode more extensively than anyone else. His achievement can be situated halfway between the learned labors of ancient Chinese archaeology and the marvelous revelations of Chinese archaeologists today. His work certainly bears the stamp of Chinese archaeology and, in order to appreciate it more fully, we must go back to the heroic days of the pioneers in this field, over a half century ago.

As a navy doctor, Victor Segalen had an opportunity to voyage around the world, at the age of twenty-seven, to discover Oceania and the Marquesas, and make contact with India. A new world opened up to him; Oceania attracted him but did not really have a hold over him. It was in the Far East that he at last encountered a culture that was complete and developed, yet still sufficiently enigmatic to assuage his desire for discoveries: the remnants of ancient Chinese art had been barely glimpsed at that time. A visit to the Cernuschi museum of Chinese antiquity, in Paris, was to strengthen his inclination. Trained in scientific methods, Segalen did not hesitate to tackle the burden of work required to initiate himself into the field. He studied Chinese at the Ecole Nationale de Langues Orientales Vivantes, where Vissière, drawing on his fund of experience, admirably guided his first steps. Segalen was so gifted and worked with such application that he was very soon able to take up archaeological studies; the great master, Edouard Chavannes, was to make him the explorer of China's archaeological wealth. Chavannes was one of the first to combine a training as historian with that of Sinologist. As a pioneer in Chinese historical studies, he quickly realized the value of the information provided by Chinese works on archaeology, especially the regional monographs (*fang-chih*), which, from century to century, noted the vestiges and monuments to be found in each region (*tung-chih*), each province (*fu-chih*), and often each individual locality (*hsien-chih*). Equipped with this information, he made a long journey, during his second expedition to China (in 1907), which took him from Korea to Peking by way of Mukden, Shantung, Hsi-an-fu (*Honan-fu*), Shensi, and Kalgan. The rubbings and documents that Chavannes brought back from this mission in the eastern portion of northern China, published in 1913 and 1915, sparked Segalen's vocation. All of the mythological scenes, the funerary frescoes where divinities and emperors danced, all of the edifying scenes from the life of the deceased with visions of fantastic animals peopling the other world must have made a vivid impression on the young poet's imagination and cast their spell over him. The themes of Segalen's work derived from Chavannes' revelations, and the research methods he was to use he learned from the great master's teachings.

It is touching to see how grateful Segalen remained to his master—a too often overlooked aspect of his personality that we should keep in mind. During Segalen's expeditions, no matter how uncomfortably he bivouacked, no matter how exhausted he was by eight to ten hours in the saddle every day, he wrote his journal, his logbook, and on top of that, every two weeks or so, he penned his letters to Chavannes. Again and again he attributed an equal share in his achievement to his companions, Jean Lartigue and Gilbert de Voisins, and still more often, speaking as with one voice for all three travelers, he expressed his gratitude to the master who constantly, benevolently, watched over them. On August 6, 1918, filled with sadness at Chavannes' death, he wrote to his widow, "Once again, I was coming back to him thankfully from this last expedition, the initiative and encouragement for which I owed to him. . . . It was at Bizerte that I learned from Paul Vitry, my traveling companion, the news that has since been weighing upon me like a personal misfortune. In the country to which he had opened the way for me, I strove to follow as faithfully as possible the path that had been laid down for me. . . . Even from far away I could feel the support he gave me and I now feel somewhat remorseful at having taken a little of his precious time these last few weeks. May I take the liberty, Madame, of expressing to you everything that I will no longer be able to tell

him, all the fervor of my gratitude and my admiration." Later he begs her to "allow Gilbert de Voisins, Jean Lartigue, and myself to place our future publications dealing in full with our 1914 expedition under the patronage of your husband's name and with that tribute thus to express all the gratitude which is due him. . . . I simply must state what seems to me so obvious: that it will be a long time before any future Sinologist will be able to take a single step without leaning on the solid foundation formed by his work. I hope too that I will be able to indicate how fecund it was." May the signatory of this quotation have fulfilled to some extent the poet's wish which is, moreover, a lesson to us. Oh, happy day when we do not know which of the two is the more to be envied—the master who can teach such a pupil or the disciple who is lucky enough to have such a teacher. Such is the way when two great minds search together for truth.

After his three missions, in 1909, 1914, and 1917, Segalen dreamed of writing a book on the great statuary of China. Certain features of it appeared in the reports that he wrote for the *Journal asiatique* in 1915 and 1916. Other elements enabled his companion, Jean Lartigue, to publish, on behalf of all three friends, an atlas of the archaeological expedition to Shensi and Szechwan in 1923, and, in 1935, an excellent study of funerary art in the days of the Han. Plans are scattered throughout his work. A page dated Nanking, April 7, 1917, and headed "Plan, scenario, schema," begins with "So, write a history of stone sculpture in China, but the text must be free of all the archaeology—or better still of all the Sinology—that will have come before it," and further on, "Doubtless I shall have to admit that China seems to have scorned stone as a means of expression, that it preferred Rhythm, Poetry and above all, the impalpable calligraphic Wen, the painting which derived from it." A page dated Brest, March 29 or 30, 1918, is a complete plan. The statuary was the first of the seven chapters planned; then came the art of the brush; the art of ceramics; the fleeces of silk and wool; molten metals and wax; the saps (lacquer ware and pearls); lastly, the philosopher's stone (alchemistic longevity, the superhuman longevity of works of art). Segalen's great design was emerging. On March 26, 1918, he wrote to Jules de Gaultier, "I am passionately beginning an impassioned 'History' of great Chinese statuary; my last trip allowed me to fill in the gaps and obtain virtually *all* of the documents known today." On August 4 that same year, he spoke of it again to Henry Manceron: ". . . Then I shall devote myself entirely to the 'Great Statuary' which is to be the history of the voluminous, non-Buddhist, profane stone work of China: Han Tigers, Liang Lions, T'ang Unicorns: ten centuries of unknown sculptures." The pages were indeed written, but unfortunately the author could not put the final touches on them: his death on May 21, 1919, only a year after Chavannes' death, deprives us today of the ultraperfected work that he had intended to write.

Would he have maintained certain cutting judgments? Would he not have curbed his flow of words so as not to move too far away from the truth? Chinese history is dealt some severe blows. The contribution made by Buddhism—which was actually a constituent element of Chinese thought and which, in a current of syncretism, produced neo-Confucianism—is denied and even heaped with blame. Could we, in the same way, ostracize Christianity from our Western culture and from our arts simply because it was born in the East? Segalen rejects the last dynasties out of hand because their genius did not lean to

statuary, but to their credit, there remain great philosophers, great writers, great painters. Should the passion for purity be taken to extremes at the risk of being deformed? These are some of the questions that the explorer's very frankness leads me to ask.

Perhaps we have his answer in his preface: "This book is not a work of compilation but rather the result of personal research . . . it is intended above all for artists." And in the body of the work, when discussing origins and influences, he reminds us, "This question is not appropriate here, in these chapters of vision, of direct observation." In this way, Segalen himself urges us not to stick closely to Sinology but to use it instead as a springboard. And this is all to our good fortune. Doubtless the number of good Sinologists is still small, but in matters of archaeology it is best to heed the true poets, who are rarer still.

Vadime Elisseeff,
Director of the
Cernuschi Museum, Paris

Index